D1616617

California's Pioneering Punjabis

AN AMERICAN STORY

LEA TERHUNE

Foreword by I.J. Singh, Professor Emeritus,
New York University

THE
History
PRESS

Published by The History Press
Charleston, SC
www.historypress.com

Front cover, top, left to right: Sarb Johl in his peach orchard. *Courtesy of Sarbjit S. Johl*; Sikh workers tend an orchard, 1912. *Courtesy of NARA*; Harvest time in the Hothi family orchard. *Courtesy of PAHS*; *center*: The Sutter Buttes overlook a placid farm. © *Dean Tokuno*; *bottom*: Activist Sarojini Naidu after a lecture at the old Stockton Sikh Temple, 1929. *Courtesy of the South Asians in North America Collection, Bancroft Library, UC Berkeley*. *Back cover, inset, left to right*: Bhagat Singh Thind during his World War I U.S. Army service. *Courtesy of David Thind*; Saund with future presidents John F. Kennedy and Lyndon B. Johnson. *Courtesy of Special Research Collections, UC Santa Barbara Library*; Bellytwins Neena and Veena Bidasha. *Courtesy of Bellytwins International*; *bottom*: Passengers aboard the SS *Komagata Maru*, 1914. *City of Vancouver Archives*.
Interior flap, top: Punjabi American women from the local community demonstrate their bhangra skills at the annual Punjabi American Festival in Yuba City. *Courtesy of Jasbir Kang*.

First published 2023
Manufactured in the United States
ISBN 9781467148870
Library of Congress Control Number: 2022943260

PAHS supported and funded this project, but the content and design are the ultimate responsibility of the author and The History Press.

*To the courageous men and women who risked everything to begin
new lives in the United States, who endured hardships and discrimination,
but who stayed to make a difference.*

Virtue is duty,
In the realm of righteousness.

—*Step 34,* The Japji of Guru Nanak

CONTENTS

Foreword, by I.J. Singh 7
Author's Note 11
Acknowledgements 13

Introduction 15

CHAPTER 1 17
It Started in India

CHAPTER 2 25
Guru Nanak and the Sikh Religion

CHAPTER 3 37
Maharaja Ranjit Singh, Emperor of the Punjab

CHAPTER 4 45
Heading West: New Opportunities, New Struggles

CHAPTER 5 65
Angel Island: South Asian Stories

CHAPTER 6 79
Difficult Times, Tenacious Immigrants

CHAPTER 7 95
From Field Hands to Landowning Farmers

CONTENTS

CHAPTER 8 105
Punjabi Pioneer Families of Northern California

CHAPTER 9 147
Marriages Between Cultures

CHAPTER 10 173
Laws Change, Families Reunite

CHAPTER 11 215
Settled and Prosperous: Achieving the Dream

Notes 277
Bibliography 283
About the Author 287

BEING AMERICAN: A SIKH PERSPECTIVE

Although this book is not exclusively about Sikhs, most of the early immigrants from the Indian subcontinent were members of the Sikh religion.

In a post-9/11 survey conducted by the University of Pennsylvania, respondents were shown photographs of Sikhs wearing turbans and beards. Their reactions were recorded when informed that these were not Muslims but Sikhs. About 78 percent of those surveyed were "disappointed, dismayed or confused" when told that Sikhism is distinctly different from Islam. This book, authored by Lea Terhune for the Punjabi American Heritage Society, helps dispel some of the misperceptions about a distinctive group that has participated in American society for many years.

Sikhs are a small minority in this vast country. The Pew Research Center estimates that, as of 2012, there were at least 200,000—by now probably thousands more—Sikhs in the United States, among the many groups that contribute to the rich diversity of America.

Yet Sikhs have been in North America for more than a century. They worked on the Panama Canal project in 1903–4. They helped construct the transcontinental railroad in the United States. The West was opened by immigrants with diverse ethnic and religious roots. Italians, Irish, Japanese, Chinese and Indians, including Sikhs from India's Punjab. More than one hundred years in a country less than three hundred years old is a substantial span, yet in many ways, Sikhs remain the new kids on the block.

As an American Sikh, I often look back on individuals who shine like stars in our struggle for an equal place at the table of this great and complex society. It was a different nation then—an unequal society with inequalities in its laws.

We remember Bhagat Singh Thind, who came to the United States as a young man and served in the U.S. Army in 1918—while retaining his traditional unshorn hair, Sikh turban and beard. At that time, the law prevented Asians from owning land and denied them the

right to citizenship, but Bhagat Singh persisted. He was granted citizenship in 1918 and again in 1919, but each time it was rescinded because he was not a "White Caucasian." He became a citizen permanently in 1936, when the Seventy-Fourth Congress enacted a law granting the right of citizenship to everyone who had served in the U.S. Armed Forces.

Another iconic Sikh presence was Dalip Singh Saund, an immigrant who took a doctorate at the University of California, Berkeley, became an American citizen and was the first Asian elected to the U.S. Congress, in 1952. Such dedication to public service is reflected today by others with Punjabi roots: former Governors Bobby Jindal of Louisiana and Nikki Haley of South Carolina, to name two.

South Asian migration to the United States came in waves, overlapping in time. The first wave bore the brunt of the Asian Exclusion Act and other such inequities, but the immigrants nevertheless helped develop the West. Many became prosperous farmers. Their lot was not easy, but they eventually succeeded.

Although South Asian immigrants sought education in the United States from the early days, after the Second World War in 1945 and India's independence from Britain in 1947, student numbers increased thanks to educational fellowships and scholarships. Usually young men, these students, Sikhs among them, were scattered widely on college campuses across the country. They often lived in communities where there were no Sikhs and few Indians. I am from that wave.

Immigration laws were humanized in the mid-1960s. After that, the American Sikh community began to grow. Often professionally educated, Sikh immigrants arrived with their families. It is this generation that built more than two hundred Sikh places of worship (gurdwaras). They started businesses and participated in local politics.

A new generation was born and raised here, products of American institutions; they are Americans first and know no country other than this. They understand American culture and are active participants in American society and politics. Mixed with them are new migrants from South Asia.

The personal narratives in this book range across the twentieth and twenty-first centuries. They are captivating stories about real people, Americans. They faced obstacles as they struggled to stay, earn an honest living and create stable families and lasting communities. Fortunately, the moral arc of American society historically bends toward justice and progress.

From the day I landed in America over half a century ago, the American Dream has been my preoccupation, as it is for all immigrants. I have heard the American Dream proclaimed from all kinds of pulpits—political, religious and in popular media. After a while, I began to wonder what exactly we mean when we talk about being an American.

An estimated eighteen million European immigrants came between 1890 and 1920. Israel Zangwill celebrated them in his 1908 Broadway play *The Melting Pot*, and thus the expression entered our national dialogue. The "melting pot" became a time-

honored model that we often mistakenly assume is America's motto. In a melting pot, the units blend irretrievably. The individual identity of each is lost.

Is this how America is? I think not. It is a land where each wave of immigrants has added inestimable value to society through collaborative interaction. American culture gains from the creativity, vitality and energy of its diverse members.

I like to think of this society as a large orchestra in which the lowly cymbals or the triangle have a place beside the naturally dominant strings and pianos. In a harmonious orchestra, the mighty and the small are heard and the conversation becomes heavenly music.

This is how I understand the actual motto of this nation: E Pluribus Unum. Equality of all people who make up this multicultural, multifaith, multireligious country. A democracy mandates that the rights of even the smallest minority are equally protected.

Sikhs would be a small minority no matter where they lived, even in India. Sikh scripture—the Guru Granth—opens with an alphanumeric that stands for the Creator. And it postulates that one God—not a partisan Jewish, Christian, Muslim, Hindu or Sikh God—embraces all creation. Sikhism tells us that to discover unity in the diversity of creation is to experience God. The oneness in the creator and creation leaves no room for distinctions in race, caste, creed, gender, color or national origin. Differences between "them" and "us" vanish. Equality, liberty, fraternity and justice are inherent in that oneness.

The First Amendment to the U.S. Constitution has two significant clauses: that the state shall not establish a church, and that it must ensure free exercise of religion. Thomas Jefferson also reminds us, "It does me no harm if my neighbor thinks there are twenty gods or that there is none." This tells me that it is possible to be a good American regardless of one's religion or lack of it.

I, and many Sikhs, wear a turban and unshorn hair—marks of our faith, just as Jewish men may wear yarmulkes or Muslim women may wear head scarves. These signs do not inhibit the ability to work effectively or contribute valuable service to the community.

To my mind, the best acceptance of diversity is to see color, gender, caste, creed, religion or national origin as irrelevant. We need to see "us" in "them" and "them" in "us."

Sikh scripture, written three to five hundred years ago, offers a poetic formulation of E Pluribus Unum. In translation it goes thus:

> *As out of a single stream, countless waves arise; And then return to the water.*
> *So from God's form, emerges all creation; To return to the One again.*
> *—Guru Gobind Singh, The Tenth Sikh Master (From Akal Ustat, 47)*

<div align="right">

I.J. SINGH
Professor Emeritus
New York University

</div>

AUTHOR'S NOTE

On September 15, 2001, I was seated in the Heathrow Airport departure lounge waiting to board a British Airways flight to Vancouver when a group of simply clad Sikhs entered the boarding gate. Their clean white kurtas, short pants, blue turbans and dignified comportment led me to assume that they were *sants*, or holy men. One was elderly, the rest younger men. They appeared to be from some rural Punjabi village, judging from the simplicity of their belongings and their evident naiveté about airports.

Northern India had been my home, by this time, for nearly two decades. I was scheduled to leave Delhi on a September 11 flight to San Francisco to see my father, who was dying. The BBC was on the TV while I packed that day. Entering the room with a handful of clothing, I stood spellbound as the live transmission of the second plane crash into the World Trade Center was beamed across the world on that sunny New York morning. I didn't travel that night. U.S. airports shut down. Scrambling to get another flight, I discovered that Vancouver, Canada, was the closest I could get to my California destination. I took it, thinking if I couldn't get a better flight in London I'd take a train from Vancouver. The London airport was in chaos. Stranded United States–bound passengers literally shrieked with frustration.

It was quiet at the departure gate for the Vancouver-bound flight. I idly watched the four Sikhs as we all waited. I recalled there was a large Punjabi population in Vancouver. It suddenly occurred to me that I was hoping these men would be all right, that someone would meet them. When some Americans beside me commented on their appearance, I found myself explaining to the couple where these turbaned men were from and some of the values of the Sikh religion, which I had learned to respect during my years in India. "They are religious persons. Sikhs are not Arab terrorists," I said, as if trying to shield the Sikh travelers from ignorant judgments. As it turned out, the group sat near me on the plane, and once or twice, in my broken Hindi, I helped them understand instructions.

During that same visit to the United States, I became aware that Punjabis were among early Asian immigrants to California. An exhibit at the University of California, Berkeley, *Echoes of Freedom*, drew attention to this unsung diaspora. Recent successes of South Asian immigrants in Silicon Valley were well known, but I knew little about these "pioneers," many of whom thrived despite decades of severe discrimination. As a native Californian, I was shocked that it took so many years—and perhaps my interest in South Asia—for me to learn about this community. There was nothing about them in our school history books. Of course, when I was growing up there were far fewer South Asians. Their number was restricted by law. Even so, it seemed that the story of early South Asian Americans should be better known. I wrote several articles about Sikhs settled in California's Central Valley. I was delighted when I was contacted by the Punjabi American Heritage Society to write this book. Now I am pleased to contribute to the literature on South Asian immigrants in the United States so that this community may be better understood and the richness they have brought to this country more widely known.

LEA TERHUNE

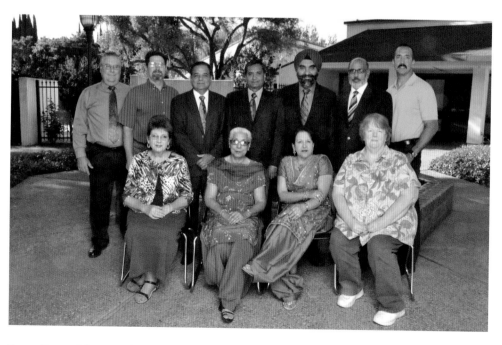

Sutter County Museum exhibit committee (*standing, left to right*): Steven Perry, Stan Cleveland, Sarb Johl, Kulwant Johl, Jasbir Kang, Hitpal Deol and Jim Whiteaker; (*seated*) Julie Stark, Gurmeet Sidhu, Davinder Deol and Sharyl Simmons. *Courtesy of PAHS.*

ACKNOWLEDGEMENTS

This book came about through the efforts of many people. It began with an idea for an exhibit at the Sutter County Museum. The late Tejinder "Ted" Sibia, who created a website documenting Punjabi pioneers in California, was a significant force in developing the concept. The Punjabi American Heritage Society (PAHS) made it happen. Museum staff and the PAHS planning committee were key to mounting the permanent Punjabi-American exhibit in the museum's Multi-Cultural Gallery, which opened in 2012.

Donors gave money and expertise, notably Sarbjit Singh Johl and Parmjit Singh Johl, Sarbjit Singh Thiara, the Bains family and the Mehar Singh Tumber family. The late Mary and Leela Rai, Kulwant Singh Johl and many families mentioned in this book donated time, money and, in the case of Kam Thakar, Chandan Cheema and Kanwaljit S. Kahlen, their fundraising expertise.

The PAHS museum exhibit committee, consisting of project director Dr. Jasbir Kang, Davinder and Hitpal Deol, Kulwant Singh Johl, Sarbjit Singh Johl, Gurmeet Sidhu and Ted Sibia, gave invaluable assistance in collecting photographs and other information in this book, as did Gerry Sandhu.

Thanks go to Dr. Jasbir Kang. Without his help, this book project, originally meant to accompany the museum exhibit, could not have been accomplished.

Thanks, also, to experts who offered comments or shared photographs and information, particularly Karen Leonard, Paul Michael Taylor, Nicole Ranganath, Dr. Inderjit Singh and Dr. Onkar Singh Bindra. Special thanks to Laurie Krill at The History Press for her guidance and encouragement over the years that this book was compiled.

Finally, the author is grateful to all those who gave their time to tell the stories of their families and who generously shared their family photographs. They are the heart of this book.

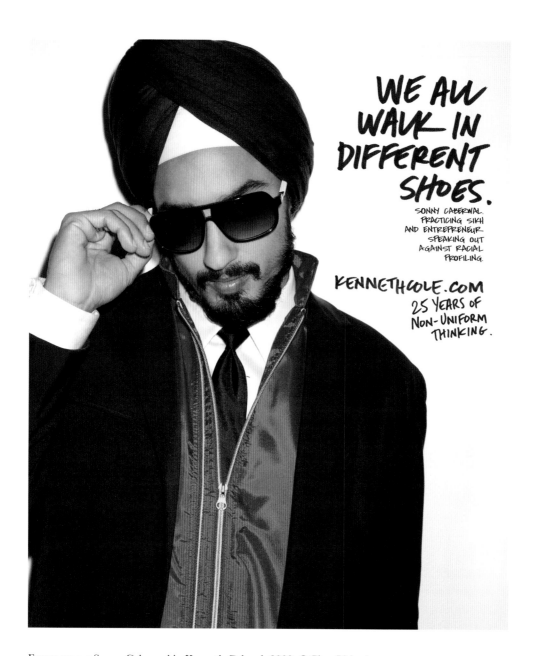

WE ALL
WALK IN
DIFFERENT
SHOES.

SONNY CABERWAL.
PRACTICING SIKH
AND ENTREPRENEUR
SPEAKING OUT
AGAINST RACIAL
PROFILING.

KENNETHCOLE.COM
25 YEARS OF
NON-UNIFORM
THINKING.

Entrepreneur Sonny Caberwal in Kenneth Cole ad, 2008. © *Terry Richardson.*

INTRODUCTION

Sonny Caberwal, entrepreneur, son of immigrants to the United States, is the face of young, successful South Asian Americans today—so much so that he also became the face of a Kenneth Cole advertising campaign a few years ago that emphasized diversity.

Sonny's story comes later in this book. Before that are the stories of adventurous men and women who paved the way for Sonny and others to make good in today's America. More than a century ago, they left a faraway land and courageously sailed into the unknown. They endured hardships, failures and, in many cases, success.

THE SOUTH ASIA CONNECTION:
PUNJABIS LED THE WAY

Ethnic South Asians who live in California today have roots in India, Pakistan, Afghanistan, Nepal, Bangladesh, Sri Lanka, the Maldives and even Bhutan. But at the cusp of the nineteenth and twentieth centuries, most South Asian immigrants came from a particular part of then-British India—the Punjab.

Some were Muslims, a few were Hindus but most were Punjabi Sikhs. Many had seen and heard about North America during their service in the British Indian Army. Others were told about the West by well-traveled relatives. However it was that they

learned about North America, in the 1890s, adventurous young Punjabis began to arrive in California. Born farmers, many ended up tilling the rich soil of the Central Valley. The land made these immigrants feel at home. It reminded them of the Punjab.

The descendants of these pioneers are still in California, many still in agriculture. More South Asian immigrants followed in succeeding decades, but few faced the challenges of the early immigrants. Their story is one of courage, ingenuity and perseverance against the odds. It is also the story of a long struggle against bigotry and institutionalized discrimination.

MISNOMERS AND MISTAKEN IDENTITIES

They were called "Hindoos" in the early days; later they were called East or Asian Indians to distinguish them from Indigenous American Indians. With the split of India into three countries—India, Pakistan and Bangladesh (in 1971)—after independence from Britain, South Asian American is a more inclusive designation for people with common ethnic and cultural roots that go back thousands of years and is the term often used herein.

Correcting misconceptions, highlighting unsung heroes and introducing to a wider audience a group of Americans who fully engage with American society is the goal of this book. Building cultural bridges and explaining South Asian traditions to those unfamiliar with them has grown more important in the years since the terrorist attacks on September 11, 2001. Since they arrived on North American shores, South Asians have worked hard to improve their own lives and those of their neighbors. This book tells their story. It is written in the hope that more Americans can know and appreciate the multifaceted brilliance and contributions the emigrants from South Asia—and the Punjabi Americans of California who led the way—continue to make to American society.

IT STARTED IN INDIA

The Indian subcontinent, approximately eight thousand miles away from California, cradled an innovative ancient civilization. Skills, ideas and philosophies developed and flourished there over millennia. These ideas informed Western civilization.

India gave the world numbers and introduced the concept of zero. Its languages trace to antiquity and infuse most languages spoken today. Its artisans created stunning art and architecture. A fascinating culture evolved, incorporating numerous ethnic groups and customs.

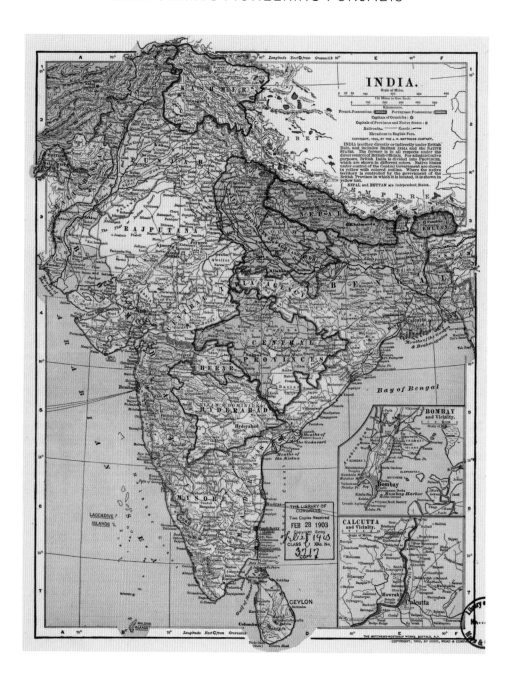

PREVIOUS: A typical farming scene in the Punjab. *Creative Commons.*

ABOVE: Map of India, circa 1900. *Library of Congress, Geography and Map Division.*

DIVERSE PEOPLE, DIVERSE LAND

Much of this happened on the Indo-Gangetic Plain, which extends across the top of the Indian subcontinent from the Punjab and today straddles India and Pakistan, parts of Nepal and Bangladesh. It was and is fertile land, fed by Himalayan rivers. India's terrain is spectacularly varied, from the southernmost tip, Kanyakumari, to the north, where the highest mountains in the world loom above Kashmir and Ladakh.

The modern Republic of India encompasses about two-thirds of what was once considered India. It is home to more than one billion culturally diverse people who live near the sea; beside rivers; and in jungles, plains, deserts and mountains. Depending on the season and location, weather may be steamy or dry heat. Winters bring freezing cold and snow to higher elevations that chill the plains.

Farming has long been the main occupation in South Asia. Crops are planted wherever people live, even on narrow terraces carved into steep Himalayan mountainsides. The plain named for the Indus and Ganges Rivers nurtured an extraordinary and still mysterious society called the Indus Valley Civilization. Ruins discovered in its chief cities Harappa and Mohenjo-Daro, in the Punjab and Sindh, date back at least five thousand years. This sophisticated culture had well-planned cities, sanitation, transport vehicles and a written system of script or symbols that, so far, has not been decoded. We still don't know much about the Indus Valley Civilization, despite significant archaeological finds. How this civilization arose, how it conducted its business over several thousand years and why it disappeared remain a matter of conjecture.

THE PUNJAB

The geographical swath called the Punjab is blessed with well-watered, rich soil. Its name refers to the five rivers that flow through it. The word comes from Persian: *panch*, "five," and *aab*, "water," meaning "land of the five rivers." These five tributaries of the Indus—the Jhelum, Chenab, Beas, Sutlej and Ravi Rivers— descend from the high Himalayas.

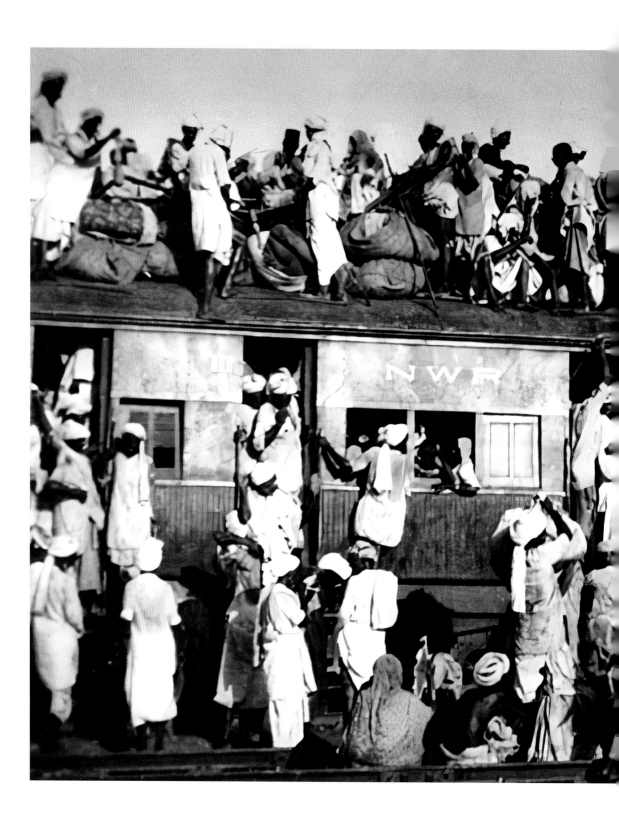

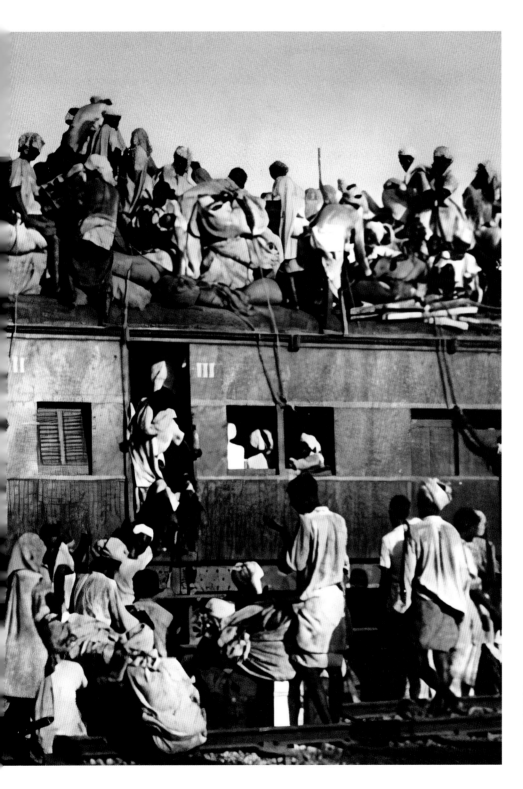

People fled
Pakistan and
India after the
1947 Partition
of India.
Public domain.

The land is perfect for farming, and the Punjab is the breadbasket of India. When the British withdrew as colonial overlords in 1947, the Punjab was politically divided between India and Pakistan. This partition resulted in some of the worst bloodshed in the history of the subcontinent, as Hindus and Sikhs fled to India and Muslims the other way, to Pakistan.

On both sides of the border, fertile plains stretch into the hazy distance. The landscape is dotted with ponds and the occasional stream, spindly shade trees and small religious shrines. Bright yellow expanses of flowering mustard herald the spring. Cultivated fields of wheat, rice, pulses and cotton are rotated through the year. Potatoes, peaches, grapes and other fruits and vegetables are grown here and shipped to the cities. Tractors and bullock carts ply the roads side by side; camels, cattle and water buffalo jostle for space on lanes crowded with cars, SUVs and trucks.

The Grand Trunk Road, originally built in the sixteenth century, runs through the Punjab and is still used. It was the main trade route linking Calcutta in the east to Kabul in the west and all the important cities in between, including Delhi, Amritsar and Lahore. The railways, built by the British, have long been lifelines for commerce.

MORE ANCIENT HISTORY

Hinduism, one of the world's oldest religions, became established around this time. Later, about 560 BCE, the Buddha lived and taught.

India clearly attracted the interest of outsiders. Persians annexed the Western Punjab into their empire (540–327 BCE). Greeks under Alexander the Great made their way to India; the Western Punjab stayed in Greek hands for about seventy-five years. Scythians and Huns rode through.

History at this period is murky. Few accurate accounts exist to supply a reliable chronicle of events. Historians deduce dates from currency, monuments and other resources. Foreign travelers helped broaden the picture of Indian history, society and culture. In the Buddhist period, the accounts of Chinese pilgrims Fa Hsien (fifth century) and Hiuen Tsang (seventh century) depict people and places in India that we would otherwise know nothing about.

Then Islam, which originated in the seventh century on the Arabian Peninsula, appeared in India. The first incursions of Arab raiders came in the eighth century. These invaders were initially repulsed but eventually held territory. They brought

Islam with them. In the tenth century, Muslim chieftains from Afghanistan and Turkey established sultanates, which lasted until a strong general from Kabul, Babur, came on the scene in 1526. He founded the Mughal dynasty, which ruled India from 1526 until the Mughal Empire petered out in the mid-nineteenth century.

Mughal emperors such as Akbar the Great were eclectic and enlightened—others were irresponsible, fanatical and brutal. Most of them were ruthless. They were potent rulers in their heyday, and the prosperous Indo-Gangetic Plain was at the heart of their empire.

At its peak, Mughal rule reached from Afghanistan and Ladakh in the north to Mysore and Tanjore in the south. The Mughals placed an indelible stamp on India, reflected in monuments such as the Taj Mahal. They also drove social and religious change in the Punjab. It is during the Mughal Empire that the Sikh religion began.

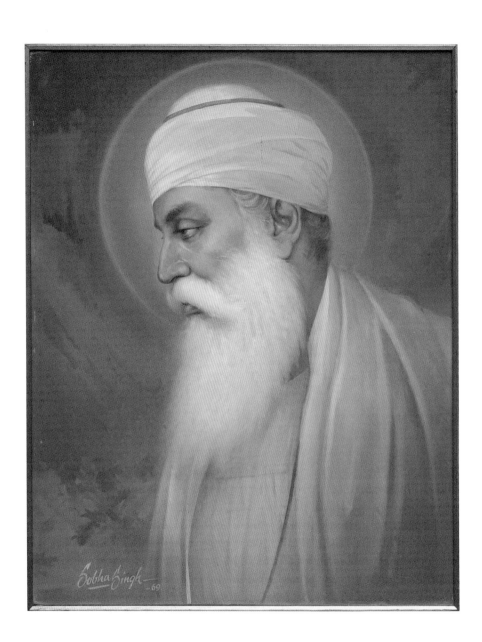

CHAPTER 2

GURU NANAK AND THE SIKH RELIGION

I t was a profoundly transitional era when Guru Nanak (1469–1539), the founder of the Sikh religion, lived and taught. Nanak was born to Hindu parents near Lahore, in what is now Pakistan. Attracted to mysticism as a boy, he sought out both Hindu and Muslim holy men.

Nanak traveled widely, reportedly as far west as Mecca and Medina in Arabia and throughout India, including Sri Lanka and Assam. He began to teach a monotheistic and egalitarian philosophy. Nanak deplored the Hindu caste system and idol worship. He taught social responsibility, harmony and tolerance and believed that doing honest work to provide for family and helping others was appropriate worship of God.

> *We reap according to our measure.*
> *Some for ourselves to keep, some to others give.*
> *O Nanak, this is the way to truly live.*[1]

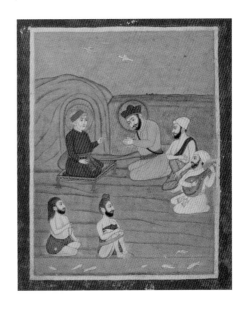

OPPOSITE: Guru Nanak painted by Sobha Singh, 1969. *Courtesy of Kapany Collection.*

ABOVE: Guru Nanak meets the poet Kabir, watercolor, nineteenth-century manuscript. *Courtesy of Asian Art Museum of San Francisco.*

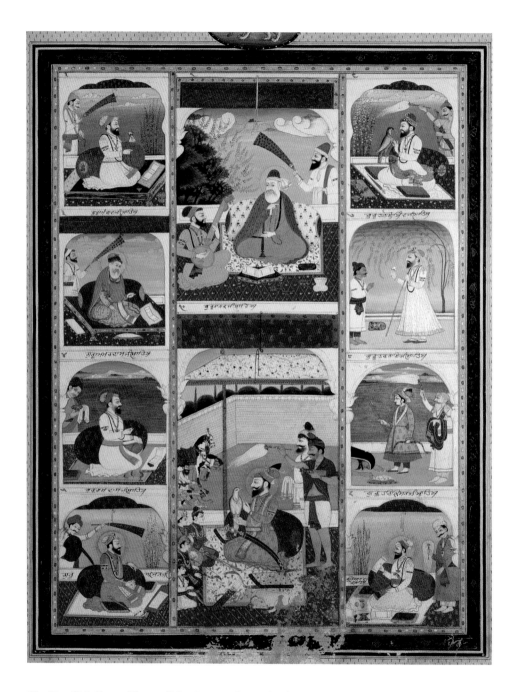

The Ten Sikh Gurus, Kangra School watercolor, early nineteenth century. *Courtesy of Kapany Collection.*

The three main tenets of his teaching were (1) devotion to the creator (*Naam Japna*), (2) honest work (*Kīrat Karō*) and (3) charity toward others, especially those in need (*Vand Chakkō*). His progressive views emphasized the equality of women and religious pluralism.

THE TEN SIKH GURUS

Guru Nanak was the first of the Ten Sikh Gurus. A proponent of peace, freedom and equality, Nanak was a realistic man. He recognized that war was a sad fact of life. His own experience informed him: he was imprisoned for a time by the first Mughal emperor Babur. Because of frequent persecution, the Sikh Gurus eventually developed a discipline of self-defense to protect them against the Mughals.

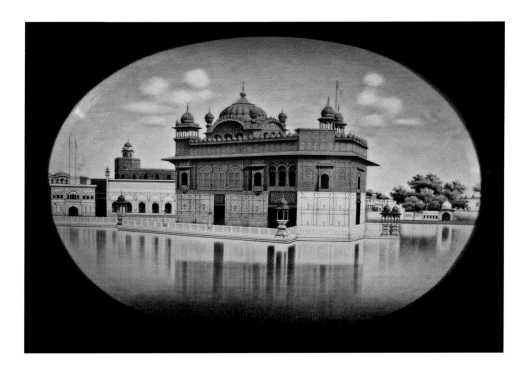

Darbar Sahib, the Golden Temple, Amritsar, late eighteenth century. *Courtesy of Kapany Collection.*

The second Sikh Guru, chosen by Guru Nanak, was Angad Dev. He continued Guru Nanak's care for others by starting the community kitchen, or *langar*, which freely offered food to the hungry. He also trained preachers to educate others about Sikhism.

The third Sikh Guru, Amar Das, continued to preach, drawing converts from other faiths. He initiated social reforms and condemned *sati*, the immolation of widows on the funeral pyres of their husbands. He was against *purdah*, or mandatory face veiling and seclusion for women. Emperor Akbar the Great broadmindedly invited leaders from all faiths to his court. Akbar is believed to have been influenced by Sikhism because of its universality. It is also said that Akbar offered to fund the Sikh communal kitchen, but Guru Amar Das refused, explaining the kitchen was run on donations from the Sikh community as part of their religious observance.

The fourth Guru Ram Das founded the city of Amritsar, which became the religious center for Sikhs. He began construction of Hamandar Sahib, the Golden Temple, Sikhism's most revered shrine.

INTERFAITH HARMONY AND THE WRATH OF EMPERORS

Sikhism spread throughout the Punjab. Their peaceful, inclusive philosophy meant that Sikhs remained on good terms with Hindus, Muslims, Christians, Buddhists and Jains. Yet not all were inclined toward religious harmony.

By the time of the fifth Guru Arjun Dev, the Sikhs were a successful and influential community. Guru Arjun Dev continued construction of the Golden Temple. Its foundation stone was laid by the Muslim Sufi Saint Mian Mir. Guru Arjun Dev compiled the religious writings of the Sikh Gurus into the Adi Granth, the Sikh scripture, and he included hymns of saints from other faiths. The seeds of an interfaith movement are enshrined in Sikhism with its acceptance of all religions and castes without distinction. The Adi Granth is unique in its inclusion of scripture from other faiths.

Arjun Dev pursued charitable undertakings such as opening a leper treatment center. But his good works did not protect him from the emperor's wrath.

Jahangir, the son of Akbar the Great, basked in the achievements of his father but was a weak and dissolute ruler. His reign was largely peaceful, and he was well regarded by the public. However, the rebellion of his eldest son, Khusrav, who fled the Agra court, angered Jahangir. It also spelled trouble for the fifth Guru. Historian Abraham Eraly

Guru Tegh Bahadur, the Ninth Sikh Guru, watercolor, circa 1670. *Courtesy of Asian Art Museum of San Francisco.*

writes, "On his way through Punjab, Khusrav sought the help of Guru Arjun Singh, the patriarch of the Sikhs. The guru at first refused to help him, saying that whatever money he had was for the poor, not for princes, but when Khusrav pleaded that he was destitute, the guru gave him 5000 rupees. It was an act of charity—the guru was not supporting the prince's rebellion."[2] Enemies of the guru told the emperor, who summoned Arjun Dev. Jahangir had him tortured to death, making Guru Arjun Dev the first Sikh martyr. The emperor's memoirs (*Tuzak-i-Jahangiri*) reveal that political vengeance and religious intolerance led him to execute the guru and confiscate his properties.[3]

Guru Arjun Dev was succeeded by his young son Hargobind as the sixth Sikh Guru (1595–1644). Having seen what happened to his father, Hargobind adopted a warrior's stance to face Mughal oppression. He began wearing two swords, one symbolizing spiritual and the other temporal authority. He encouraged Sikhs to be ready to defend their faith, wear arms and become good equestrians. He raised an army. He also constructed the Akal Takht, or "temporal throne of the eternal," in Amritsar. Here the guru conducted business and settled disputes. It is the oldest of five such structures built over the centuries. It was destroyed and rebuilt several times. Its most recent restoration came after 1984, when it was severely damaged by the Indian army's heavy artillery targeting militants in the temple complex. Guru Hargobind, like his father, fell afoul of the Emperor Jahangir for a time and spent several years in prison, although he was released.

Guru Har Rai (1630–1661), the seventh Sikh Guru, avoided serious problems with successive Emperors Shah Jahan and Aurangzeb. Guru Har Rai appointed his younger son Har Krishan as the eighth Sikh Guru. But Har Krishan was a child of five when he assumed this role and died three years later.

The youngest son of the sixth Guru Hargobind, Tegh Bahadur (1621–1675), became the ninth Sikh Guru during the rule of fanatical Emperor Aurangzeb, who persecuted non-Muslims and destroyed their shrines. He seized power and imprisoned his own father, Shah Jahan, in the Agra Fort overlooking the Taj Mahal, the tomb Shah Jahan built for his favorite wife.

The growth of Sikhism, the prosperity of Guru Tegh Bahadur and the Sikh army irked Aurangzeb. The emperor summoned Tegh Bahadur, demanding that he convert to Islam. The guru refused. By some accounts, the guru rebuked Aurangzeb for his religious persecution: "I may believe not in the supremacy of Veda or the Brahmins, nor in idol-worship of caste or pilgrimages and other rituals, but I would fight for the right of all Hindus to live with honor and practice their faith according to their own lights."[4] Outraged, the emperor had him tortured and beheaded in New Delhi after brutally torturing Guru Tegh Bahdur's three companions to death.

Guru Gobind Singh and the Panj Piare, painting by Devender Singh, 2014. *Courtesy of Kapany Collection.*

GOBIND SINGH, THE LAST GURU

Gobind Singh (1666–1708), the Tenth Sikh Guru, was the son of Guru Tegh Bahadur. He was a child when the severed head of his father was brought to his family in Anandpur. After he assumed leadership of the Sikhs, he became a scholar of Punjabi, Persian and Sanskrit. Harassment by local Hindu princes for his opposition to caste distinctions and the memory of his father's murder caused Guru Gobind Singh to focus on defending the Sikh faith.

He introduced significant changes into Sikhism, including codes of dress and behavior intended to convey strength and solidarity within the Sikh community. He

institutionalized the outer signs by which Sikhs are identified today when he formed the *Khalsa*, or "pure," order. The Khalsa began with five devotees. Gobind Singh gave the men the name Singh, or "lion." Women were given the name Kaur, sometimes translated as "princess," to identify them as Sikhs. But according to Gopal Singh, "The meaning of the word 'Kaur' is prince, not princess, as the Guru wanted to give women the dignity of the male."[5]

Membership in the Khalsa was conferred by baptism. Baptismal water—*amrit*, or "nectar"—was made from water and sugar stirred with a *kirpan*, a curved dagger, as Sikh scripture was recited. Initiates were given the amrit to drink and then were sprinkled with it. The new members of the Khalsa were required to wear the "five Ks" that identified them as Sikhs. These are the five articles of the Sikh faith:

- *Kesh*, unshorn hair
- *Kanga*, a comb, to keep the hair neat under a turban, which every male Sikh should wear
- *Kara*, a steel bangle worn on the wrist
- *Kachh*, shorts worn under the clothes
- *Kirpan*, a steel sword[6]

Four of the first five Khalsa members were men from lower castes, another way Guru Gobind Singh emphasized the equality of all.

The formation of the Khalsa and first Sikh baptism was held on the first day of the spring holiday Baisakhi, in March 1699. According to tradition, Gobind Singh did this dramatically. He asked the members of a large congregation at Anandpur for "a Sikh who can offer his head to me, here and now."[7] When one man volunteered, the Guru took him out of sight behind the tent, where, the story goes, he slaughtered a goat. He returned with a bloodied sword and repeated his request to an increasingly fearful congregation. When five men had volunteered for what appeared to be human sacrifice, Gobind Singh produced the five, dressed in the signature garments of the Sikh *panth*, or "brotherhood": a blue turban; a long, loose shirt; a waistband; short underwear; a sword; and a steel bangle.

Gobind Singh, like each of the previous Sikh gurus, adamantly opposed the caste system and told the five: "From now on, you have become casteless. No ritual, either Hindu or Muslim, will you perform, and believe in superstition of no kind, but only in the one God who is the Master and the Protector of all, the only Creator and Destroyer. In your new order, the lowest will rank equal with the highest and each will be to the other a *Bhai* (brother)," reiterating the essential teaching of Guru Nanak. He also said, "Women shall be the equal of men in every way." Then Gobind Singh

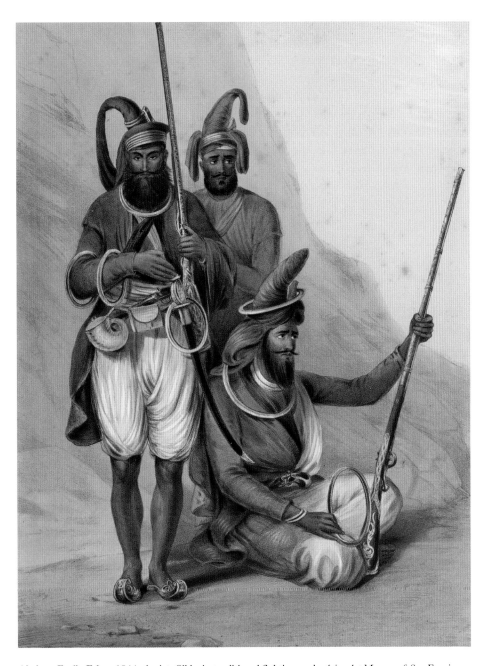

Akalees, Emily Eden, 1844, depicts Sikhs in traditional fighting garb. *Asian Art Museum of San Francisco.*

asked the *panch pyare*, or "five beloved" as these first members of the Khalsa are called, to give him amrit, or "nectar of immortality." This astonished them.[8] Not only was he supreme guru, but he was a high-caste man accepting amrit from the hands of lower-caste men. It was contrary to long-established social mores.

The army raised by Gobind Singh to defend the Sikhs against the Mughals was relatively small, but the Sikh soldiers fought well in battles against forces of the Emperor Aurangzeb. Two of Guru Gobind Singh's young sons were abducted on the orders of Wazir Khan, a provincial governor. When given the choice to convert to Islam or die, they refused to convert and were killed by being bricked alive into walls. Gobind Singh's two elder sons died in battle against the Mughal army.

THE LINE OF LIVING GURUS ENDS

At the age of forty-two, by then a legend among Punjabis, Guru Gobind Singh was killed. An Afghan assassin hired by Wazir Khan stabbed the Guru as he relaxed in his camp. Gobind Singh killed his assailant on the spot. The guru died several days later after donning his battle dress and offering prayers before the Adi Granth, the Sikh holy book. He then declared an end to the personal lineage of Sikh Gurus. He circumambulated the Adi Granth four times and, "making an offering of five paisas and a coconut, as was customary at the time of the succession of the new Guru, bowed before it, thus formally declaring the Holy Book to succeed him as the 'True Guru.'"[9]

Since then, the Adi Granth has served as the living Sikh Guru and is called the Guru Granth Sahib.

The turmoil that was rife during the life of Guru Gobind Singh worsened after his death. Gobind Singh's assassination and the murder of his sons inflamed the Sikhs, who waged war in whatever ways they could against the brutal Wazir Khan and his Mughal allies.

The Mughal Empire declined as intrigues infected the court in Delhi. Sikhs formed armed bands and roamed the countryside to defend their communities against the continuing persecution. Persian military genius Nadir Shah, in a brief but costly incursion, ransacked Delhi and bore away Shah Jahan's priceless bejeweled Peacock Throne among the spoils. Shah's army, lugging the booty back to Persia, was raided and looted by bands of Sikhs as they crossed the Punjab.

Khushwant Singh recounts an apocryphal conversation, based on historical record, between Nadir Shah and the governor of the Punjab Zakarya Khan. When

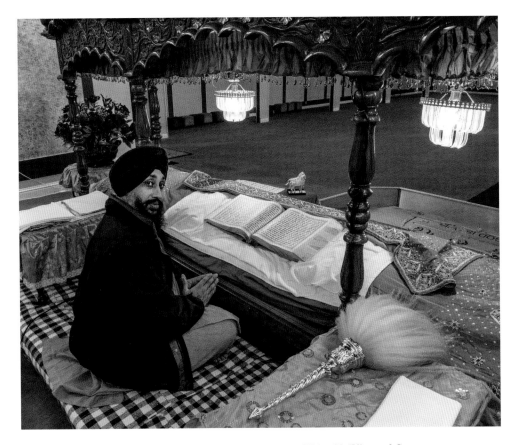

A man reading the Guru Granth Sahib, Yuba City. *Carol M. Highsmith/Library of Congress.*

Shah inquired who these Sikh brigands were, he got a dismissive answer from Khan. "'Where do they live?' enquired Shah. 'Their homes are their saddles,' replied Khan. Shah is said to have prophesied, 'Take care, the day is not far distant when these rebels will take possession of your country.'"[10]

Sikh groups honed their skills. They fought off other invaders. With their strategically located forts and military prowess, they sowed the seeds of Sikh dominance in the Punjab.

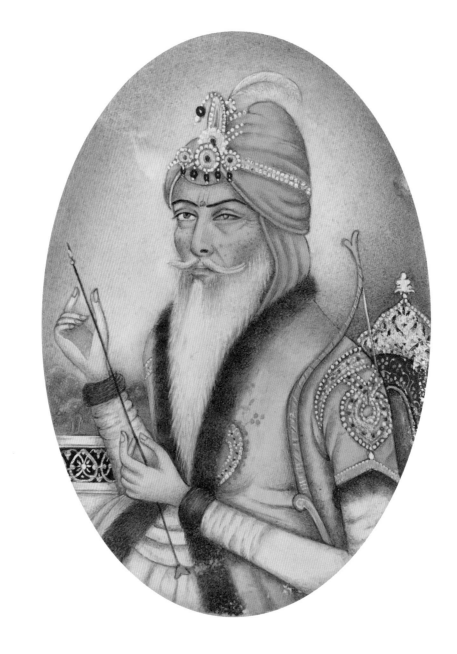

Maharaja Ranjit Singh, painting on ivory, circa 1850. *Courtesy of Kapany Collection.*

MAHARAJA RANJIT SINGH, EMPEROR OF THE PUNJAB

A century after the death of Guru Gobind Singh, a boy was born who was destined to unify the Sikh world and create the first and only Sikh empire. Ranjit Singh (1780–1839) was an extraordinary ruler whose power extended to significant territories in India, Pakistan and Afghanistan.[11] In his four-decade reign, he built a Punjabi army that kept the British and all others at bay.

Ranjit Singh was born into the powerful Sukerchakia clan.[12] At a young age, he was betrothed to the granddaughter of the chief of the rival Kanhaya clan. Smallpox blinded Singh in one eye. His father died when he was twelve years old, and at fifteen he became chief of the Sukerchakias. He married his betrothed, which gave him power in the Kanhaya clan. He gradually drew the patchwork of clan-ruled territories in the Punjab under his control, a process that required diplomacy and military acumen.

And there were other players in the mix. The most formidable were the Marathas, a confederacy that ruled much of India from 1674 to 1818 and whose army was trained and led by French generals. Another threat came from the British East India Company, whose governors were ambitious to increase their sway over the subcontinent. They also had a disciplined army to help them do it.

Ranjit Singh was shrewd. When he conquered Lahore at the age of eighteen in 1799, he knew that first he must build confidence in his followers while lulling outsiders into complacency. He organized an effective government, appointed new administrators and, although he did not immediately declare himself king, began holding a *durbar*, or court, in the custom of the Mughals. It was open for the public to discuss problems, grievances or appeals for redress. Through the durbar, Ranjit Singh

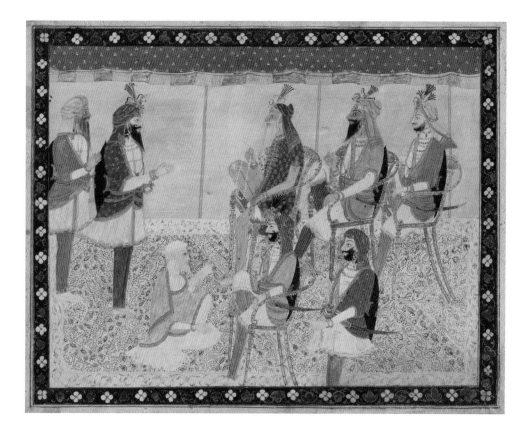

Maharaja Ranjit Singh with members of his court, watercolor, circa 1825. *Asian Art Museum of San Francisco.*

remained in touch with the people. Unlike most rulers of the day, he made a point to sit on the same level as his subjects.

In 1801, he was formally declared maharaja of the Punjab, giving him power over the clan chieftains. The picture of Maharaja Ranjit Singh that emerges from history is of an extremely appealing, broadminded, self-effacing man who was a brilliant strategist and diplomat. He governed with the interests of his people at heart rather than his own. His casual durbar, where equality was the rule, impressed outsiders. Illustrations of his court show a ruler in eye-to-eye conversation with his subjects and associates. Khushwant Singh notes, "Despite the sonorous titles which the sycophants in the court used for him, the one by which he preferred to be addressed was the plain and simple Singh Sahib."[13]

The coins he issued bore the name of Guru Nanak rather than his own. Ranjit Singh wanted his government to embody Sikh principles, but he made it clear he wanted a secular state in which people of all religions would have equal rights under the law. Hindus, Muslims, Buddhists, Jains and a few Christians populated the regions he conquered and ruled. Some were in Ranjit Singh's employ. Seeing the disciplined armies of the Marathas and the British, he was quick to retain European officers to train his troops. He had about forty foreigners on his payroll, including Europeans and Americans. He was aware of colonial ambitions among the English and Europeans. He did not trust outsiders, so he used them as advisers but did not give them significant positions of power.

A Yank in the Durbar: Josiah Harlan

Ranjit Singh's rise coincided with equally dramatic events in the Western Hemisphere, where thirteen English colonies were building a new republic after successfully revolting against their English overlords, the very same who were ambitious to control India.

The British were anxious to avert a replication of America's revolution in India. Wary of Ranjit Singh because of his manifest brilliance in leadership, the British were particularly worried when French and Americans appeared among the maharaja's advisers.

One American who wandered into Ranjit Singh's orbit was the adventurer Josiah Harlan, a Quaker from Philadelphia. Harlan's story is worth a diversion, because he was among the earliest Americans to have contact with India. And he has a particular connection to the Punjab and Afghanistan.[14]

Josiah Harlan's travels began on merchant ships to Asia—to Canton, China, and later to Calcutta, India. On his second journey to Calcutta, he decided to stay. Harlan had some self-taught medical skills and was appointed surgeon at the East India Company's Calcutta hospital. He was subsequently transferred to the Bengal Artillery in Rangoon, Burma, where he served as medical officer. He was twenty-five years old. After Rangoon, he was sent to Karnal, in the eastern Punjab.[15] His term of service being up, Harlan decided to try his luck with Ranjit Singh.

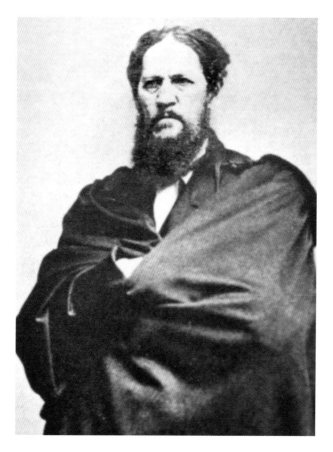

American adventurer Josiah Harlan. *From* Central Asia: Personal Narrative of General Josiah Harlan, 1823–1841.

His first attempt to enter Ranjit Singh's territory was rebuffed, so he took a roundabout route, via Kabul, with the help of his neighbor in Ludhiana, Shah Shuja-ul-Mulk, the exiled Afghan king. Ousted by his half brother, the king went to Ranjit Singh for help—a bad idea. Ranjit Singh kept Shuja prisoner and forced him to hand over the Koh-i-Noor diamond in exchange for an idle promise of help to restore his throne. Shuja escaped with his retinue to the

protection of British India. That's where Harlan met him and proposed an expedition to Kabul. The king agreed to fund it, Harlan raised a mercenary army of sorts and set out for Afghanistan in 1827. He also agreed to spy for the British.[16] In Afghanistan, Harlan was befriended by Jabbar Khan, an influential half brother of Dost Mohammed Khan, emir of Kabul. Jabbar Khan was friendly with the European officers who served Ranjit Singh in Lahore, French generals Allard and Court and the Italian Avitabile.

After Kabul, Harlan made his way to Lahore in 1829, where he settled down to practice medicine. He met Maharaja Ranjit Singh, who wanted to hire him as a military officer. Harlan declined, but when Ranjit Singh offered him the post of governor of Nurpur and Jasrota, old princely states in the Himalayan foothills bordering the Punjab, he accepted. In 1831, Ranjit Singh made Harlan governor of Gujrat, a district of the Punjab now in Pakistan. Harlan signed a contract with the government and swore an oath of fidelity to the maharaja on the Bible.

Jean-Marie Lafont quotes the British resident of Punjab Henry Lawrence's "pseudo-testimony in his novel, Adventures of an Officer," where Lawrence writes, "The American Governor of Gujrat 'is a man of considerable ability, great courage and enterprise.' That he was a jolly fellow is also attested by the Reverend Wolff who was received in his residence in Gujrat where he could hear him singing Yankee Doodle 'with the true American snuffle.' Wolff described him as 'a fine tall man, dressed in European clothing and smoking a hookah' who introduced himself as 'a free citizen of the United States, from the city of Philadelphia.' During their discussions Harlan laughingly summarized his contract with the Maharaja as follows: 'I [Ranjit Singh] will make you Governor of Gujrat. If you behave well, I will increase your salary. If not, I will cut your nose!' The observant Wolff concluded that 'the fact of his nose being entire proved that he had done well.'"

Further proof of Harlan's satisfactory service was that Ranjit Singh sent him with a trusted minister on a delicate diplomatic mission to Afghan emir Dost Mohammed Khan. But Ranjit Singh's plan to encircle and entrap the Afghan army failed. Ranjit Singh was furious. Lafont speculates that Harlan's loss of favor with the maharaja may have stemmed from that upset, but he also cites accounts that give other reasons.

After being deported from the maharaja's territories to British holdings across the Sutlej River, Harlan returned to Kabul, evidently to revenge himself on Ranjit Singh. Dost Mohammed Khan welcomed Harlan, hiring him to train infantry. He remained for several campaigns, including the First Anglo-Afghan War. After the British took Kabul, Harlan was escorted out and eventually sent back to the United States. Harlan's flamboyant career is thought to have inspired Rudyard Kipling to write "The Man Who Would Be King."

Back in Philadelphia, Harlan published *A Memoir of India and Avghanistan* in 1842. It included an incisive assessment of British rule that was an indictment of the corruption, arrogance and rapacious exploitation of India and its people. Lafont notes that Harlan's analysis was corroborated by several historians of the day and by others since. The appointment of Lord Cornwallis as governor-general of India, fresh from fighting American colonists, underscored English worries about a revolution in India. "His obvious task was to prevent India from following the path of America," writes Lafont. Not surprisingly, the British suppressed distribution of Harlan's memoir in India. Harlan did not return to Asia, but he consulted for the U.S. government on South Asia matters. He raised a regiment for the Union army in the Civil War, Harlan's Light Cavalry, also known as the Eleventh Cavalry. He was colonel in the Army of the Potomac. After the Civil War, Harlan moved to San Francisco, where he resumed his medical practice and died in 1871.

THE END OF AN ERA AND AN EMPIRE

Ranjit Singh ruled consistently and well until his death in 1839. Without his inspired leadership, his empire quickly began to disintegrate. Incompetent and self-serving successors undermined and murdered each other as different groups contended for power. The British jumped at this chance to bring the Punjab under their control. Historians frequently cite an incident reflecting the prescience of Maharaja Ranjit Singh: "'What does the red colour stand for?' asked Maharajah Ranjit Singh when

he was shown a map of India. 'Your Majesty,' replied the cartographer, 'red marks the extent of British possessions.' The maharajah scanned the map with his single eye and saw nearly the whole of Hindustan except the Punjab painted red. He turned to his courtiers and remarked: '*Ek roz sab lal ho jaiga*—one day it will all be red.'"[17] He was right. The British manipulated his heirs, going so far as to coerce his youngest son to offer the Koh-i-Noor diamond to Queen Victoria, who incorporated it into the English Crown Jewels, where it remains to this day. The British invaded the Punjab. In the First Anglo-Sikh War (1845–46), they annexed part of the Punjab and Kashmir. In the Second Anglo-Sikh War (1848–49), they finished the job, acquiring the rest of the Punjab and bringing most of India under their rule.

The British were skilled at divide and rule. Having profited from the chaos resulting from Hindu, Sikh and Muslim factionalism in the Punjab, they proceeded to use each group according to its strengths. They recruited the Sikhs into the army, creating elite units for them and prohibiting any interference into their religious practices, including the wearing of turbans.

After putting down the bloody 1857 mutiny, also called the Indian Rebellion, among other names, the British redoubled development efforts. They introduced new crops to bolster Punjabi agriculture and dug canals so deserts could be irrigated. They built railways, roads and other public facilities. But crop failures and economic distress made Punjabis look outside India for opportunity in the late nineteenth century. Some who had served in the British army knew of a place of opportunity on the other side of the world. A few of them went there.

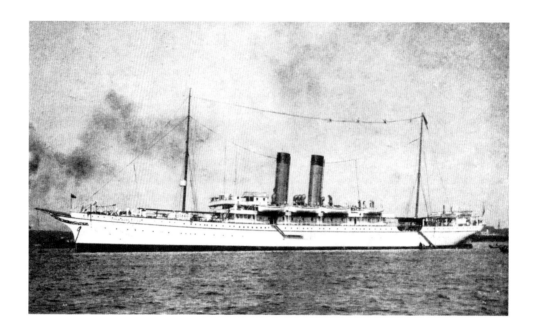

The *Nippon Maru*, 1828, a ship that took many immigrants to the United States from Asia. *Wikimedia Commons/public domain.*

HEADING WEST: NEW OPPORTUNITIES, NEW STRUGGLES

Improvements in farming and infrastructure made by the British were not enough to preserve Punjabi prosperity. Inflation of land prices, famines in India and a rapidly growing population created more poverty. Indebtedness grew and moneylenders prospered.

Punjabis, some of whom saw distant lands while serving in the British Indian Army, began to travel to Southeast Asia and Africa seeking better economic opportunities. The most adventurous went farther still, to North America: Canada and the United States.

Travelers left India with enough money to reach another Asian port, where they earned funds for onward passage. They worked as security guards or dockworkers in ports such as Hong Kong, Shanghai and Singapore. Then they embarked for North America, often from China, Japan or the Philippines.

About 85 percent of these travelers were Sikhs. Canada was often their destination of choice because—until laws were passed restricting their entry—Indians could enter Canada as British subjects.

Indian seamen reportedly visited America as early as 1790,[18] and stories exist of South Asians in the gold rush of the 1850s. But it was the late nineteenth and early twentieth centuries when small groups of Punjabi migrants began to arrive in California. They often traveled with relatives or friends from their native villages. One such arrival was documented in the *San Francisco Chronicle* of April 6, 1899, under the headline "Sikhs Allowed to Land." The short piece ran:

The four Sikhs who arrived on the Nippon Maru the other day were permitted yesterday to land by the immigration officials. The quartet formed the most picturesque group that has been seen on the Pacific Mail dock for many a day. One of them, Bakkshlied [sic] Singh, speaks English with fluency, the others just a little. They are all fine-looking men, Bakkshlied Singh in particular being a marvel of physical beauty. He stands 6 feet 2 inches and is built in proportion. His companions—Bood Singh, Variam Singh and Sohava Singh—are not quite so big. All of them have been soldiers and policemen in China. They were in the Royal Artillery, and the tall one with the unpronounceable name was a police sergeant in Hongkong prior to coming to this country. They hope to make their fortunes here and return to their homes in the Lahore district, which they left some twenty years before.

The tall, handsome man, fluent in English, matches the description of Bakhshish Singh Dhillon, who, according to his daughter Kartar Kaur Dhillon, traveled several times from India to Canada, California, South America and back. It may well have been him. "My father first came sometime in the 1890s," she said. "He was a very adventurous person." His story will be told later in this chapter.

Bruce La Brack, in his comprehensive study *The Sikhs of Northern California, 1904–1975*, says Sikh soldiers learned about America during the Boxer Rebellion in 1900. When Chinese revolted against foreigners in their country, a joint expeditionary force was formed that included British, European and American soldiers. The British troops included Punjabi Sikhs. "The Sikhs would have had ample opportunity to interact with Americans as the U.S. forces were some 2,500 strong."[19]

New knowledge and the economic problems in India prompted the first significant arrivals of Punjabi immigrants in North America in the early 1900s. The South Asian immigrants landed on the Pacific coast at a time when westward expansion and development were ramping up. Territories annexed by the United States after the Mexican-American War (1846–41) lured settlers. The California gold rush (1849–53) attracted tens of thousands. Some people stayed. California's rich soil was a magnet for settlers seeking good ranch and farmland long after the gold rush ended.

Immigrants from East Asia came, too. The first transcontinental railroad link was completed in 1869 by the Union Pacific and Central Pacific Railroad companies' largely Chinese workers. These jobs that required back-breaking manual labor brought the first significant wave of Asian immigrants to America. There were more routes to build up and down the West Coast. Workers cleared forests and laid tracks, and when that work ran out, they labored in fields.

The low-paid manpower was welcome, but Asian immigrants were poorly treated. Well before Punjabis reported for work in the United States, discriminatory laws and

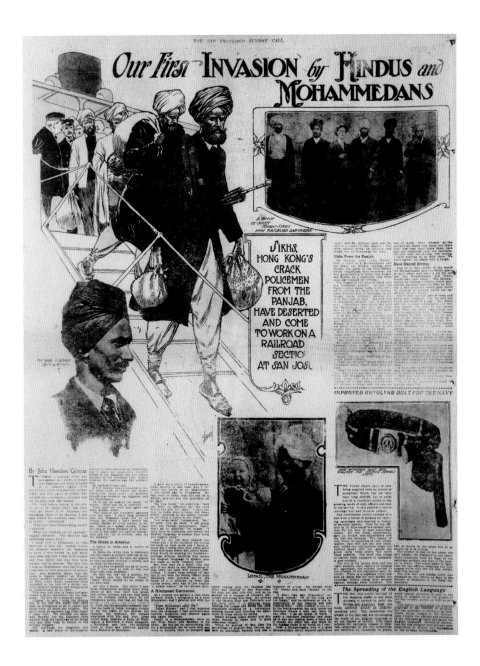

"Hindu Invasion" article expresses common xenophobia of the time. "A Group of giant Hindu Sikhs, now railroad laborers." *From the* San Francisco Call, *1906/CDNC.*

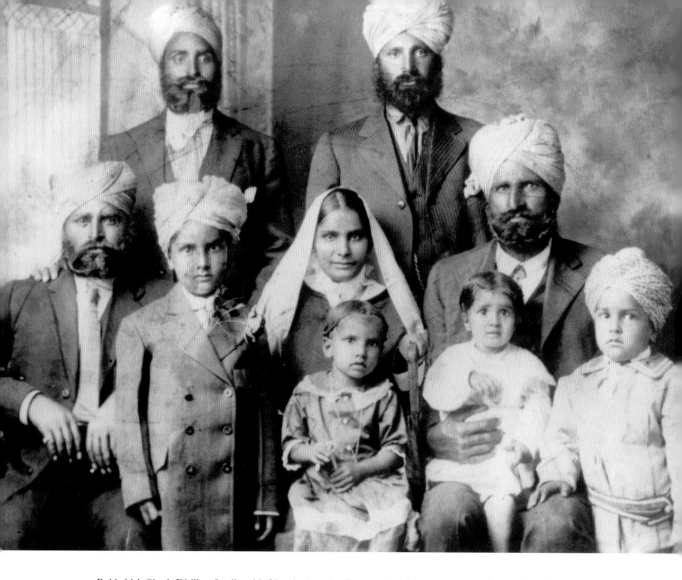

Bakhshish Singh Dhillon family with friends, Astoria, Oregon, 1916. Kartar Dhillon is seated on her father's lap. From left to right are (*front row*) Karm, Kartar and Budh; (*middle row*) Bhan Singh, Kapoor, Rattan Kaur and Bakhshish Singh; (*back row*) Mula Singh and Arjun Singh. *Courtesy of the Dhillon family.*

practices against Asians were in place. Expensive "head taxes" were levied before the immigrants could disembark from ships in Canadian and American ports. Nonwhites were excluded from citizenship in the early days of the republic by the 1790 Naturalization Law. Only "free white persons" were eligible for citizenship, effectively barring slaves, indentured servants and the many Asians who later came to build America.

In 1882, a Chinese Exclusion Act was passed, the first law that prohibited naturalization for a specific nationality. It was valid for ten years, renewed in 1892 and made permanent in 1902. But even earlier, the Page Act of 1875 barred immigrants considered "undesirable"—convicts, forced laborers or prostitutes. It was particularly aimed at Chinese women, the part of the law that was most effectively enforced. The Page Act was the first federal law to restrict entry to the United States.

The Chinese were culturally and linguistically incomprehensible to ethnically European Americans. They looked different. Even worse, they worked hard and for less money than white workers, so employers preferred to hire them. This was deeply resented.

As Ronald Takaki writes in his book *From a Different Shore*, "'Color' in America operated within an economic context. Asian immigrants came here to meet demands for labor—plantation workers, railroad crews, miners, factory operatives, cannery workers and farm laborers. Employers developed a dual-wage system to pay Asian laborers less than white workers and pitted the groups against each other in order to depress wages for both."[20] This antagonism resulted in calls for restrictions on their immigration.

South Asian immigrants, being Caucasian, were viewed slightly differently, although this tolerance was fragile. Many South Asians strove to conform to the new culture. Sikhs took off their turbans, cut their hair, shaved their beards and tried as best they could to become like Americans. Those who continued to wear turbans stood out and became targets of verbal and physical attacks.

The South Asians who came to California were good workers. Farmers, desperate for reliable help, were glad to hire them, often in preference to white Americans. So, the same antagonism that arose toward the Chinese and the Japanese was directed against the immigrants from India. Legislation finally caught up with them, too. In 1917, the U.S. Congress passed the Asiatic Barred Zone Act, which stopped immigration from South and Southeast Asia, just as Chinese immigration was stopped in 1882.

BAKHSHISH SINGH DHILLON FAMILY

Bakhshish Singh Dhillon traveled widely before settling down in California and starting one of the first American-born Punjabi families. His last surviving child, Kartar Dhillon, spoke of her father and family at her daughter Ayesha Gill's Oakland, California home in 2006.[21] "My father first came in the 1890s," she said.

Bakhshish Dhillon was from Sur Singh village in the Punjab. It was fertile farmland between the Ravi and Beas Rivers, not far from Amritsar. "I don't know where all he went, but he was a seagoing man," a merchant seaman, Kartar, said, adding that his first stay in North America was brief. "He went back a couple of times. He went to South America. He traveled around. He was a very adventurous person."

Kartar Dhillon told T.S. Sibia how this younger of two brothers began his adventures when he was barely twenty years old in the 1890s.[22] "It was a desperate situation for the family as the British had levied heavy taxes, some of which were as much as 50 percent," she said. "The only recourse was for one of the two brothers to seek employment elsewhere. Now the irony of the situation in Punjab was that the only employment available was in the British army."

Kartar recalls her father as "a man of huge stature, tall and strong." He was over six feet tall, had "a military carriage and a twinkle in his eye." After enlisting in the British Indian Army, he was sent to China, assigned to heavy artillery. Kartar said the best benefit of his army experience was his fluent English. "This put him in a position to be of great help to his fellow workers," she said.

When Bakhshish Dhillon returned to India for the last time, his father arranged his marriage to Rattan Kaur. "My mother was among the very first women who came," Kartar said. "She was here in 1910." On that trip, Bakhshish Dhillon did his part to attract migration to America by passing out flyers given to him by California ranchers. "He distributed these bulletins when he went back to Punjab for his marriage. He urged them to bring their wives with them," Kartar said.

"My father was a farmer, and my mother came from a farming family, too." He did all kinds of work, but it was natural for him to farm. "My mother lived a busy life taking care of us all. There were eight kids, all born here," she said. Kartar was the fourth child, born in Simi Valley, California. Six of the Dhillon children were California-born. Her father moved the family to Oregon for a few years. He worked in the Hammond Lumber Mill in Astoria. Kartar recalled how green and beautiful it was, the abundant daffodils and blackberries, how they lived in a house heated by a woodstove and lighted by kerosene lamps because there was no electricity. It was in Oregon that she and her siblings first experienced harassment because they looked different. She was in the first or second grade. "There was a lot of snow," she said. "And we'd be walking to school in the morning, and there would be snow on the ground. And all these little non-Indian kids—I hate to use the term white—they would throw snowballs at my brothers and knock their turbans off. They were very little then." So, her father decided to cut the boys' hair.

The film *Turbans* by Erika Surat Andersen, Kartar's granddaughter, is based on her grandmother's experience. The film eloquently portrays the difficulty and the

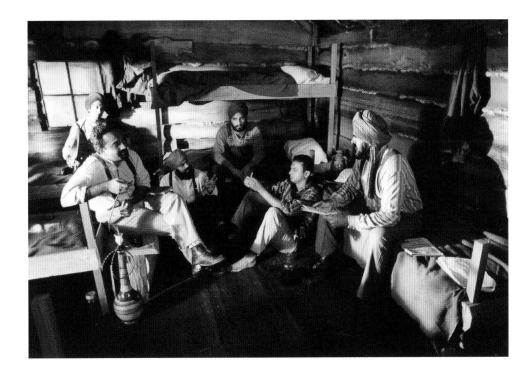

A still of the workers' shack from the film *Turbans. Courtesy of Erika Surat Andersen.*

heartbreak of the decision. Kartar said her mother cried when the boys' hair was cut. "My mother couldn't bear the thought," she said. The family was religious and prayed together daily. Uncut hair and the turban are important Sikh articles of faith. But Bakhshish Singh knew it would help the boys fit in better. When the family went back to India, they could grow their hair again.

Kartar recalls that her mother talked a lot about India: "She missed it so. We just lived for the day that we would all be going to India. We never expected to stay here. But we did." She said that most Punjabi immigrants had the same idea, to go back one day, once they got the money to do so. She said her mother filled trunks with toys and books to take back to her village in the Punjab. Kartar remembers a loving, devoted father who worked hard to provide for the family. "They kept producing children and making very little money. But he kept working. I had a wonderful father."

Bakhshish Singh took his social obligations seriously. He was active with the union. He joined the Industrial Workers of the World (IWW). The other union, the American

Federation of Labor, Kartar said, "did not want any foreigners, anybody who is not white. But the Industrial Workers of the World wanted everybody in their union." The union called a strike over poor work conditions: "Hours were too long, the pay was too low, and there was discrimination in pay between what the Indians, Japanese or other non-white workers got and what the white workers got. The latter got the high pay. The truth was all workers, including the whites, were immigrants; the only real Americans were the natives called American Indians. So, the strike was called in Astoria and several other places. The union won but it was a hard-won battle. There was better pay, shorter hours. My father was instrumental in educating the Indian workers because he was the only literate person among them. He had learnt English and Punjabi; he could read and write both languages."

Alongside homegrown American union activism, a movement advocating Indian independence from Britain was growing. It began in Oregon as the Hindustan Association of the Pacific Coast but soon became known as the Ghadar Party. Ghadar means "revolt" in English. It attracted a large following, and the Dhillons, along with most Indian immigrants of the day, were members.

Kartar thought the unfairly discriminatory laws against Asians passed in America and California were partly responsible for the growth of the Ghadar Party: "When our men were confronted by the vicious racism, they realized that their first priority was to kick the British out of their own country." Both Bakhshish Singh and Rattan Kaur Dhillon supported India's fight for freedom. Their second-eldest son, Budh, embarked on a Ghadar Party mission, setting off for India when he was twelve years old. Instead of India, he ended up in Russia, studying there during the decade following the Russian Revolution. He returned to America when he was eighteen.

The Ghadar Party

The Ghadar movement was an early twentieth-century Indian nationalist campaign started by Indians living in North America. They felt the racial antipathy they experienced there was because of their status as colonial subjects of the British Empire. They believed that if they overthrew British rule in India, they could live with dignity and respect abroad as well.

The leaders of the Ghadar movement were intellectuals, farmers and laborers. They came from diverse religious backgrounds—Hindu, Muslim and Sikh—and from different parts of India, especially the Punjab and Bengal.

Sohan Singh Bhakna, a Punjabi Sikh immigrant in Oregon, was the founding president of the Ghadar Party and a leading Indian revolutionary in the 1915 efforts to overthrow the British government in India. Most Ghadar activists were Punjabi Sikhs who formed the backbone of this international movement headquartered in San Francisco. Jawala Singh and other visionary Sikh farmers in the Stockton area supported the Ghadar cause and education for Indian students in America. They were joined in this by a radical Stanford University lecturer, Har Dayal, a Hindu. They established the Guru Gobind Singh Fellowship at the University of California, Berkeley, to help South Asian students obtain a higher education. The fellowship still exists today.

The Ghadar Party and its publications promoted India's independence from Britain, urging revolt against hundreds of years of British economic exploitation and oppression. Har Dayal left the United States and the party in 1914, but the movement continued.

A young Sikh, Kartar Singh Sarabha (1896–1915), whose family had sent him to the United States to study, was a key figure. He ran the press the group set up in San Francisco. The first issue of the party newspaper, *Hindustan Ghadar*, was published in 1913. The press also printed collections of songs and poetry, known as the *Ghadar di Goonj*. Sarabha wholeheartedly supported Indian independence. A gifted speaker, he raised funds for the effort. He returned to India with a group of fellow activists in August 1914, plunging into the independence struggle. The British arrested him. He was hanged in November 1915 at the age of eighteen, becoming the first Sikh martyr to the cause.

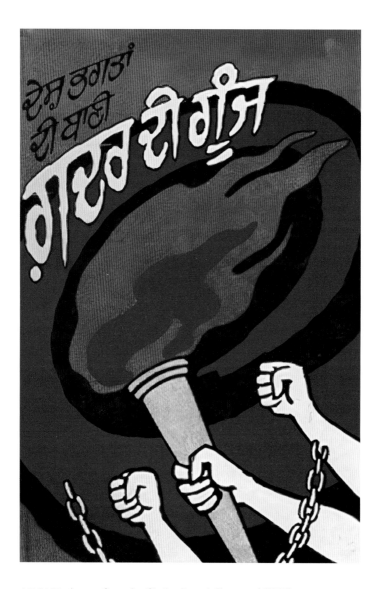

ABOVE: A page from the *Ghadar di goonj. Courtesy of PAHS.*

OPPOSITE: A page from *The Hindustan Ghadar* with an illustration of Abraham Lincoln, much admired by immigrants from South Asia. *Public domain.*

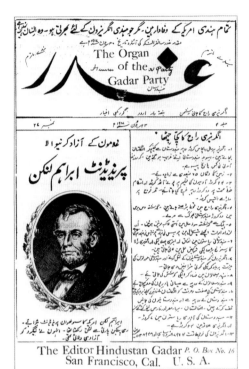

The Editor Hindustan Gadar *P. O. Box No. 16*
San Francisco, Cal. U. S. A.

About one thousand Punjabis had returned to India by December 1914 and several thousand more by early 1915. Among them were Jawala Singh and other leaders, who were promptly arrested. The rest went back to their villages in the Punjab, where they found little sympathy toward the Ghadar movement.

Britain's enemy Germany funded some Indian independence and Ghadar activities. This was revealed in the sensational San Francisco Hindu-German Conspiracy Trial in 1917, in which Ghadar leaders and their German collaborators were charged with violating neutrality during the war. At the trial's end, one of the accused shot another dead in the San Francisco courtroom. The trial and its finale soured public opinion on the "Hindoos." With the exodus of more radical elements back to India, the Ghadar Party changed. Its influence eroded, although it continued as a political party until 1948, after India won independence from Britain.

In the long run, the Ghadar Party did not benefit Punjabi immigrants. Their attraction to it was a direct response to oppression experienced first in India and later in North America.[23] Bruce La Brack echoes this sentiment: "Ghadar gave substance and direction to the California Punjabi community's struggle for identity, and it provided a platform for the assertion of their human rights to freedom and dignity."

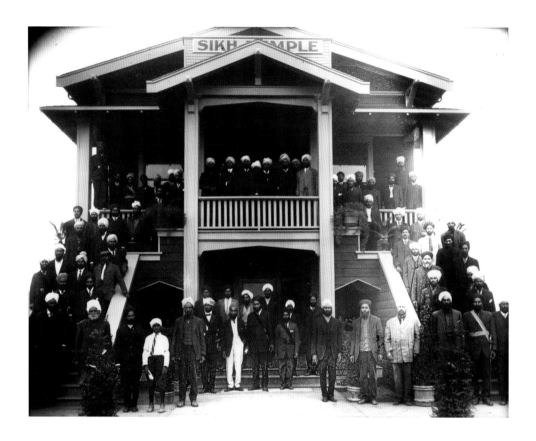

The old Stockton Sikh temple, 1915. It was the first gurdwara in the United States. *Courtesy of PAHS.*

The Dhillon family returned to California, living for a time in the Imperial Valley, before they settled near Fresno. Kartar recalled what it was like for the men who worked on the farms: "Since they couldn't own land, they lived wherever housing was available. It was camp life they lived. They set up cots for sleeping, and all their possessions were in a suitcase under their bed. They worked from sunrise to sunset, and on their one day off, they did their washing by hand. Whoever had a car would share it with others for transportation."

It was hard work, but there was some social life. "The main focus for Punjabis was our Sikh temple in Stockton," she said. "Just coming in from the country to go to a meeting at the gurdwara in Stockton was the highlight of our lives when we were

children, getting to ride in a car and go someplace. There weren't many cars around. A whole bunch of us would pack into one car."

The Stockton gurdwara was a religious and social center for Sikhs, Muslims and Hindus alike, before the first California mosque or any Hindu temples were built in the area. Established in 1912 at 1936 South Grant Street, Stockton, the gurdwara was the first Sikh temple in the United States. Meetings began in a converted wooden house, and when enough money was raised, a new gurdwara was built in 1929. The original wooden building remains on the property and is used as a library. According to people who were there at the time, such as Kartar Dhillon, Muslims performed their prayer rituals in a corner of the gurdwara and joined in the social activities. In fact, prior to the independence of India in 1947, Sikhs, Muslims and Hindus socialized without any great distinctions being made. Their religious observances were personal. After Indian independence and the subsequent bloodshed that the 1947 partition of India and Pakistan brought, more distance developed. As many as one million Sikhs, Hindus and Muslims were massacred in communal violence in the days following partition; Muslims fled to Pakistan, while Sikhs and Hindus went to India.

Kartar Dhillon recalls wearing mostly western dress. The harassment her brothers experienced meant Kartar and her sisters were not obliged to wear dupattas, the long Punjabi scarves, over their heads. "My father said no, don't have them wear it. Somebody's likely to take it and choke them or something with it. So, we didn't." Her mother wanted them to dress "in the proper Punjabi fashion." She added, "My mother always had her head covered," which is a common practice in India. Her mother was worried about her three girls. "She was so strict with us, so worried that something would go wrong with us in our growing up. She felt this country was so immoral, coming from where she did. And my brother [Budh] would champion me when he first came back. He'd say, you are always criticizing her, you shouldn't do that." Budh was a strong influence on Kartar, especially after her father's death in 1926. Budh encouraged her to study. Kartar's mother died in 1932, the same year Kartar graduated from high school in Caruthers, near Fresno.

The *Komagata Maru* Incident

An early incident that coincided with the formation of the Ghadar movement happened in Vancouver's harbor in 1914. A group of Punjabis, mostly Sikhs, contested Canadian immigration laws by attempting to enter Canada via Vancouver on the SS *Komagata Maru*. Although as British subjects Indians could legally enter Canada, an influx of several thousand Punjabis prompted the Canadian government to enact severe immigration restrictions. Entry could be refused to anyone who did not come by continuous passage to Canada from the country of origin. The Canadian government also pressured shipping companies to refrain from selling direct tickets from India to Canada. This virtually ended immigration from India to Canada.

The *Komagata Maru* was chartered in Hong Kong by Gurdit Singh, a wealthy Sikh businessman, to test these harsh immigration laws. He tried but failed to charter a ship from Calcutta. So, from the outset the passengers did not meet the continuous journey requirement. Nevertheless, the organizers felt they could successfully contest the immigration laws in Canadian courts, so they proceeded with the plan. The *Komagata Maru*, carrying 376 passengers, arrived in Vancouver on May 23, 1914.

Gurdit Singh told journalists who came alongside in boats that as British citizens the Indians on board had a right to visit any part of the empire. But when the passengers attempted to disembark, all but twenty-four returning residents and the ship's doctor were prevented from doing so by immigration authorities. Knowing supplies on the *Komagata Maru* were low, the authorities held the ship with all on board in the harbor, hoping to force the immigrants to leave.

The six-thousand-strong Punjabi community in Vancouver raised money to send food to the ship's passengers and pay the outstanding debt of $15,000 to the Japanese ship owner for the charter. After a month, the British Columbia Court of Appeal agreed to hear arguments. The five judges ruled against letting the passengers into the country. The *Komagata Maru* was denied entry. More drama ensued as the government tried to force the ship to leave at gunpoint before it was restocked with provisions. The passengers refused to leave until they took on supplies.

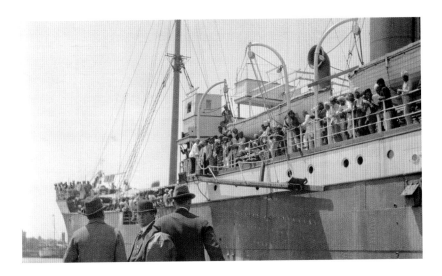

Passengers stuck aboard the SS *Komagata Maru* in Vancouver Bay, 1914. Canadian locals look on. *City of Vancouver Archives.*

The *Komagata Maru* left Vancouver on July 23 with 352 passengers. The ship was refused entry at British-run ports of Hong Kong and Singapore. As the ship proceeded to India, World War I broke out. The British, fearing the passengers were potential revolutionaries, sent armed police to meet the ship in Calcutta. As police escorted the disembarking passengers to a train bound for the Punjab, a fight broke out. Nineteen passengers and several Englishmen were killed. Gurdit Singh and others were imprisoned. The rest returned to their villages in the Punjab, where they remained under "village arrest" until the end of World War I. Canadian prime minister Justin Trudeau formally apologized for Canada's role in the incident in 2016.

Kartar Dhillon dreamed of going to college. "Well, I got married right out of high school." She explained that it was mostly because her eldest brother, Kapur, who was head of the family, wanted to send her to India for an arranged marriage after her elder sister Karm eloped. Although Kartar was excited about going to India, she didn't want to be controlled by her brother. She wanted to continue her education. Surat Singh Gill, the man she married, told her she could do that if she married him. So, they secretly married.

Educated at the University of California, Berkeley, Gill came from Chetanpura, Punjab, when he was nineteen years old. While at Berkeley, he became a Ghadar Party stalwart. He changed his major from medicine to political science and worked on the Ghadar newspaper. He was a brilliant orator. Kartar said they had "a happy few years," but she was disappointed about being unable to continue her education. Independent by nature, she had mixed feelings about marriage. "It's confining, marriage is. And I just decided that I wanted to be on my own."

Despite his degree from UC Berkeley, Surat Singh Gill could not get a job and was forced to resort to farming. Life on the farm was so isolated. Kartar preferred the city, where there were more cultural and educational opportunities for her children. When they moved to Los Angeles, she again wanted to attend university. Gill refused. He also objected to her participation in a strike. She decided she had enough. "So I took my children and left. That was the end of the marriage." She divorced Gill after ten years of marriage and started life as a single mother with a son and two daughters.

She supported herself and her children by doing odd jobs. An incident in Boyle Heights in Los Angeles brought home the attitude of white Americans toward darker people. "I was walking along the street, and it was very busy, coming and going, and one woman coming in the other direction said, 'Do you do housework?'" Dhillon said she was taken aback at being accosted like that. "To have a total stranger walk up to me and say do you do housework? What else would I be doing there? In her mind, here I am, a dark-skinned person, and it's a white neighborhood." She said she felt insulted. "And then I thought, I'm looking for work. I said, 'yes.'" Kartar did housework for the woman, who referred her to others, and it gave her an income for a time. Then she found work as a machinist in an aircraft plant.

Kartar didn't like Los Angeles, so she moved to San Francisco. There she held various jobs to support her family, from waitressing to working for a labor union paper. She also finally began her higher education.

During World War II, she worked for the U.S. Marine Corps. "We drove convoys. Sometimes I drove a truck in a convoy to pick up the boys coming back from overseas." She liked the work. She said it was good to be a civilian because "you could say whatever you wanted to say." Once she became aware of mischief brewing. Some of

The Dhillon brothers during World War II (*left to right*): Teja Singh, Hari Singh (*standing*), Kapur and Shamsher "Budh" Singh. *Courtesy of the Dhillon family.*

Kartar Dhillon in the 1960s. *Courtesy of the Dhillon family.*

the soldiers were plotting to harass Black GIs. As it happened, she knew the colonel. She was a gifted artist, and she sketched his portrait at his request after he saw her sketching in her spare time. She went to the colonel and told him what she knew. The colonel immediately called the sergeant "and put a stop to it." She said later that the sergeant came up to her and asked, "Why didn't you come to me? Next time please come to me first before going to the top." She added, "Yes, and it was going on under his nose and he wasn't bothered to do anything about it." During the war, her brothers Budh and Teja served in the army, and her youngest brother, Hari, just seventeen, was killed shortly after he arrived in Okinawa.

Kartar got a good job at an architectural firm and later became the secretary for the San Francisco Teamsters and Abestos Worker's unions. "I'm all for unions, so I got into the office workers union, and then all my office work was through the union." She later worked for Cesar Chavez, who fought for better working conditions for migrant farm workers through the United Farm Workers Union in

the 1960s. Kartar Dhillon was a writer and contributed an essay about her life, "The Parrot's Beak," to *Making Waves: An Anthology of Writings by and about Asian Women*, published in 1989.

Like her father, Kartar traveled widely, but she always came back to the San Francisco Bay Area. She visited India at last, staying mostly in Patiala with close family friends. "I just loved it. It was going to the country that my mother had me live in through her mind, all her stories," she said. "It was just like I walked into the home she had created in my mind."

Kartar's children grew up to be successful in business and academia. Kartar remained engaged in political and social action. In the 1990s, she traveled back to her early home, Astoria, Oregon, with her granddaughter Erika, to help her research the film *Turbans*. Kartar Dhillon spent her last years living with her daughter Ayesha, delighting in her grandchildren and great-grandchildren. She remained passionate about social justice until her death in 2008 at ninety-three.

CHAPTER 5

ANGEL ISLAND:
SOUTH ASIAN STORIES

Bakhshish Singh Dhillon came to the United States early and stayed once he brought his wife. Others who arrived later or returned after harsher immigration laws were adopted could not count on admission, even if Americans vouched for them.

To get off the boat at an American port, the average immigrant needed a few hundred dollars to pay fees and show he could support himself. Families who aided the immigrant financially saw it as an investment, because if the son or brother who went abroad did well, he would become a source of much-needed income for the family back in India.

Besides paying fees, an immigrant must not give the impression of someone "likely to become a public charge." Those words on an official document were enough to confirm deportation. When immigrants disembarked at the Angel Island Immigration Station in San Francisco Bay, they faced uncertainty. The amount of money an immigrant carried, proof of assets abroad or the promise of employment in America could sometimes sway the often-prejudiced immigration board to allow him to stay—but not always. Records from Angel Island reveal just how arbitrary the decisions whether a person could stay or be deported were.

Surviving records[24] of South Asian immigrant arrivals in the National Archives in San Bruno contain poignant case histories from the early twentieth century. If a photo of an individual accompanies a file, it invariably shows a well-dressed man,

OPPOSITE: Immigrants disembark from a ship at Angel Island Immigration Station, circa 1925. *Courtesy of California State Parks.*

A group portrait of twelve Sikhs on Angel Island, circa 1925. *Courtesy of California State Parks.*

often in a three-piece suit and tie or sometimes in a sherwani, typical north Indian attire. They obviously dressed in the best style they could afford. Sikhs usually are bearded and wear turbans in these photos; Muslims often wear a neat cap. These are faces of young men, mostly in their twenties or early thirties. Their expressions are serious and guarded, perhaps expectant. There is a look of courage in their eyes. One can only wonder what their thoughts were at being stopped at the doorstep after coming so far.

THE TWENTY-FOUR "HINDU ALIENS"

A memorandum dated November 15, 1913,[25] written by an unnamed acting commissioner general, concerns deportation cases of twenty-four "Hindu aliens" detained in San Francisco.[26] Regardless of their religion, all South Asian immigrants at this time were called Hindus. The memorandum delineates the "law and regulations" under which the men were arrested.

They were found in violation of the immigration act "for the following among other reasons: That the said aliens are members of the excluded classes in that they were persons likely to become public charges at the time of their entry into the United States."[27] An alien could be taken into custody and deported within a period of three years after entry. Admission to ports in U.S. territories Hawaii, Puerto Rico and the Philippines "does not insure free and unquestioned landing at continental ports and the privilege of remaining in the mainland." The memorandum goes on to say, "Hindus are generally in ill favor in the section of the country where these men wish to go; and that the feeling against them, arising partly from their racial characteristics, partly from their modes of life, and partly from their proclivity to work for extremely low wages and the dissatisfactions with them as laborers, has a tendency to interfere with their earning a living and to push them into questionable methods of gaining a livelihood."

Files in the National Archives show that men who met the criteria of having guaranteed employment and sworn affidavits testifying to their good character were routinely deported anyway. The men discussed in the 1913 memorandum had similar stories to tell. All of them had embarked for San Francisco from Manila, and before that many had spent time working in Shanghai or Singapore. Some of them had served in the British Indian Army. Most of them claimed to have property in India, but none had brought proof. All but one said they had friends or a relative in America. None of them had more than a few hundred dollars, most had only about fifty. Some of them were diagnosed with hookworm, a "dangerous contagious" disease that could weigh against an immigrant's case, despite available treatment. Of the twenty-four men, six were allowed entry into the United States.

Henry F. Marshall Defended Angel Island Immigrants

The name of lawyer Henry F. Marshall often appears on legal documents in the Angel Island files from the early twentieth century. He defended many immigrants seeking entry to the United States.

"Carefully preparing his cases, he goes into court with the conviction that his premises are sound and with the determination to fight for the interests of his clients to the last ditch," a 1916 newspaper article notes.[28] The truth of this is borne out in file after file of clients he defended.

Lawyer Henry F. Marshall helped many South Asian immigrants avoid deportation. *Courtesy of California Digital Newspaper Collection.*

Marshall was highly respected. He was not only a tenacious opponent who won many of his cases but also a champion golfer and chess player.

Marshall was born in Brookline, Massachusetts. He served in the U.S. Army, distinguishing himself in the Spanish-American War as first lieutenant. After earning a law degree, he worked at the War Department in Washington, D.C., was an immigration officer for the Department of Commerce and Labor in New York City, transferred to the Department of Justice and was sent to San Francisco to open a local office of the Bureau of Naturalization. He was also a librarian and a reporter for the *San Francisco Chronicle* before he opened a law office.

"In his practice Mr. Marshall displays penetrating sagacity and a remarkable legal acumen. He is a keen and earnest student of the law, which, aided by sound practical judgment, has made for him a most creditable record for legal discernment."[29]

He specialized in immigration cases, drawing on his experience to advantage. He represented the twenty-four "Hindus" during the three-year court battle and prevented deportation of six of them. He defended many others.

Marshall maintained a busy practice until heart disease forced him to step back and eventually close his Market Street law office in 1927. He died in 1934.

KEHAR SINGH PERSEVERED

The first time Kehar Singh and his brother Dal Singh reached California shores, they were turned away for the want of five dollars to pay the port fee, according to Kehar Singh's son Judge Brar.[30] So they went back to Singapore to earn more money. Luckily, they were admitted on their second immigration attempt in 1913, but not until lawyer Henry F. Marshall successfully petitioned for their release.

Kehar Singh was almost deported after he arrived on the *Nippon Maru* for his second visit in 1913. *Courtesy of NARA.*

They worked as farm laborers, sleeping in barns. They eventually settled in Clovis, near Fresno, where Kehar Singh acquired land to farm. By the time he died at the age of ninety-four, Kehar Singh had become an integral and respected member of the farming community. He was a man who did what he could for others. Japanese friends, fellow farmers, were taken to internment camps during World War II. "Some of his very good friends were interned in internment camps. He actually took care of some of the farms while they were interned," Brar said. Kehar Singh also visited them in the camps.

Once the Asian Exclusion Act was repealed in 1947 and Asian immigrants could safely visit their home countries, Kehar Singh returned to India. He was fifty-five and unmarried, but he brought a young bride back with him to begin the family that still farms the land in Clovis.

KALA SINGH WAS LUCKY

Kala Singh, thirty-eight years old, was a watchman in Shanghai for seven years before coming to the United States. He brought good character references from his employers there. In his affidavit, he described land he owned in his home village Chuharchak in District Ferozpur, Punjab: "This property consists of 400 vigas [approximately one-third of an acre] of the best farming land with two houses upon it." He told the immigration officials that he had money available abroad. He did not bring more than $50 because the agents for the steamship company told him "when I showed that amount of money I would be allowed to come ashore all right. If the steamship men had told me that I must show $100 or $500, I would have brought that amount with me just as easily." In addition, affidavits filed on Kala Singh's behalf backed up his claims. Two men from his village who had settled in the Imperial Valley, Rur Singh and Mota Singh, said his claims were true.

Kala Singh's friends helped him remain after he arrived on the ship *China* in 1913. *Courtesy of NARA.*

Mota Singh became a successful farmer near El Centro and is well remembered there. He made a particularly eloquent deposition in support of Kala Singh. At the time, Mota Singh had been in the United States for six years. He declared that he was from the same village and a cousin of Kala Singh. Mota Singh stated he was "employed as general foreman over the Hindu labor on the property of G. Shima, the Japanese Potato King of the State, who operates 17,000 acres of land in the San Joaquin Valley." He oversaw employing all the Hindu labor. He added, "I, myself, pay the Hindu laborers by check drawn in the name of G. Shima upon his bank." He gave details about the number of "Hindu Boys" he employed and the number he needed. He said that if Kala Singh were released, "I will give him employment the year round near Stockton for $2.00 a day," a good rate at the time.

"Since I have been in this country," Mota Singh went on, "I have found that there is some prejudice against the Hindu people among the dwellers in the cities, but among the farming communities, however, there is no prejudice against my people, but on the contrary, there is a great demand for them for the reason that they are obedient, teachable, and never cause any disturbance." He said Hindu workers were in demand in the San Joaquin Valley and added, "The American working man does not desire to work upon the farm and avoids ranch work wherever possible."

His plea worked. Kala Singh's arrest warrant was canceled, and he was allowed to stay in California.[31]

SHER MOHAMMED, "A FINE MAN"

Sher Mohammed, twenty-four years old, was told by the immigration board that he would be deported, despite his five years' service in the British Indian Army, letters of recommendation from his officers, certificates of English language study and the ability to speak English well. He claimed family land, a farm "worth from 7,000 to 10,000 rupees, which is his separate individual share among three brothers; cannot substantiate this claim by documentary proofs."[32] But Sher Mohammed appealed the decision, and with the help of Henry F. Marshall, he won his case. Marshall's handwritten letter on behalf of Sher Mohammed, asking for his release, reads, "This is a fine man, educated to a degree and speaking very good English. I myself would employ him if released pending the decision of his case," asking that Sher Mohammed "be paroled to me." Sher Mohammed's release was ordered on December 1, 1913.

Sher Mohammed impressed his lawyer with his character. *Courtesy of NARA.*

ATTAR SINGH, DENIED DUE PROCESS

Henry F. Marshall also defended Attar Singh, a thirty-six-year-old former soldier of good record, who was discharged from the Thirty-First Punjabi British Indian Army Regiment before making his way to America. His case was like the others. When asked by the interviewer on Angel Island why he had come to America, he said, "To improve my prospects," saying he would look for "laboring work." He said he owned farmland and a house in India from which he received some income but did not have documentary evidence of his assets, saying reasonably enough, "I have not got them here, because nobody travels with those titles with them."

In Henry Marshall's application for a writ of habeas corpus on Attar Singh's behalf, he said, "Attar Singh was denied a fair hearing in good faith, such as is guaranteed by law." He continued, "Attar Singh was not informed of the charges or allegations made against him," nor were the proceedings correct. Marshall also stated that the immigration commissioner "detailed an Immigration Inspector to canvass the people of the State of California for evidence to support the charges," and that "there was placed in the record certain expressions of passion and prejudice culled from persons in various parts of the State of California in the form of affidavits, interviews and letters made, given and written by persons unknown to your petitioner, or to the said Attar Singh." He had no opportunity to cross-examine the people who made the statements or otherwise defend himself. Marshall noted that about one thousand "newspaper clippings of matter, views and reports of a character adverse and prejudicial to the Hindus as a race" had been placed on the record. Marshall's affidavit on behalf of Attar Singh is an indictment of actions of immigration officers in the case. While Marshall may have drawn some attention to corrupt immigration practices, his plea was unsuccessful for Attar Singh, who was deported.

OPPOSITE: Attar Singh, despite his good credentials, was deported. *Courtesy of NARA.*

ABOVE: The SS *Tenyo Maru* transported Bishen Singh and other hopeful immigrants to San Francisco. *Public domain.*

BISHEN SINGH, DEPORTED DESPITE SUPPORT FROM WHITE FARMERS

Bishen Singh had been to America before. He worked in California from 1910 to 1913, where he earned a good reputation among the farmers. Nevertheless, when he disembarked from the *Tenyo Maru* on June 1, 1916, he was arrested by the Immigration Service "as a person likely to become a public charge." Thirty-year-old Bishen Singh told the Angel Island immigration interviewers[33] that he had a wife and daughter who lived in India. He named several friends in California who owned a farm in partnership in Fowler, California. He presented a recommendation letter from one of his former employers, J.R. Firth of the Dry Bog Orange Company in Porterville, who wrote, "We have found him faithful and industrious."

Bishen Singh said he had a farm in India, and while there he worked his land, but "I can't make a living for so many people on the ten acres in India, so I came to the U.S. to earn more money." The interviewer quizzed him about his religion and marriage practices. When asked if he had more than one wife, Bishen Singh said, "Only one." When asked if he thought a man should have more than one wife, he replied, "Some rich man might have more." The interviewer pointedly recorded that Bishen Singh intended to pick fruit or perform farm labor, something that was often used against arriving Asians.

Several immigration inspectors were present at his interview, and at the end, they disagreed. Inspector Robinson recommended his deportation "for the reason that he has a small amount of money and the laboring conditions at the present time are such that I do not think he will be able to obtain employment." Another, Inspector Nicholls, disagreed: "The alien before the board presents a very neat and clean appearance. This is not his first trip to the United States, he having been here from the year 1910 to the year 1913, and he had taken pains to acquire a fair knowledge of the English language. He has stated before the board that he was able to make a living during his former stay in the United States and there is nothing before the board to show that he will not do the same now. He is a farm laborer and fruit picker and will not go into the congested districts but will probably go where labor is mostly needed. He has

OPPOSITE, TOP: Sikh workers tend an orchard, 1912. *Courtesy of NARA.*

OPPOSITE, BOTTOM: Five immigrants from India at Angel Island Immigration Station, circa 1925. *Courtesy of California State Parks.*

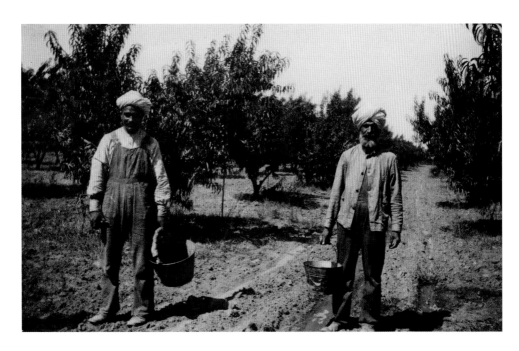

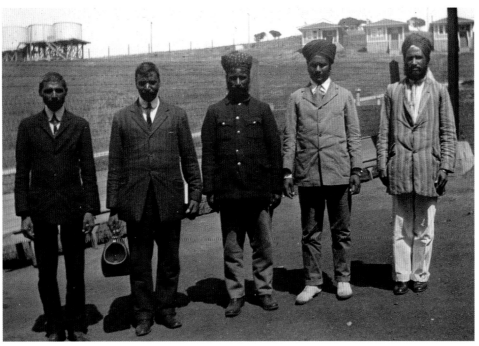

sufficient funds in all probability to last him until he can find employment. He has all the appearance of being as he represents himself and has also stated before the board that he has some countrymen, who have evidently sufficient funds to buy property in the U.S., who will care for him and find him employment. He has presented a letter of recommendation from his former employers. There seems to be nothing before the board to show why this man should be more excludable than a man of any other nationality. His whole statement before the board and his demeanor lead me to believe that it would be a great hardship for him to return to his native land. I cannot agree with the motion to exclude." The third inspector agreed with the first, that Bishen Singh be "deported as a person likely to become a public charge." They informed him of his right to appeal. He did.

Bishen Singh's lawyer Joseph P. Fallon wrote to the secretary of labor appealing the board decision.[34] He stated Bishen Singh was in good health and "that he has labored in California and his former employers are anxious for him to return and resume that labor; that the condition of the labor market is such that there is a great demand for such a competent workman as this applicant has in the past proven himself to be; and that the wages he can command at said labor will amply meet all of his demands and insure against his becoming a public charge." Fallon also wrote, "He has a job awaiting him at Porterville, California, and it would seem under the circumstances that he should be allowed to proceed to the place and go to work." He reiterated Singh's good character, that he was well-liked and competent. He also submitted the affidavits of Bishen Singh's former employers. P.P. Firth stated, "Bishen Singh proved himself to be one of the most reliable, steady, trustworthy and industrious men that [Dry Bog Orange] Company ever had in its employ," and that his services were needed. J.E. Berndtson swore that he "can heartily recommend said Bishen Singh both a workman and as a man of fine character," and that Bishen Singh "can command steady employment at good wages all year in said Tulare County." F.M. Pfrimmer of Lindsay said Bishen Singh "was considered one of the very best men." All three deponents asked for his release and wrote separate letters to the immigration board. Firth wrote, "We sincerely hope that the authorities will see their way clear to allow him to return here, as we are sorely in need of just such faithful men."

Despite his strong case and the number of reliable American citizens speaking on his behalf, whose testimony belied the "evidence" relied on by the immigration board, Bishen Singh's appeal was denied. No reason was given to his lawyer in the letter that remains in the file, only that "after carefully considering the evidence presented in the record, the Acting Secretary has affirmed the excluding decision of the board and directed deportation." Bishen Singh was deported on the SS *Anyo Maru* on July 30, 1916.[35]

According to the research of Erika Lee and Judy Yung, "South Asians had the highest rejection rate of all immigrants passing through the immigration station during its thirty-year history."[36] Besides nativist bigotry, Ghadar Party rhetoric made South Asians politically suspect.

Mota Singh was correct in his observations about the prejudice in urban areas. Unfortunately for most aspiring immigrants, their fate was often decided by bigoted officials in San Francisco or Washington, D.C., who made decisions based on their prejudices, disregarding verifiable facts and proper court procedures.

It is not surprising that in the face of this treatment immigrants risked their lives to cross illegally into the United States. When it became nearly impossible for Asians to enter Canada because of harsh immigration restrictions there, they traveled to South America, sometimes taking years to work their way up to the United States to the porous Mexican border.

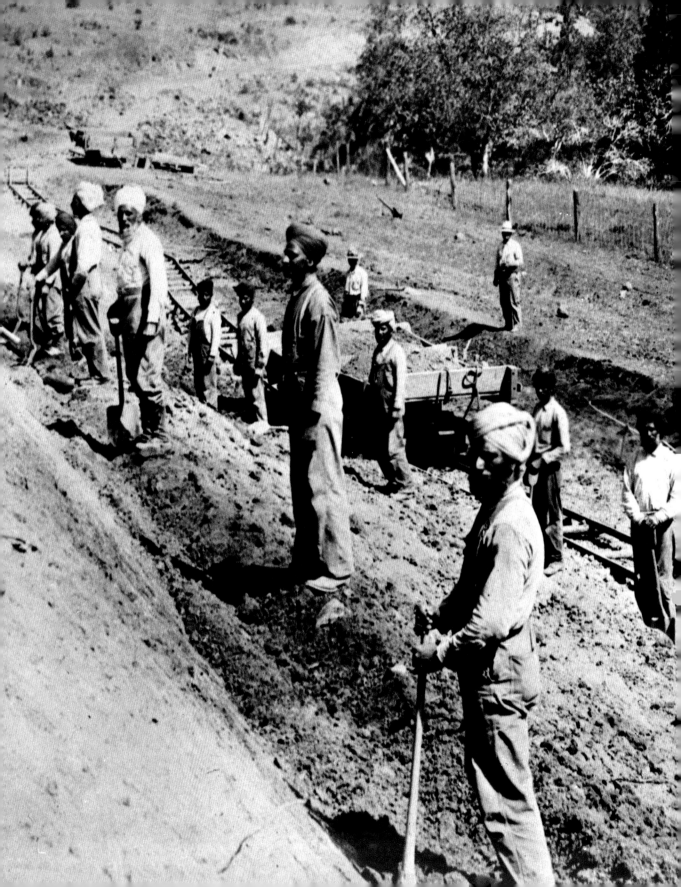

DIFFICULT TIMES, TENACIOUS IMMIGRANTS

The first Punjabi immigrants admitted to the United States settled primarily in California, Arizona, Oregon and Washington. They took jobs as loggers, railway workers or longshoremen, but their real knowledge was agriculture. Punjabis became field hands up and down California, tilling its rich soil.

Northern California's Central Valley reminded homesick migrants of the Punjab: five rivers watered it and high mountains flanked it, although the climate was kinder. At least it was in the north. The desert-like Imperial Valley in Southern California, which also hosted an early community of Punjabis, is another story. There temperatures soar dangerously high in the summers.

LEFT: Sikhs often took railroad construction jobs. This crew is building the Pacific & Eastern Railway, circa 1909. *Courtesy of Southern Oregon Historical Society.*

AGRICULTURE WAS SECOND NATURE

California crops were familiar to the Punjabis, who had cultivated wheat, rice, vegetables, almonds and fruit in India. There was plenty of work in California's orchards and fields. Good laborers were hard to find. Asians were hard workers, according to contemporary accounts, and they were often sought after by farmers.

The Chinese had been excluded by law, and Japanese immigration was limited by the so-called Gentlemen's Agreement (1907–8), whereby the Japanese government agreed not to issue passports to laborers for travel to the continental United States. Farmers looked to "Hindoos" to fill the gap. Although Punjabi immigration increased from 1899 onward, its peak was between 1906 and 1910. More than one thousand Punjabis arrived each year in that period, after which the numbers of recorded immigrants decreased. By 1920, more than seven thousand Punjabis had legally entered the United States.

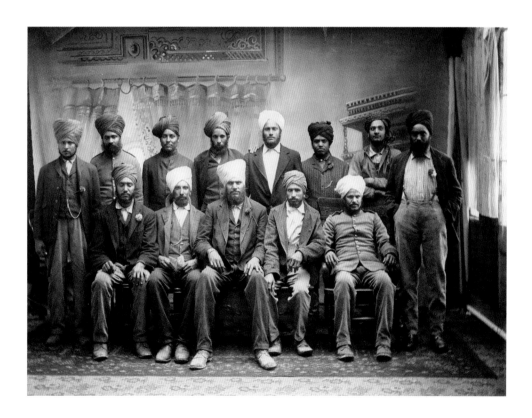

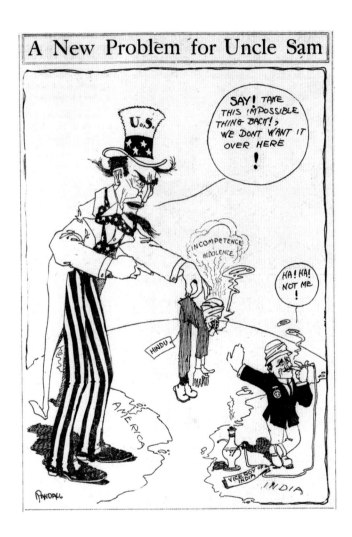

OPPOSITE: A studio portrait of California Sikhs, 1910. *Courtesy of California State Library Photograph Collection.*

ABOVE: A racist cartoon depicts "Hindus" with inaccurate negative stereotypes in the *San Francisco Call*, August 13, 1910. *Courtesy of California Digital Newspaper Collection.*

Immigrants with a gift for management became bosses of "Hindu" work "gangs." These were reliable men with a network of contacts that allowed them to procure workers for farmers on a seasonal basis. Mota Singh, who deposed on behalf of Kala Singh, saving him from deportation, was one of these trusted bosses.

As La Brack and others have noted, Punjabis rarely came to America alone. If they did travel alone, they usually had an uncle or friend already in the States. Early arrivals paved the way for relatives and friends, beginning a system of chain migration that continues today.

DISCRIMINATION AND ISOLATION

After the Immigration Act of 1917 including India in the Asian "barred zone" and the 1924 Oriental Exclusion Act, legal immigration stopped. Wives could not join their husbands in America. Very few wives had made the journey prior to the restrictions. The men could not participate in the extended families to which they were accustomed at home. Nor could they go back to India and expect to return, because reentry was not guaranteed. Often a man had left a wife and child behind, intending to bring them when there was enough money or return to India after a few years. But because families in India depended upon money sent to them, some immigrants who decided to stay in America never saw their families again. Others married here, to Anglo or Mexican women, starting an offshoot community of Punjabi-Mexican families, also called "Mexican Hindus."

The Punjabis got along with others and were respected by the farmers for their hard work, although newspapers frequently published racist stories and illustrations depicting them negatively. Anti-Asian clubs such as the San Francisco–based Asian Exclusion League vilified Chinese, Japanese and South Asian workers. There were incidents, like that reported by the *Sutter Independent* on January 30, 1908: "Live Oak People Tire of a Camp of Beturbaned Hindus and Tell Them to Get." The article describes how white men burst in on sleeping workers, threw their things outside and robbed them of a total of $1,972.55, no small sum at that time. Two men, E.A. Taylor and W.M. Speer, were charged with the theft, but the case was dismissed "for want of sufficient evidence."

As if discrimination against Asian migrant laborers and poor working conditions were not enough, in 1913 California passed the Alien Land Law, which decreed that aliens who were not eligible for citizenship could not own or lease land. After the

Civil War, the 1790 Naturalization Law that barred all but "free white persons" from citizenship was amended to give eligibility to the formerly enslaved. The Fourteenth Amendment (1868) and additional legislation in 1870 allowed persons of African descent citizenship.

But Punjabis are Caucasian. What of them? Already they had experienced racism because of their darker coloring, different culture and the perception that they were taking jobs away from American citizens. The anti-immigration Alien Land Law was aimed primarily at East Asian immigrants. The status of South Asians in the United States was less clearly defined. Nearly seventy had become naturalized American citizens. But ultimately, they were excluded with the rest, many retroactively. The defining moment was the Supreme Court ruling in the case of Bhagat Singh Thind in 1923.

THE BHAGAT S. THIND DECISION: NOT WHITE ENOUGH

Bhagat Singh Thind was born near Amritsar in the Punjab on October 3, 1892. He grew up a religious Sikh interested in philosophy. He was educated at Khalsa College in Amritsar and graduated with a degree in divinity in 1912. According to a brief biography written by his widow, Vivian Thind, he was drawn to America after reading American transcendentalists Emerson, Whitman and Thoreau. After his graduation in 1912, he left for North America. His journey to the United States was typical, punctuated by a nine-month stay in Manila en route to Seattle, Washington. He arrived there aboard the *Minnesota* in July 1913.

Thind intended to pursue a university degree. Son David Thind said that his father put himself through university by working summers at an Astoria, Oregon lumber mill. He earned a doctorate from the University of California, Berkeley, where he studied philosophy and psychology. Like most South Asians in California at the time, he was also active in the Ghadar Party.

When the United States entered World War I, Thind enlisted. He was inducted on July 22, 1918, and served at Camp Lewis, Washington. David Thind said that his father was the first Indian to serve in the U.S. Army and the first to serve wearing his turban. "He fought that discrimination. They wanted him to shave his beard and he said due to his religious beliefs he would not do that, and he won." In perhaps the best-known photograph of Thind, he is depicted wearing his army uniform and turban.

Bhagat Singh Thind was promoted to acting sergeant a month before the war ended. He was honorably discharged in December 1918. His discharge papers noted his excellent character.

Thind was determined to become an American citizen and petitioned for citizenship several times. The first time it was granted, in December 1918, it was canceled a few days later. He applied again in May 1919, and in October 1920 the U.S. District Court in Oregon ruled favorably. He was granted citizenship one month later, on November 18, 1920.

Bruce La Brack cites Harold S. Jacoby, whose research revealed that "at least thirty-two courts in seventeen different states" had granted naturalization to sixty-eight South Asians between 1907 and 1923. Jacoby also said the first applicant was a Sikh named Veer Singh, whose petition

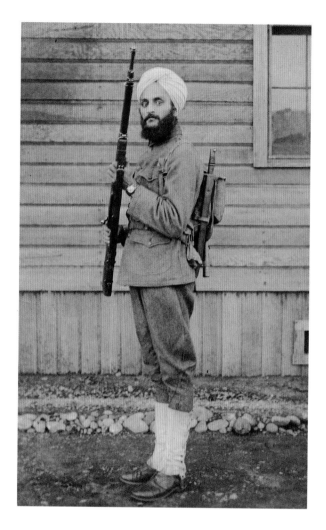

Bhagat Singh Thind during his World War I U.S. Army service, 1918. *Courtesy of David Thind.*

failed because he refused to remove his turban during the oath of citizenship. The first successes were two Punjabi Muslims in New Orleans.

Courts were inclined to grant citizenship to Asian Indians because they were Caucasians, despite India's inclusion in the Asian barred zone. But a naturalization examiner questioned the legality of Bhagat Singh Thind's citizenship. This initiated a legal case that went to the Supreme Court. The Ninth Circuit Court asked for a ruling

Bhagat Singh and Vivian Thind. *Courtesy of David Thind.*

on "whether a high-caste Hindu was a white person and whether the Immigration Act of 1917 disqualified him from naturalization."

The Supreme Court ruling on the Thind case shocked South Asians throughout the country. It essentially said that Thind wasn't white enough to be an American citizen: "The term 'white persons' is a popular and not a scientific term, and must be given its popular meaning, and as such is not to be construed as identical with 'Caucasian,'"

85

Bhagat Singh Thind in his Los Angeles garden. *Courtesy of David Thind.*

the February 19, 1923 decision read. It goes on to say that "white persons" in the Naturalization Act "refers to immigrants from the British Isles and Northwestern Europe." The Supreme Court held that a "Hindu" could not be considered a white person because the law "does not employ the term 'Caucasian,' but the words 'white persons,' and these are words of common speech and not scientific origin," despite racial ancestry.

After dismissing the validity of the anthropological classification of Caucasian, the court ruled, "We are unable to agree with the District Court, or with other lower federal courts, in the conclusion that a native Hindu is eligible for naturalization" under the law. Bhagat Singh Thind's citizenship was rescinded, and he was issued a Certificate of Cancellation from the Immigration and Naturalization Service on June 26, 1926.

A cascade of citizenship revocations followed. By 1926, the government had canceled forty-two naturalization papers of Asian Indians, mostly Sikhs. Two court cases in 1926 and 1928 successfully challenged retroactive rescindment of citizenship. Erika Lee and Judy Yung in *Angel Island: Immigrant Gateway to America* tell a tragic story of Vaisno Das Bagai, a Hindu from Peshawar, now in Pakistan, who brought his family to San Francisco in 1915. He became a naturalized citizen and bought property. He lost his general store and home when his citizenship was revoked. He died by suicide in 1928, leaving a poignant letter despairing of "obstacles this way, blockades that way and bridges burnt behind."[37]

The push to nullify South Asians' citizenship ended, but most of those who lost their citizenship were unable to have it restored until the Luce-Celler Act in 1947 made them eligible to become citizens again.

Bhagat Singh Thind's citizenship was restored in 1936. According to his son, David, "There was a great concern among Americans in the early 1930s about the treatment of Asians who served in the United States Army, thus in 1935, the Seventy-Fourth US Congress passed a law allowing citizenship to U.S. veterans of World War I. Dr. Thind received his citizenship through the state of New York in 1936, with no objection from the INS."

Thind went on to become a revered spiritual teacher who traveled around the United States lecturing about Sikh mysticism and meditation. He married Vivian Davies in 1931, and they had a son and daughter, David and Rosalind. He authored numerous books on spirituality, among them *The Radiant Road to Reality* and *The House of Happiness*. Bhagat Singh Thind died in 1967. His son, David, published several of Thind's books posthumously and is documenting his father's life on film.

DALIP SINGH SAUND, FIRST ASIAN IN U.S. CONGRESS

Indian students gravitated to academic centers in the United States beginning in the late nineteenth century. Sons of Indian elite attended major American universities such as Harvard, Columbia and Stanford.

The University of California, Berkeley, drew Indian students in numbers large enough to justify the purchase of a house at 1731 Allston Way for use as a student hostel. The Stockton-based Pacific Coast Khalsa Diwan Society raised the money to buy it. Such residences for Indians in Berkeley served them much as fraternity houses served other students. Indian students were excluded from fraternities.[38] The Allston Road hostel was free. Scholarships, such as the Guru Govind Singh Sahib Educational Scholarship set up by wealthy farmer Jwala Singh, helped bright students get degrees.

Berkeley, then as now, offered a broadminded atmosphere where professors interested in Asian cultures mentored and encouraged young South Asians. Sanskrit scholar Arthur Ryder translated classical plays into English that were then produced by students. Gobind Behari Lal, who became a noted American journalist and the first Asian to win a Pulitzer Prize for journalism, helped stage the prologue of *Shakuntala* when he was a student at Berkeley in 1914.

The Indian independence movement's ardent supporters clustered around West Coast universities. Among the Punjabis at Berkeley in the 1920s was a young man who would channel his energies into politics, not in India, but in his adopted country. He became the first Asian to be elected to the U.S. Congress. Dalip Singh Saund was born in 1899 in Chhajulwadi village in the Punjab. His family of prosperous but uneducated farmers supported his education through graduation from the University of Punjab in Amritsar, where he majored in mathematics. They also gave him money for passage to the United States.

Saund studied at Berkeley from 1920 to 1924. Like other Indian students, he paid his way through university by doing farm labor during term breaks for McNeill, McNeill and Libby and the California Packing Corporation. He was politically active when the Gadar Party ratcheted up support for India's independence. Saund believed in and admired American democracy. Abraham Lincoln, Thoreau, Woodrow Wilson and Theodore Roosevelt were among his heroes. He was impressed by Mohandas K. Gandhi and wrote a monograph titled "Gandhi: The Man and His Message," highlighting Gandhi's nonviolent and tolerant approach. Saund's nascent political acumen got him elected as the national president of the Hindustani Association of

The official congressional portrait of Dalip Singh Saund. *Courtesy of Special Research Collections, UC Santa Barbara Library.*

GREEK THEATRE
UNIVERSITY OF CALIFORNIA

SHAKUNTALA

SATURDAY, JULY 18, 1914, 8 P.M.

America while he was at Berkeley. "All of us were ardent nationalists and we never passed up an opportunity to expound on India's rights," he wrote.

In his autobiography, *Congressman from India*, Saund wrote that he intended to return home. He studied agriculture but eventually took master's and doctorate degrees in mathematics. By the time he received his doctorate—despite offers of professorships from Indian colleges—"I had decided that I was going to make America my home." He had grown fond of America. "Even though life for me did not seem very easy, it had become impossible to think of a life separated from the United States. I was aware of the considerable prejudice against the people of Asia in California and knew that few opportunities existed for me or people of my nationality in the state at that time."

He turned to his hereditary work, farming: a year after he graduated from Berkeley, in 1925, he took a job as foreman at an Imperial Valley ranch and moved to Southern California. He saved money and grew lettuce in Westmorland, near the Salton Sea. Saund still wore a turban, and neighbors remember him working his fields in typical "Hindu" dress. He joined local organizations, including the Brawley Toastmasters chapter, where he honed his skills as a speaker.

He met his future wife, Marian, at a speaking engagement at the Los Angeles Unitarian Church. From a family of Czech immigrants, she was a student at the University of California, Los Angeles. They were married in 1928. Marian was active in the Imperial Valley community and in supporting her husband's political career. They had three children: Dalip Jr., Julie and Ellie. According to Tom Patterson, a local man who knew

the Saunds, Marian moved the children back to Los Angeles after the children were treated badly in the Westmorland school because they were half East Indian.

Although Saund did not dwell on discrimination, he always fought for immigrants' rights. He actively campaigned for the passage of the Luce-Celler bill as head of the India Association of America. When the bill passed in 1946, ending restrictions against South Asians becoming citizens, he was among the first in line for citizenship, which he obtained on December 16, 1949. Shortly thereafter, he ran for the office of justice of the peace in Westmorland. He won, but an opponent sued for him to be disqualified because he hadn't been a citizen for a full year, although he would have been by the time his term began. The court ruled in favor of his opponent. That did not stop Saund, however, who ran and won again in 1952.

By 1951, Saund had become chairman of the Imperial County Democratic Central Committee, learning about managing a congressional election campaign. When the longtime incumbent Republican John Phillips announced he would not run again in 1956, Saund, who by then was very well known in the Twenty-Ninth Congressional District, announced his candidacy.

Saund had already shown himself to be a man of action as justice of the peace. He was a successful farmer who understood farmers' concerns. Opponents called him a foreigner and brought up Saund's old legal tangles over some debts, which he had paid off.

Saund won the primary election. This attracted national interest, particularly because he was pitted against Republican—and female flying ace—Jacqueline Cochran Odlum. Odlum's flamboyance and airborne campaign notwithstanding, Saund won by 3,300 votes in a district of about 115,000 voters.

Because of Saund's unique background, he was appointed to the House Foreign Affairs Committee as a freshman senator. During three terms, he supported strong international diplomacy and security. He advocated for small entrepreneurs and farmers. His hard work won him reelection by more than 60 percent majorities in 1958 and 1960.

While preparing to run for his fourth term in May 1962, Dalip Singh Saund suffered a serious stroke that rendered him unable to walk or speak. His brilliant political career was over. In the preface of his book *An Indian in Congress*, he credited his "wise though unlettered mother, who had loved me dearly and taught me the lessons in good living," and his devoted wife, Marian, "who knew how to chide and guide." He added, "My religion teaches me that love and service to fellow men are the road to earthly bliss and spiritual salvation." Although he later was able to walk, he could not speak and remained an invalid. He died in 1973.

In 2005, the U.S. House of Representatives voted unanimously to honor Saund by naming a U.S. Post Office in Temecula, California, after him. The bill was cosponsored

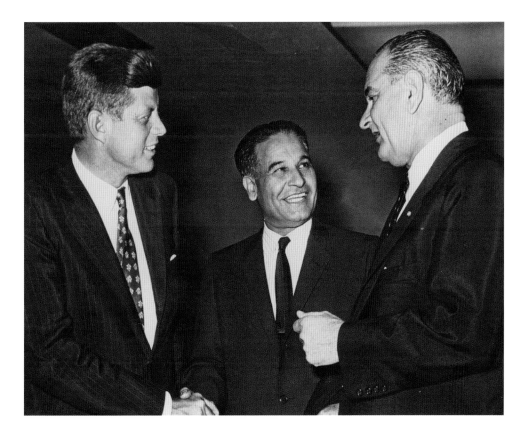

Saund chats with future U.S. presidents John F. Kennedy and Lyndon Baines Johnson. *Courtesy of Special Research Collections, UC Santa Barbara Library.*

by Congressmen Darrell Issa and Bobby Jindal, the second Indian American to be elected to the U.S. Congress. Jindal was elected governor of Louisiana in 2007, the first ethnic South Asian to become a state governor.

Individuals such as Bhagat Singh Thind and Dalip Singh Saund not only cut a path for later immigrants to follow but also made significant contributions to strengthening democracy in the United States. Their belief in the inalienable rights of the individual as outlined in the U.S. Constitution, rather than in prejudiced minds, fueled their dedication. The groundwork they laid in courts of law and legislatures supported the civil rights movement, which came to its fruition in 1964 with the passage of the Civil Rights Amendment.

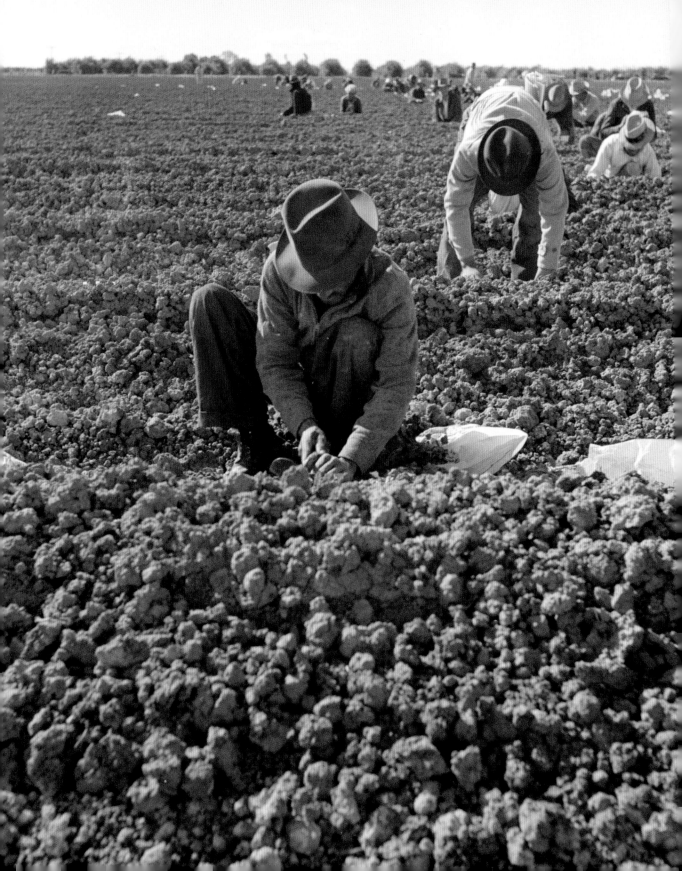

FROM FIELD HANDS
TO LANDOWNING FARMERS

Migratory workers followed the seasonal harvest schedule up and down California. Eventually, the enterprising Punjabis put down more permanent roots. A small group of them stayed in the arid Imperial Valley, but the farms in the northern counties around Yuba City and Marysville drew larger numbers of settlers.

The Northern and Southern California immigrant communities interacted for business and socializing when they met at the Sikh gurdwara in Stockton. Punjabis from as far away as Arizona gathered there a few times a year to swap news. That included news from India, since the gurdwara was the first stop in California for new arrivals. Newcomers knew they were certain of receiving hospitality and maybe a job through Stockton contacts.

As the Punjabis saved money and got loans, they leased and later bought their own land. They continued their day jobs while managing their small farms on the side. Because the Alien Land Law prevented them from owning property, they often put the land title in the name of a trusted American friend or business associate. This worked well most of the time. Occasionally, the "Hindus" were unable to make good their debts due to reverses of fortune, but they were generally seen as trustworthy and hardworking.

OPPOSITE: Migratory laborers planting cantaloupes in the Imperial Valley, 1937. *Dorothea Lange, Library of Congress.*

The Alien Land Law forced Punjabi farmers to make verbal agreements with white businessmen to lease land and distribute their produce. They obtained loans with a promissory note and a handshake. Punjabis were among the first to begin working the land after large-scale irrigation of the Imperial Valley began in 1911. By 1919, they leased 32,380 acres of land there.[39]

Unfortunately, they sometimes became victims of unscrupulous cheats.

DRIVEN TO MURDER: THE STORY OF PAHKAR SINGH

An incident in the Imperial Valley in 1925 underscores the vulnerability of immigrants who trusted unscrupulous white men. It is a well-known tale in the area. South Asia scholar Karen Leonard researched and wrote about it in detail.[40]

Pahkar Singh arrived in Seattle, Washington, from his village in the Punjab via China in 1913. By 1917, he was working in the Imperial Valley.

He farmed lettuce, a lucrative crop, on leased land. Because of the demand for lettuce in 1925, his crop was estimated to be worth about $50,000, a great deal of money at the time. He spent about $14,000 in producing the crop. Two shipping agents with whom he had a verbal contract, Victor Sterling and John Hagar, refused to pay him anything, even as his bumper crop of lettuce was being packed and shipped. They could easily take advantage of him, because neither verbal nor written agreements with Asians would stand up in a court of law. After several attempts to get money from the agents so he could pay his workers and defray expenses, he went one last time, with his pistol. The frustrated farmer killed Sterling and Hagar and went off to kill a third man, William Thornburg, who Singh believed was their accomplice. Thornburg's pregnant wife convinced Singh not to kill her husband. Singh then gave himself up to the sheriff.

Leonard interviewed Mota Singh, Pahkar Singh's former partner. "Pahkar Singh was a smart man, he went to get a lawyer, he went to all the judges, he went to the district attorney. He told them all about it," Mota Singh said. "They all said, 'By law we can do nothing. It's up to you now.'"

When Pahkar Singh again asked Sterling for payment, Sterling refused, saying, "Go home. We won't give you anything. Even the horses belong to us....You have nothing here. All this lettuce here, this horse here, it's ours. Take your blanket and go." Mota Singh recalled Sterling as "some kind of a mean man."

The next day, Pahkar Singh returned, and Sterling again refused to pay, saying, according to Mota Singh, "No, I tell you. Go away you goddamn Hindu." So Pahkar Singh killed him and Hagar.

The ensuing trial dominated headlines in the local papers and was hotly discussed in the Imperial Valley. Despite prejudice in the valley against Asian workers, many people sympathized with Pahkar Singh. He had a good reputation, and it was clear that the men he murdered had cheated him. Asian farmers were not the only ones swindled by shippers and brokers. Even farmers who were citizens were cheated by unscrupulous agents. All small-time farmers were at a disadvantage under the consignment system, in which they could not set the price for their produce and had to absorb the losses if the market price changed by the time it was sold. Feelings ran high. Pahkar Singh had supporters among his Punjabi friends and some prominent members of the Anglo community.

Pahkar Singh was convicted of second-degree murder for killing Sterling. Then, at his lawyer's request, the venue was moved from the Imperial Valley to Riverside, where Singh was convicted of first-degree murder in the Hagar case and sentenced to life imprisonment. A successful appeal by his attorneys citing a prejudiced judge reduced it to second-degree murder with a ten-year sentence.

Pahkar Singh served fifteen years at San Quentin Prison and was released in 1940. He wanted to return to farming in the Imperial Valley but was advised to go elsewhere for his safety. Thornburg had become a successful grower there. So Pakhar Singh went to Arizona. Yuba City old-timer Mary Rai, who was born in Arizona, said that he stayed with her family when he first arrived there. She recalled a quiet man. He farmed in Arizona for a few years but returned to the Imperial Valley. Singh farmed there unsuccessfully, married a Hispanic woman with whom he had four sons and eventually settled in San Jose.

According to an account published by the Pacific Coast Khalsa Diwan Society, written by Nirmal S. Mann, Pahkar Singh visited India in 1970. While there, "He praised the modern California society as being fair, just and basically a meritocracy. He advised his grandnephews and grandnieces to migrate to California. He commented that in 1925 if he had killed two white men in India, England or Canada, he would surely be hanged, whereas a reasonable U.S. jury found him guilty of 2nd degree murder because they felt there was enough provocation and his action to some extent was justified."[41]

Pahkar Singh died in 1973. In the Imperial Valley, he is remembered as the successful farmer who was cheated, and the case is still debated.[42]

Generally, the Punjabis, including Pahkar Singh, forged strong ties of trust with local business and community leaders. Although the Pahkar Singh case was an anomaly, it highlights how the Alien Land Law pitted Asians against Anglos.

Lettuce harvest by migrant field hands in the Imperial Valley, 1937. *Dorothea Lange, Library of Congress.*

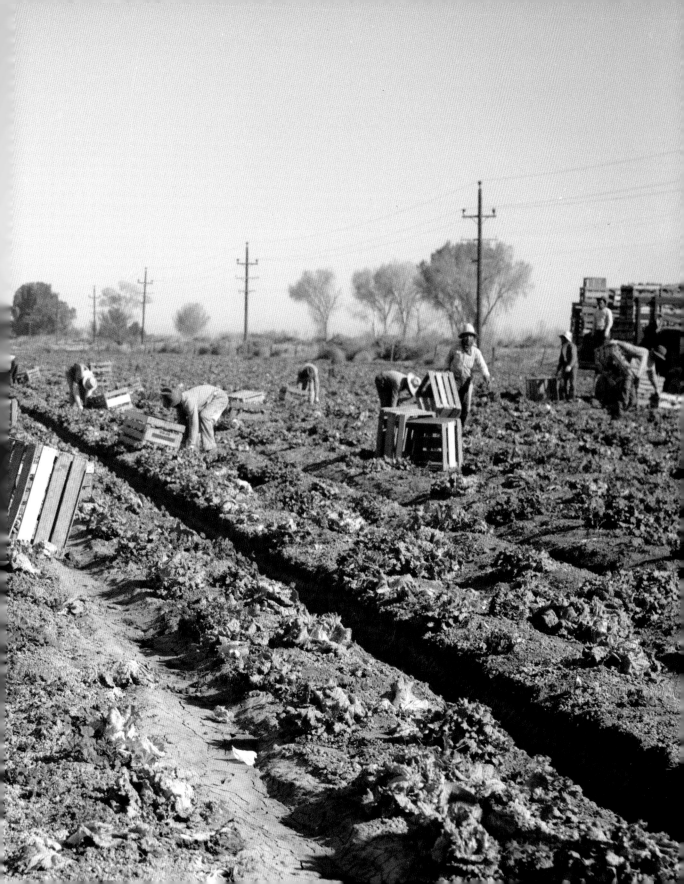

PERSEVERANCE DESPITE DISCRIMINATION

Even when things went well, the built-in hardships could be daunting. But Punjabis did not give up easily. They continued to work hard and invest their money in the land for the future of their families.

Punjabi men who married white American women or Mexican women eligible by law for citizenship might put the property in their wives' names. Later it could be put in their children's names. The children were citizens by birth. Marriage to white women or Mexicans wasn't easy. County clerks would look at a prospective bride and groom, and if the woman was fairer skinned than the man, a marriage license could be refused on the grounds of anti-miscegenation laws, which prohibited interracial marriage. Or it was denied just because of plain prejudice.

There are stories of couples traveling to another, more broadminded state to be married. One man even chartered a boat so he and his intended could be married at sea by the captain, out of the reach of the restrictions on land. But the 1907 Expatriation Act linked a woman's citizenship to that of her husband. Worse still, American-born women marrying Punjabis or other "aliens ineligible for citizenship" were stripped of their citizenship under the 1922 Cable Act.

Dalip Singh Saund's wife Marian's citizenship was rendered invalid when she married him. The law did not apply to men. The Cable Act was repealed in 1936, and it appears to have been unevenly enforced.[43]

FARMING THE IMPERIAL VALLEY TOOK GRIT

The Imperial Valley figures prominently in early Punjabi immigrant history in California because of the many migrants who passed through it and those who settled there. Those who stayed there formed a small but tenacious community.

The Punjabi immigrant farmers endured much harsher climatic conditions in this southernmost region than those who settled in Northern California. The Imperial Valley was a poorly watered desert where temperatures sometimes reached 120 degrees Fahrenheit in the summer. It relies on water diverted from the Colorado River.

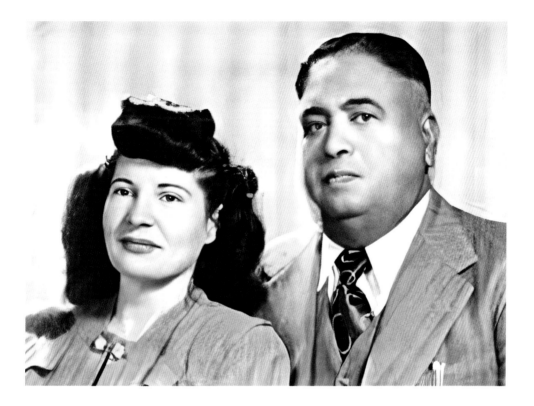

Community-minded Mota Singh and Consuelo Singh were respected among Imperial Valley farmers. *Public domain.*

Norma Saikhon, the daughter of Punjabi-Mexican couple Mota and Consuelo Singh, later married Hector Saikhon, son of early immigrant Purn Singh Saikhon. She said that babies were so vulnerable to the heat that someone would be detailed to fan them all day long so they would not die. Air conditioning did not exist. The first immigrants were lucky if they had basic conveniences in the barns or barracks they called shelter. Some had to sleep in the fields. Yet the immigrants still came.[44]

Norma inherited her father Mota Singh's sense of civic responsibility. Her father, after all, had defended fellow immigrants by filing court affidavits on their behalf and was involved in the local community. She became a lawyer involved in local politics and served for years as public administrator for Imperial County in El Centro.

THE CHELL FAMILY: SHANGHAIED IN SHANGHAI

The Imperial Valley Punjabi community was small but colorful. Bob Chell, son of Nand Singh Chell, related the engaging story of his father's trip to America to escape poverty in the Punjab. Nand Singh got enough money together to reach Shanghai, China, where he did "police work," as many of his countrymen did.

"While on the job he and another guard were shanghaied." Bob Chell quoted his father's account from memory: "'Our hands tied and sacks pulled over our heads. We were put into a small boat and rowed out into the bay and thrown overboard. We thought we were finished, only to find that we could stand in the shallow water and were able to walk out.'" After five years in China, Nand Singh and his younger brother Kunda left for the Philippines, where they boarded the SS *Minnesota*, arriving in Seattle in January 1913. They settled in the Imperial Valley in 1916. Nand Singh married Silveria.

Their son, Bob Chell, and his wife, Karmen, live in Holtville, where they continued working the farm Nand Singh started. Karmen told a story about how Nand Singh and Silveria married: "The men had a pact that if somebody in the community died, one of the bachelors would marry the widow so the children wouldn't suffer. My mother-in-law got very lucky because Nand never married.

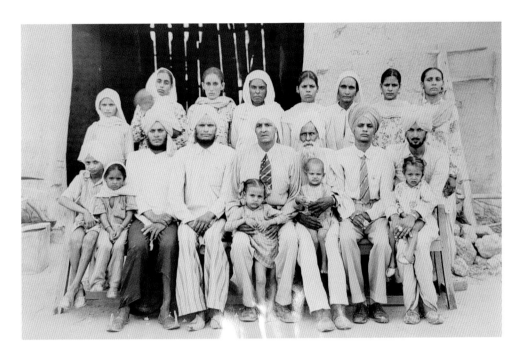

OPPOSITE, TOP: Nand Singh Chell was a generous man. *Courtesy of the Chell family*.

OPPOSITE, BOTTOM: Nand Singh with son Bob in the 1940s. *Courtesy of the Chell family*.

ABOVE: Nand Singh Chell on a 1955 visit to his home village in India. He helped them purchase land to build a school. *Courtesy of the Chell family*.

LEFT: Bob and Karmen Chell at a party in the early 1990s. *Courtesy of the Chell family*.

When he married her, she had six kids." Bob was their only child together. Nand Singh Chell died in 1968 at the age of eighty.

In 2005, Bob and Karmen visited Nand Singh's village, Bhiki, near Mansa in the Punjab. They were received like dignitaries. Nand Singh built a school there in the 1950s. According to Karmen, he brought $100,000 in the 1950s to help them buy land and build the school. Bob and Karmen Chell continue the philanthropy.

The Imperial Valley saw many border crossing tragedies. The front page of the *Holtville Tribune* on August 20, 1915, read: "Hindu Band May Be Lost on Sand; 2 of 54 Arrive." Most of a party of twenty Japanese, three Chinese and thirty-three "Hindus" who tried to cross the desert from San Felipe, Mexico, "with the intention of securing work in the south end of the Imperial Valley," disappeared and were believed to have perished, according to the account. The Mexico-California route was—and still is—a common one for illegal entrants to the United States. Then, as now, people were willing to risk everything to escape war and poverty and improve their lives.

CHAPTER 8

PUNJABI PIONEER FAMILIES OF NORTHERN CALIFORNIA

Puna Singh Chima harvesting celery in Yuba City, 1922. *Courtesy of PAHS.*

While a community of stalwart Punjabi immigrants stayed in the southernmost Imperial Valley, most gravitated north. These farmers fully appreciated the fertile land of California's Central Valley, bounded by the Coast range on the west and the Sierra Nevada mountains on the east. It was reminiscent of home.

The following stories are about a few of the first Punjabis to till the soil there. They worked hard and made good, and their descendants carry on their legacies.

"HAPPY" SAHOTA SOUGHT BRIGHTER PROSPECTS

Rattan Singh "Happy" Sahota made much of his long, dangerous trip from Central America on foot.[45]

Adventure marked his early life. He was born in 1899 into a farming family near the Punjabi city Jalandhar. When he was twenty-one years old, he was badly injured in an altercation at a village fair, where, according to Sahota, his opponent in a wrestling match attacked him with a sickle after losing the match. He bore the scar above his right eye all his life. Sahota bided his time and, a year later, challenged the man to another match. This time Sahota had a stick. He hit the man on the head a few times and left. The man later died. Sahota was tried for the crime but acquitted due to a lack of witnesses.

The incident spurred Sahota to leave India in 1921. He traveled to Sri Lanka, Yemen and eventually Germany, where he worked in a vineyard for six months. He didn't like Germany, so he moved on to France, where he found a small community of Punjabis. He remained two years, working at a foundry. When the foundry closed, he moved on to Central America. In Panama, where he worked on the docks for two years, he met Punjabis who told him about the great opportunities in the United States.

Sahota and six Punjabi companions set out for the United States in 1927. They walked along railroad tracks, slept in fields, lived off the land or begged meals from locals. It took them about thirty days to walk across Guatemala to Mexico. They were caught in Mexico and deported to Guatemala, where they were jailed. Sahota said he won their freedom when, during a Saturday night party at the jail, the jailor told him that if he could pin him down in a wrestling match, he could go free. Sahota bested the jailor in the fight without hurting him. The jailor apparently thought this feat earned more than one man's freedom, so he released Sahota and his companions. They went back to Mexico, covering six hundred miles in forty-five days, only to be deported again.

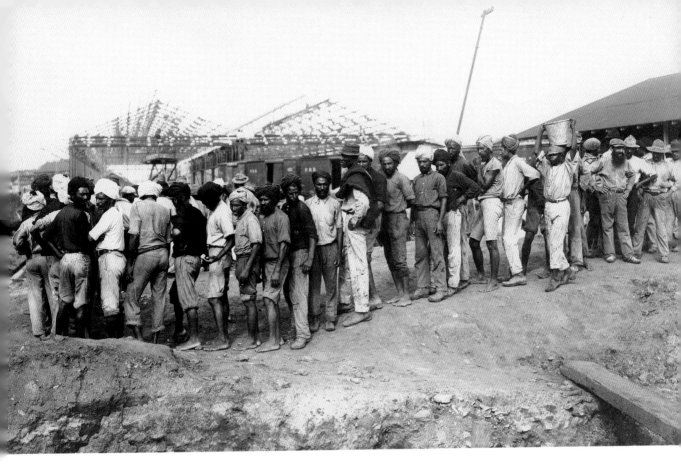

"Hindoo laborers" line up for wages in Panama, 1913. *Courtesy of University of Florida George A. Smathers Libraries.*

They worked odd jobs in Guatemala and returned to Mexico a third time. Six months of walking brought Sahota's group to Mexico City, where they caught a train to Mazatlán. Bandits accosted them, but they were broke. When the bandits heard their story and learned they hadn't eaten for days, they took the travelers in for a week, fed them, clothed them and sent them off with four pesos each. Once in Sonora, they met other Punjabis living there. Sahota and his friends stayed there for six months before continuing to America.

When they reached the California border, an American man, who claimed to be related to a border immigration officer, offered to take them to Stockton for $300. He put them in the trunk of his 1928 Ford for the nine-hour journey. It was uncomfortable, but they got to Stockton on November 28, 1928. They asked to be taken to the Stockton gurdwara, where they knew they would get a meal and other Punjabis would help them get settled.

Tuly Singh Johl takes a break from the orchards, 1962. *Courtesy of Tuly S. Johl family.*

They found work in the orchards for two dollars a day. In 1929, the group went to Yuba City, but two of Sahota's traveling companions were apprehended by U.S. immigration officers and deported to India.

Sahota worked for low wages throughout the Great Depression. Immigration authorities caught him in 1935, but he put up $1,000 bail and was released; with the help of a friendly bank manager, Sahota won his court case. He stayed and became a U.S. citizen. He married Dorothy Sexton in 1942, and they had two children, son Daljit and daughter Patsy.

Sahota purchased forty acres of land, a prune orchard, in Yuba City and added eighty acres a few years later, which he farmed. He was a successful and popular grower. His wife, Dorothy, tragically died in a fire, and he never remarried. His contribution as an upstanding citizen of Yuba City was acknowledged when Happy Park was named in his memory.

TULY SINGH JOHL AND FAMILY

"There are more Johls than Smiths in Yuba City," realtor Gordon Stromer, long-acquainted with Yuba City's Punjabi community, once said. The abundance of Johls came about partly through the persistence of another old-timer who left his mark on Yuba City, Thakar Singh, better known as Tuly Singh Johl.

"He was humble, hardworking, and honest. He would always stand up for the underdog. He never challenged anyone but was never afraid if someone challenged him. Everyone liked him. His friends said that he never let anyone down," his son Dr. Gulzar Johl wrote twenty-five years after Tuly's death at age 106.[46]

Like most of his compatriots who journeyed to North America to better their lives, Tuly Singh Johl had little education. He arrived from Canada in 1905 with several other Punjabi men, including distant relative Nand Singh Johl. Already thirty-three years old when he came to America, Tuly Singh had left a wife, Basant Kaur, and young son in India. He was born on a farm that grew wheat, corn, cotton and sugar cane. After leaving India, he first tried his luck in Canada, after hearing it was a land of opportunity, but jobs were hard to find. There he met a recruiter for American railway construction workers. He got work laying railroad tracks in the Feather River Canyon in Northern California.

According to Gulzar Johl, when Tuly worked on the railroad, "When he had a day off, on a Sunday, he would come to Yuba City."[47] One of the biggest ranches at that time was the Eager ranch. When he saw the vineyards, orchards and fields of rice he decided to find work on a farm. Farming was in his blood—and the railroad work in the mountainous Feather River Canyon was dangerous. Eager offered him a job. Tuly Singh wound up his work on the railroad, and he was made foreman at the Eager ranch. His ethics, his ability to inspire cooperation among the workers, settling disputes, and his physical stamina earned Tuly Singh the respect of fellow workers and the ranch owners.

At the beginning of World War I, Tuly Singh returned to India carrying revolutionary Ghadar movement material to distribute to Indian army soldiers. "My dad went in 1914 to fight for freedom in India, but he was taken and put in jail," son Kartar Singh Johl said.[48] His family paid a hefty bail to get him out. "He was imprisoned in our town. He was not allowed to leave the town at any time. If he wanted to go out, he had to get a permit from the police," according to Kartar Singh. After Tuly Singh's release on probation, he could live at home but had to report to the police frequently. Later he was given more freedom to travel within the area but was kept under surveillance

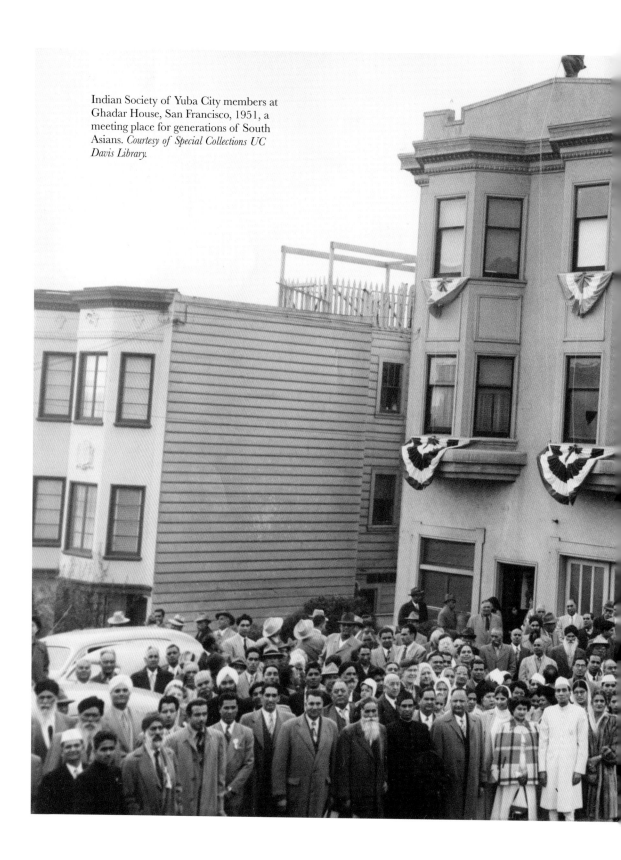

Indian Society of Yuba City members at Ghadar House, San Francisco, 1951, a meeting place for generations of South Asians. *Courtesy of Special Collections UC Davis Library.*

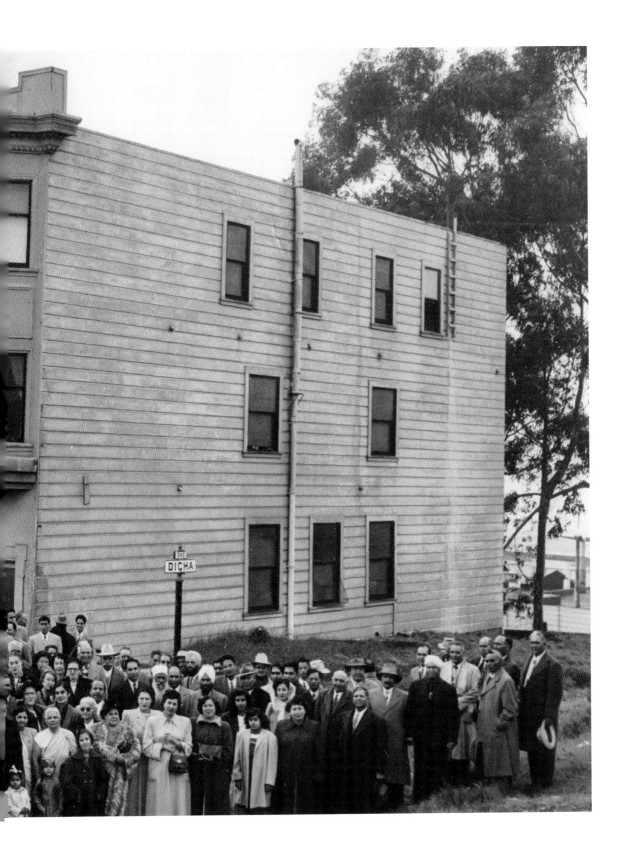

until the end of World War I. During that time, he worked on the family farm, and he and Basant Kaur had three more children.

In 1924, Tuly Singh returned to the United States. At that time, the laws had made legal entry almost impossible, so he went to Mexico. He and four other Punjabis and a Mexican guide came back to California. "They had to travel through the jungles at night," said Dr. Gulzar, but he made it.

Back on the Eager Ranch in Yuba City, he resumed his work as foreman. Bill Eager sold his ranch to Frank W. Poole. Tuly Singh and the crew continued in his employ. Both Eager and Poole treated the workers well. Tuly Singh remained foreman there until he retired in the 1960s. Gulzar said his father was a meticulous record-keeper. His logs of workers' names and hours worked proved useful to fellow Punjabis. "This record-keeping was the source for thirty-five to forty people proving U.S. residency and eventually getting citizenship of the U.S.A."

The interdependency and trust among the South Asian community is evident in the ways Tuly Singh and his partners bought land. One Yuba City Punjabi, Balwant Singh Sidhu, was an American citizen by virtue of his service in World War II. Tuly Singh helped Sidhu get his degree at UC Berkeley by employing him at the Poole ranch during his breaks. Balwant Singh Brar, who came to California in 1922 as a student, wrote of Sidhu, "He had registered with the draft board in Berkeley where he was inducted. He was the first alien East Indian in the entire United States to be drafted into the armed forces. Later in 1942 and 1943 many others were drafted."[49] Balwant Singh Sidhu was wounded and sent back home. He took advantage of the law allowing Asians who fought in World War II to become naturalized citizens; he was granted citizenship and could legally own land in California. Tuly Singh and his farming partners put their land in his name.

Gulzar Johl wrote, "In 1946, Indians were allowed to buy property, so the partners were going to divide the property. Tuly asked Balwant which property he wanted. As Balwant did not think the others would give him what he wanted, he hesitated to choose, but Tuly asked him to tell him anyway. Balwant told him that he wanted the place on Highway 99 (now Live Oak Boulevard), close to Yuba City. The next day at a meeting, one of the partners said, 'Let us give the student the place on Oswald Road.' Tuly Singh told him you can't give a thing if you don't own it. We don't own the property, he does. We should ask him if he wants to give us any or not, because he owns the property.' No one argued and Balwant got the land he wanted."

In 1948, when young Gulzar came to America himself, he was reunited with his father after twenty-four years. He came to study. He recounts a conversation with his father the day after he arrived: "He asked, 'What do you want to study?' 'Medicine,'

Gulzar Johl in 1948, the year he arrived in America. *Courtesy of Tuly S. Johl family.*

I said. He said, 'It's very hard and it's very expensive.' I said, 'What would you want me to study?' He laughed. He said, 'You want me to tell you what to study? I don't even know what the inside of the school looks like.' He told him that of the five or six Punjabis he knew who studied medicine at Yuba College, none of them finished. 'All I want you to do is, whatever you want to study, stay with it. Expenses, we'll manage it some way.'"

And so, they did. The value of education was clear to Tuly Singh. When his son Kartar Singh wrote from Khalsa College in Amritsar in 1936 complaining that he did not like it and wanted his father's permission to quit, he refused. He wrote his son that he wanted him to be educated so he could command more respect with his knowledge and improve not only his own lot but also that of the world. Kartar Singh continued at college and came to Yuba City the year before Gulzar, in 1947. His father met him in San Francisco, and they stayed overnight at the Ghadar ashram, at 436 Hill Street in San Francisco.[50] He enrolled in Yuba College, just as his brother Gulzar would later do. Kartar Singh studied agriculture and farm mechanics. "Later on my Dad bought us forty acres on Eager Road to take care of our expenses. He got his own property, but he gave it to us to work," Kartar Singh said. He and Gulzar had to farm the forty acres of prunes, peaches and almonds while attending college at the same time. Kartar Singh said he wore his turban when he received his degree from Yuba College.

Dr. Gulzar Johl recalled how hard Punjabis worked in the old days. They wanted their children to go to school. "Because of being hard workers, they could always find work. Everybody wanted them." In those early days, he said, there were not that many Punjabis, and they got along well. "Every month we had parties, with everyone there. As more people started coming after 1963, [with] different ideas, different ideologies, different personalities, then the problems started. In those days nobody tried to be a millionaire, nobody thought about being a millionaire."

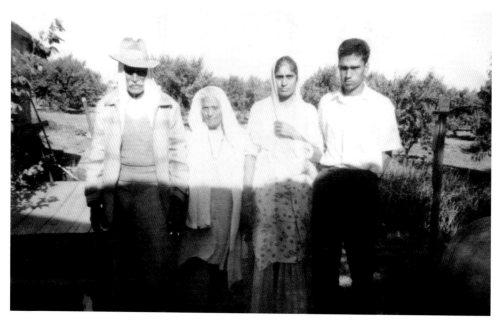

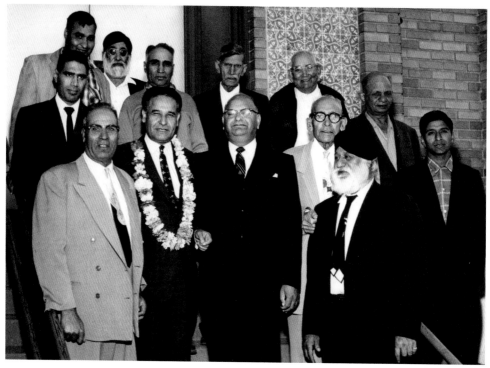

OPPOSITE, TOP: Tuly S. Johl with his family on the farm, 1958. *Courtesy of Tuly S. Johl family.*

OPPOSITE, BOTTOM: Local dignitaries with a garlanded Dalip S. Saund, Tuly Johl in the back row, at the Stockton gurdwara. *Courtesy of Tuly S. Johl family.*

ABOVE: Dr. Gulzar Johl in his ophthalmology clinic in 1961. *Courtesy of Tuly S. Johl family.*

Gulzar's elder brother Kartar also remarked on how times had changed. He said people didn't have as much, but they were happy. "We are only told three things…just remember God. Work hard for a living. If you have got something, give to others," he said, regretting that there are so many disputes now. The dreams of Tuly Singh Johl and his fellow pioneers were realized in the succeeding generations. "Now I think there are seventeen doctors in my family," Kartar Singh twinkled.

Into his nineties, Kartar Singh still drove a car, grew vegetables on his farm on Onstadt Road and socialized with friends. He passed away in 2013 a few days short of his ninety-seventh birthday. Dr. Gulzar Johl became an ophthalmologist, the first Asian Indian doctor in Yuba City. Now retired, he saw patients into his eighties at the

same clinic on Live Oak Boulevard he opened in 1961. Tuly Singh Johl had three sons and one daughter. His eldest son died early. He had nineteen grandchildren, fifty-three great-grandchildren and more than thirty great-great-grandchildren. The Johls, from Tuly Singh's immediate family and more distant relations from his village, number in the hundreds in the Yuba City–Marysville area.

Tuly Singh Johl died at the age of 106 in 1978 and is fondly remembered. Tuly Road in Yuba City was named after him. Much of the property along which it runs is Johl land.

NAND SINGH JOHL

Among Tuly Singh Johl's traveling companions who arrived in Yuba City in 1906 was Nand Singh Johl. When he left his village near Jalandhar in the Punjab, he also left his wife and his two-year-old son, Harbhajan Singh. Nand Singh worked for valley ranchers until 1922, when he started his own farm. He was a rice farmer who helped to bring the crop to California's Sacramento Valley.

Nand Singh was also active in the community. He was among the group of Sikh farmers who hosted Sikh congregational prayers before the first Sikh temple was started in 1912. According to the account of scholar Onkar Bindra, Nand Singh held the first Sikh congregational prayer at his camp near Stockton. Once the Stockton gurdwara was built, a 1915 article in the *Stockton Record* notes that Nand Singh Johl presided over the temple's dedication ceremony. He was chairman of the temple committee. In the speech he gave, he cited similarities between Sikh and American values. He explained the importance of the gurdwara's free communal kitchen in these words: "We do not permit our people to become charges on public charity. If a man is hungry and out of funds, we feed him....The unfortunate hungry American will be as welcome as our own people." At a time when immigration agents would refuse entry to Punjabis on the pretext that they were "likely to become a public charge," Nand Singh's words carried particular significance.

After 1946, as soon as Punjabi Americans could purchase land in their own names, Nand Singh did so. He continued to purchase farmland over the next decade. His son, Harbhajan Singh Johl, came to America in 1955 to help his father work the farm. Nand Singh wanted to return to India to see his wife and family, and he planned to do so after Harbhajan came to America. But before he could realize that dream, he died, in 1956. Today his descendants farm more than one thousand acres in and around Yuba City.

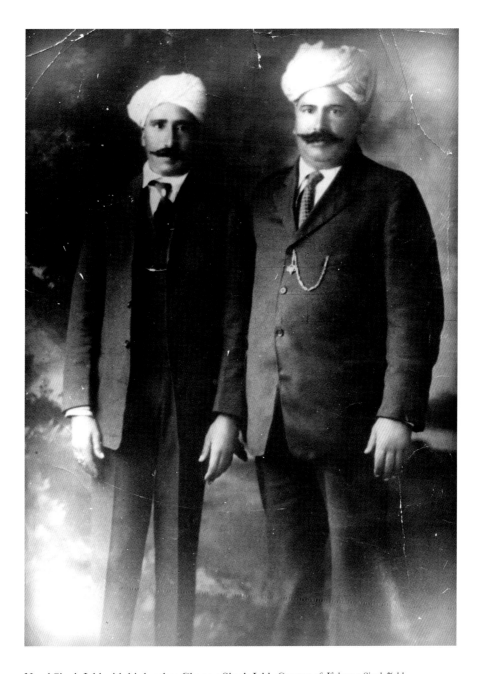

Nand Singh Johl with his brother Chanan Singh Johl. *Courtesy of Kulwant Singh Johl.*

BACHAN SINGH TEJA

Bachan Singh Teja was another pioneer who built a good life in America from nothing. "We are not sure when he was born, but he was born in Shimli, in Hoshiarpur in India," his son Dave Teja recalled.[51] "My father always said that he was born in December 1903, but that's incorrect. He was probably born around 1898. He was about ninety-three when he died."

Bachan Singh shipped out on the SS *City of Benares*, arriving at New York's Ellis Island in 1921. "He was pretty well educated in India, he even could read Sanskrit. He and one of his cousins in his home village corresponded in the Urdu script all their lives." He headed for California because he had three older relatives who worked at the Penryn food company north of Sacramento. "The relatives got him a job at the Penryn Food Company. The first thing he did was go to a school in Berkeley to lose his British accent," Dave Teja said. "He removed his Kara [stainless steel bracelet worn by Sikhs], he got his hair cut and he shaved. He wanted to be an American in the worst way. He actually lost his British accent."

Bachan Singh focused on his education during the next ten years, enrolled in the pre-med program at the University of Minnesota until he contracted a bronchial ailment. He finished his senior year at the University of Arkansas. "He met mother and married in 1931." Teja's mother, Delle, was born in Gilbert, Louisiana. Her ancestors fought in the War of 1812. "She had a job as a schoolteacher in a one-room school. The school closed, it was the Depression, and he became a farm laborer." Bachan Singh went back to Penryn and worked with his three uncles. Two eventually returned to India. "I remember seeing them off in San Francisco, all the streamers thrown to the people on the dock. The third died in 1944 in Sutter County."

When Bachan Singh and his wife returned to California, they lived in a house on Penryn Food Company land. His mother learned Indian cooking at the Penryn Indian camp. "I was born in 1934 in Auburn. In 1939, they bought ten acres in the Tierra Buena district, which is now part of Yuba City but it was its own rural community then. We moved there when I was six years old," Teja said, recalling how it was to be a "Tierra Buena boy." He remembers a "mixed community—East Indians, Indo-Mexicans, gold dust refugees like my parents really were and families all mixed up.…I had this large group of interracial friends. We went to school together, we played together, we even worked together." Bachan Singh farmed about twenty acres of peach and prune orchards, and his children grew up to have their own careers.

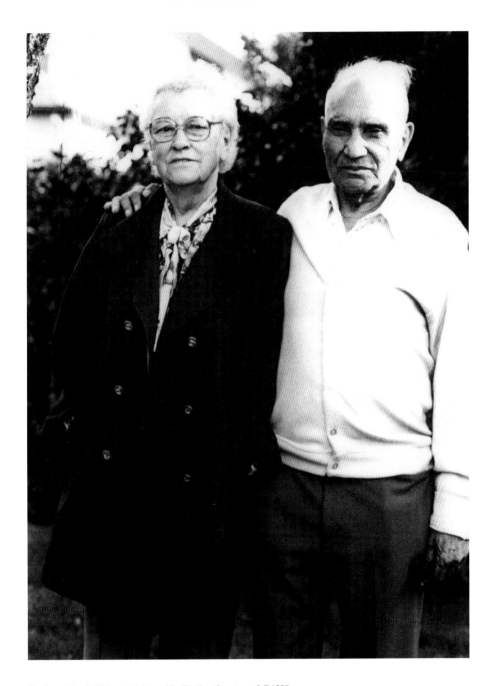

Bachan Singh Teja with his wife, Delle. *Courtesy of PAHS.*

DAVE TEJA, NOTED LAWYER

Dave Teja grew up in Yuba City. After studying at the University of California, Davis, and Sacramento State University, he became a Marysville police officer. He then pursued a law degree at the University of San Francisco law school. He opened his Yuba City practice in 1961. While still a law student, he married Billie Ann Ray. As a young Sutter County district attorney in the 1970s, he prosecuted serial killer Juan Corona in one of the most famous murder trials in California history. Corona was charged with murdering twenty-five men and burying them on Yuba City ranch land. In January 1973, Corona was convicted on twenty-five counts of murder and sentenced to twenty-five consecutive life sentences without possibility of parole. The conviction made Teja's name as a lawyer. Teja served as judge in the Sutter County municipal court from 1976 to 1978 and was a faculty member at California State University, Sacramento. He died in 2010.

Before he became a lawyer, Dave Teja was a police officer. *Courtesy of PAHS*.

THE POONIAN AND BAINS FAMILIES

Dhana Singh Poonian first came to California in 1906. He held various jobs before settling down in Loomis in 1911, where he started the Poonian Nursery. He was one of the few early immigrants who brought an Indian wife to America. In 1923, Dhana Singh returned to India, where he married his brother's widow, Raj Kaur. This is a common Punjabi custom meant to protect the widow and avoid difficulties over property. Raj Kaur already had two sons, Paritem Singh and Dalip Singh. Dhana Singh Poonian brought them all back to California. Paritem eventually joined the family agricultural business.

Paritem married Janie Singh, the daughter of Diwan Singh, who developed Arizona desert land, Casagrande, into a productive farmland. Paritam and Janie's daughter

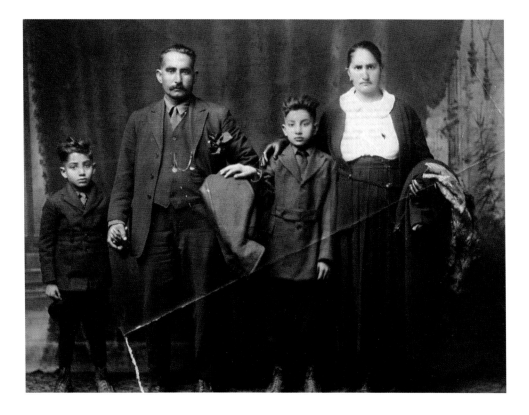

The Dhana Singh Poonian family (*left to right*): Paritem Singh, Dhana Singh, Dalip Singh and Raj Kaur, circa 1927. *Courtesy of UC Davis Library Special Collections.*

Santi married Didar Singh Bains, who established a successful land development and agriculture business in Yuba City.

Branches of the Bains family have been in the Central Valley for generations. An early Bains arrival, Jawala Singh Bains, first came to Canada in 1907 on the steamer *Monteagle*. He did not work his way to California until his second trip to North America in 1923. In 1930, he arrived in Yuba City, worked hard and saved money. He bought sixteen acres of land there, where he grew peaches. He became an American citizen in 1964 and then sponsored family members to come from India. His wife, Jai Kaur, raised his daughter, Mohan, and three sons, Sukhdev, Davinder and Baldev, in his absence. They all eventually immigrated to the United States, Mohan after her marriage to Mohinder Singh Thiara. Many Yuba City Thiaras descend from Mohan and Mohinder Singh. Jawala Singh had no formal education, but he achieved his

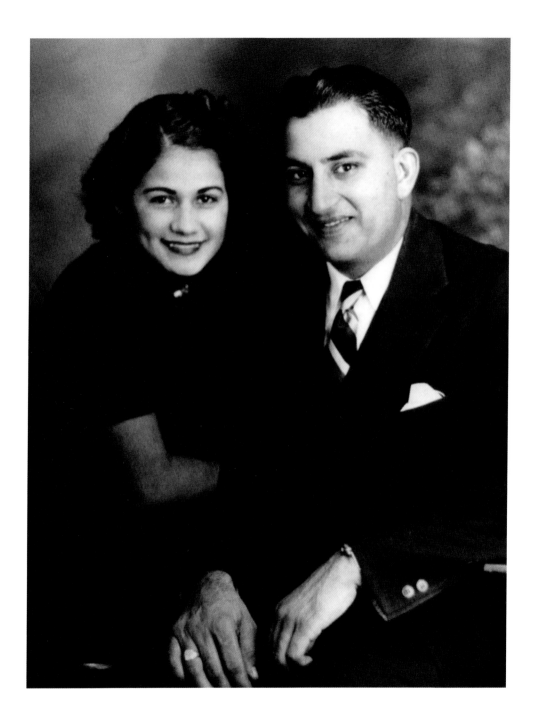

Jawala Singh Bains with the family of his son Kartar Singh in India (circa 1966)
L to R: Davinder Singh, Mohan Kaur and her husband Mohinder Singh Thiara, Jawala Singh, Baldev Singh (standing), Sukhdev Singh and his wife Surinder Kaur (standing), Kartar's wife Joginder Kaur, and Sarbjit Singh Thiara (in lap)

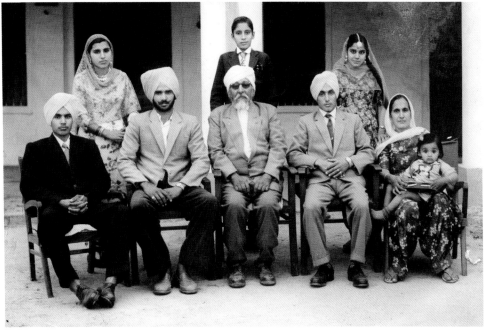

OPPOSITE: Janie Singh Diwan and Paritem Singh Poonian after their wedding, 1939. *Courtesy of the Bains family.*

ABOVE: Jawala Singh Bains family in India, circa 1966. Jawala Singh is seated, center. *Courtesy of the Bains family.*

American dream. He died in India at the age of ninety-two. His family recalled, "His favorite scripture in his bedroom read: There is only one God and love is God."

Didar Singh Bains, who became the largest peach grower in California in the 1990s, descended from another Bains who, like Jawala Singh, came from the same region of the Punjab. "My great-grandfather, my father told me, came in 1890," Didar Bains said. His great-uncle, Kartar "Ram" Bains, arrived in America in 1920. He came via Mexico after being denied entry in San Francisco. Like others, he worked in Imperial Valley orchards before working his way up north. He eventually purchased land near Yuba City, where he planted orchards.

He helped his nephew Gurpal Singh, Didar's father, come over from India. As Kartar Singh remained unmarried without children, he left his land to Gurpal Singh when he

died in 1979. "My father came in '48. I came in '58. I was very young," Bains said.[52] Didar's mother arrived in 1962 to help the family peach business grow. She and her husband, Gurpal, were active in the community.

Didar Singh Bains was eighteen years old when he came from Nangal Khurd village in the Punjab's Hoshiarpur district. "We came here empty-handed," he said. "We worked really hard, borrowed, struggled, took risks our whole lives. God is always good to us." Besides peaches, Bains also grows prunes, grapes, almonds and walnuts, an operation that included canneries and packing houses.

Along with building his business, Didar also began a family when he married Paritam and Janie Poonian's daughter Santi on June 21, 1964.

Santi and Didar have three children—Ajit, Diljit and Karmjit—all of whom have played roles in the family business, carrying on the tradition to a new generation.

TOP: Meher Singh Tumber, farmer and founding member of the Tierra Buena gurdwara, and Gurpal S. Bains. *Courtesy of the Bains family.*

BOTTOM: A young Didar Singh and Jaswant Singh Bains. *Courtesy of the Bains family.*

OPPOSITE: Cake-cutting at the wedding of Didar Singh Bains and Santi Poonian, 1964. *Courtesy of the Bains family.*

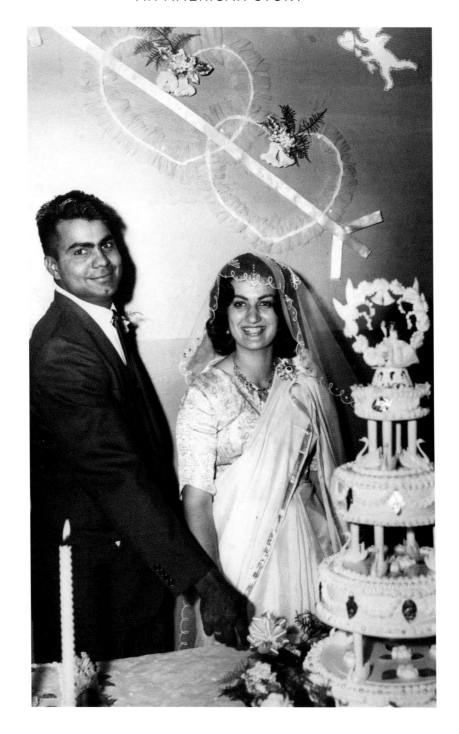

OPPOSITE: Didar S. Bains, second from left, at Nagar Kirtan, the Sikh Parade. *Courtesy of the Bains family.*

ABOVE: The Sikh Parade in front of the Tierra Buena temple. *Courtesy of PAHS.*

In recent years, Bains—still a large landowner—downsized his farming operations by selling land for commercial and residential development. One of the notable conversions of his farmland to commercial use is the site of the Yuba City Sam's Club and Walmart. This deal with Bains in 1992 was the last Sam Walton signed before his death.

Bains's success allowed him to not only expand operations in California but also begin farms in Washington State and British Columbia, Canada, to grow cranberries, raspberries, blueberries and black currants.

Always active in the community, Bains helped establish the annual Sikh parade in 1979, which draws Sikhs from all over the country. The event, which honors the Sikh holy scripture, the Guru Granth Sahib, takes place every November. During the

OPPOSITE: The Tierra Buena gurdwara. *Courtesy of PAHS, photo by Laura Schwoebel.*

ABOVE: Didar Singh and Santi Bains. *Courtesy of the Bains family.*

Jaswant Bains. *Courtesy of the Bains family.*

celebration, Sikh hymns, or kirtan, are sung, and all are welcome, regardless of faith. In addition to parade floats, free food stalls ensure that all are well fed with Punjabi snacks.

Bains also helped found and continues to support the Yuba City gurdwara on Tierra Buena Road. The gurdwara was built in 1969 and was the first in Yuba City, giving Sikhs a formal place of worship locally and making the trip to Stockton unnecessary.

Through his life, helping others has been a priority to Didar Bains. He remembers how hard it was to start from nothing, and in gratitude for his own good fortune, he gives back. He has brought family and other immigrants to Yuba City, helping them find homes, jobs and educational opportunities so they could be self-sufficient. Besides generous donations of land and funds to build gurdwaras, he donates to other Sikh causes. He donated money for a wing of the old Freemont Hospital in Yuba City and raised funds for the new Rideout Regional Medical Center Tower.

Didar Bains believes in political action. He donates to candidates he supports. "Punjabi people should be more involved in politics, I don't care what party, some are Democrats, some Republicans. It doesn't matter." Engaging in the system is the way to success, he says. He greatly appreciates American democracy and compares the ideals enshrined in the U.S. Constitution with those of Guru Nanak, a sentiment echoed by many Sikh immigrants. Bains is proud of what the Punjabi Americans have accomplished: "People have known us for over a hundred years. People know what our traditions are and what our religion is, so they are very familiar with us now. We are part of the community here. We are part of the economy here in California. We have people all the way to Los Angeles," adding that better education has put the younger generation at all levels of business, academia and public office.

Didar's brother Jaswant Singh Bains, also a successful businessman, arrived in America in 1962 at the age of fourteen. "When I came I only knew the alphabet," Jaswant said, but he enrolled in Yuba High School and Yuba College, mastering English as he went.[53] He went on to earn bachelor's and master's degrees in business economics from Sacramento State University. He joined the family farming business and was partner with Gordon Stromer in Stromer Realty for many years. "It's the

fulfillment of the American dream," he said, adding that America gives people who work hard the chance to become successful and even grow rich. "Americans are less discriminatory than in India—we discriminate against our own," he said. His brother Dilbagh and five sisters ultimately settled in America.

THE THIARA FAMILY

The Thiaras are a Punjabi pioneer farming family descended from Hukam Singh Thiara, Bhaghat Singh Thiara and other Thiaras who immigrated over the decades. Bhagat Singh and Hukum Singh came to America in 1906 with ten others from their home village Dhakowal, in Hoshiarpur. Gurdev Singh Thiara described a hard journey. They cut sugar cane in Cuba. They tried a few times to cross the Mexican border but were sent back before they finally succeeded. Once here they worked hard, saved money to buy land and farmed.[54] Bhagat Singh attended Yuba College in 1935 and graduated from Heald Engineering College, San Francisco, in 1944.[55]

An early arrival, Bhagat Singh Thiara came to America with ten others from the Punjab in 1906. *Courtesy of PAHS.*

A report from a Canadian Sikh who traveled to California in the 1950s noted that Bhagat Singh was president of the Stockton gurdwara.[56] "Our Stockton temple is the most progressive and beautiful temple on the North American continent. After visiting the temple, I learned that our esteemed president, Bhagat Singh Thiara, and his two capable assistants, Gurdip Singh, secretary, and Lal Singh Rai, treasurer, were driving 110 miles from Marysville to meet me and take me back up there with them. There arc a very few Sikhs in Stockton proper and most of our people live in the Marysville area," the visitor wrote.

Successive generations of Thiara sons and nephews immigrated seeking new prospects as the immigration quota system allowed. Harsev "J.R." Thiara recounted how his great-uncle Munsha Singh Thiara arrived in Canada in 1906 and slept under trees because workers were not allowed to sleep in the barns. J.R.'s father, Harsev "Horsey" Thiara, came from India in 1953. J.R. grew up in Live Oak helping his family farm peaches, walnuts and other crops. His interest in alternative medicine led him to co-found HempGuru, LLC, which makes a variety of hemp-based products.

Gurdev Singh Thiara came to America when he was twenty years old. His father was Lachman Singh Thiara. He said most of the Thiaras worked for Richard Wilbur in the early days and learned about orchards from the Wilbur family. By 1964, when he had been here four years, Gurdev had saved up enough money to buy his first piece of land in partnership with his brother. Gurdev Thiara now owns part of the old Wilbur Ranch. At first, the Thiaras' small farm wasn't enough to support them, so they continued working for other ranchers. Gurdev did go back to India, where he married; not long after, he returned with his wife. He became an American citizen

OPPOSITE: Baldev, wife of Bhagat Singh Thiara, as a young woman. *Courtesy of PAHS.*

LEFT: Gurdev Singh Thiara. *Courtesy of PAHS.*

BELOW: Gurdev S. Thiara family. *Courtesy of PAHS.*

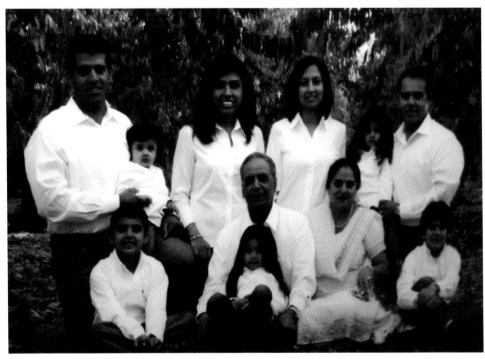

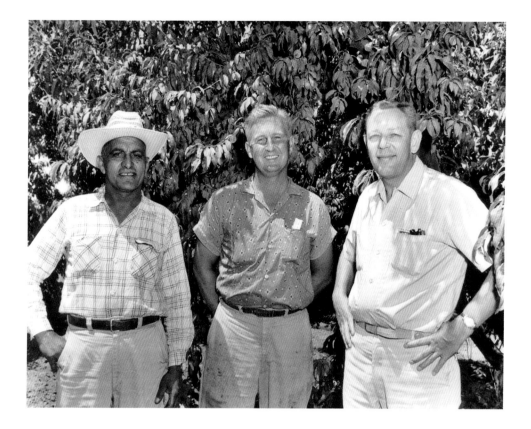

ABOVE: Richard Wilbur was among the first farmers to employ Punjabi laborers. (*Left to right*) Bawa Singh, George Johnson and Wilbur at the Wilbur Ranch. *Courtesy of the Wilbur family.*

OPPOSITE: Gary Thiara and his wife, Navneet, who helps run the family business. *Courtesy of Gary Thiara.*

that same year, 1966. Since then, he built a successful agricultural business, owning and cultivating thousands of acres in California's Central Valley, from Chico to Bakersfield.

The Thiaras acquired land in Yuba City, Merced, Willow and Tulare. They grew peaches and plums (prunes), later adding almonds. They started to dry their own prunes. But Gurdev says they, too, have downsized. "Peaches take a lot of labor. It's a hard job. The pay scale is not too high," because of competition from foreign countries such as Chile, Argentina and China, Gurdev said. But times have changed, he said. "It's not easy to find a small farm at a reasonable price, and equipment is very expensive."

Gary Thiara, born in the United States, is part of the fourth generation since the first Thiaras arrived in the early twentieth century. "When my grandfather called my father over the intention was, you're going to work here for some time, until you make some money and then you will come home, which was what everyone had been doing in the past."[57] But his father, Gurdev Thiara, liked it in America. "Our forefathers were farmers. We don't mind the hard work. We like it here," Gurdev Thiara said, adding Yuba City is a nice town where everyone knows one another.

"When you go back and look at the first wave of anybody, whether it's Italian, the Irish, whoever, the first wave of people that came over were generally hardworking, pioneering, just kept their heads down and worked hard," Gary Thiara said. Even in his own life he has seen the community become more mainstream. "I would have to say that we are very, very assimilated," and the younger generation is even more so.

Gary is a successful businessman, a partner in the family farming business. He was Yuba City–based Sunsweet Growers Inc. Cooperative's chairman of the board for seventeen years and remains on its board of directors. "For me personally it has been very exciting to be part of all that," he said. Sunsweet is among the largest processers of dried fruit in the world.

Seeing a need for a community bank, Gary Thiara, who worked in banking for several years after earning his degree in economics and an MBA, joined with eleven other local investors in 2006 to start River Valley Community Bank. "It's a $60 million bank and growing pretty fast," he said, adding, "We started out, like everybody else, with just a little bit of capital, and now we're a pretty good size community bank so

that's exciting," he said. The focus is on serving the business community. Investors represent every segment of local business: "People from retail, from car dealers to agriculture and manufacturing," Thiara said.

In 2011, Thiara started Empire Nut Company, which operates a huller and dryer and sells walnuts grown on the family farm. His wife, Navneet, is business manager at the company. A pioneer in his own way, Gary Thiara demonstrates the entrepreneurial acumen and work ethic that buoyed his forebears.

PUNA SINGH AND NAND KAUR

Among the few couples who migrated from India together in the early years were Puna Singh and Nand Kaur. They were at the center of the Yuba City farming community, where they lived for many decades. Puna Singh joined a Sikh regiment in the Indian army when only sixteen. He liked the military life, but after two years he was ready for something else. When he returned to his village in the Punjab, he heard about opportunities in North America. Two men from his village had gone to Canada. Since his parents were dead and his uncles and brothers managed the family farm, he tried his luck in foreign lands. His family gave him money for passage, and he embarked from Calcutta to Hong Kong. He said in a published narrative, "The ship set sail for Hong Kong with three hundred Punjabis of varying ages and backgrounds on board. Of the four other men from my village, I was the youngest. My fellow travelers were congenial, and I felt at home during the long voyage."[58] They traveled to Vancouver, Canada, from Hong Kong. "A group of us took jobs at a lumber mill where the foreman and many of the employees were Punjabis," he said. Puna Singh said they felt more at home in a strange land because of the Sikh families who had settled there. But when he and his friends heard they could enter the United States, they did so in 1906. "Since our mill had been understaffed and we had been overworked for many weeks, we seized the opportunity to make a change," he said.

"On arriving in the Sacramento Valley, one could not help but be reminded of the Punjab. Fertile fields stretched across the flat valley to the foothills lying far in the distance," Puna Singh recalled. There he found many Punjabis doing farm labor, and he did the same for several years. In 1910, he was hired by the Southern Pacific Railway Company to do construction work, along with about twenty other Punjabis. When he got to Salt Lake City he stayed, working for a sugar beet company. He and a partner bought some land and started growing sugar beets. "It was good to be a landholder again," he

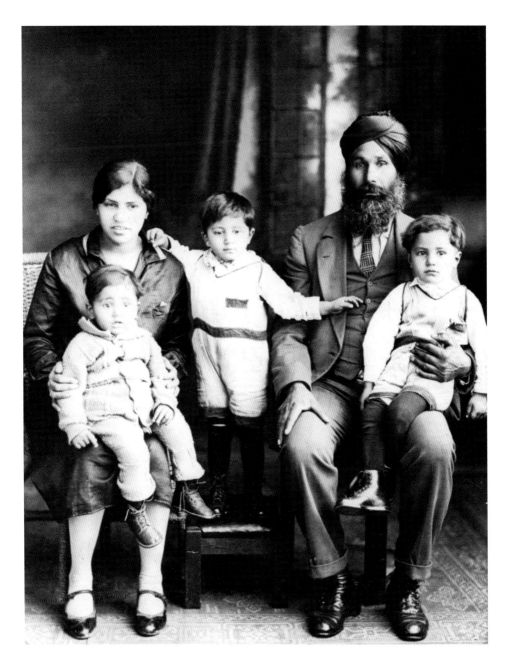

Nand Kaur and Puna Singh with their three eldest children—Kirpal, Pal and Mahinder—1928.
Courtesy of the Puna Singh and Nand Kaur family.

said. "During those early years in California and Utah, the Punjabi community was small but close knit. Not only did groups of Punjabis work together but there was also a tendency to congregate whenever there were holidays, whether Indian or American," he said. Another meeting point in those early days was the Ghadar Party. Puna Singh said he was "immediately drawn to the organization" and became a supporter. He said, "There was generally a feeling of kinship among Indians living here at the time; people were generous with their time, money and labor."

He said many Punjabis came to America, worked for a while and returned to India. He began wanting to return, too, but only for a visit. "Both my partner and I were happy with our farming enterprise," he said, adding that he only wanted to see his family, "perhaps marry, and return to Utah." There were serious obstacles to bringing a wife back unless he was a legal resident. A sympathetic doctor in Ogden helped him complete the application and push it through. "While I was somewhat hopeful, my friends were completely skeptical." They didn't think a bearded, turbaned Sikh would easily obtain citizenship. "Three weeks later we were all surprised when I was granted my citizenship papers," he said.

The next year, he went to India and married. But while he was there, the Bhagat Singh Thind decision was handed down. Puna Singh received a letter from a friend telling him that all Indians' citizenship had been revoked in October 1922. He knew that could make bringing his wife difficult, but "we decided to take a chance and left India in August 1923."

He and his new bride, Nand Kaur, went to Vancouver and entered the United States through Seattle without difficulty. Puna Singh took Nand Kaur to Utah and resumed farming, but she developed a severe sensitivity to the snow. She went snow blind. "She regained her eyesight after one month, but her doctors warned me that living in a snowbound climate would continue to be a danger to her vision." So in November 1924, the couple and their new son left Utah for Yuba City, California. "I had left a farm of my own and now I was working for others. It was a struggle in the beginning and continued to be one until 1929 when I was able to purchase land again," he said. Puna Singh purchased a dairy and farm on Township Road. Despite the Great Depression, the dairy farm was an "enterprise that allowed us to settle down comfortably and make a permanent home." They brought their seven children up to know Punjabi and Sikh culture, but Nand Kaur adapted to American customs. She was friendly and helpful to newcomers, according to those who knew her, and got along well with everyone, Anglo, Hispanic and Punjabi alike. Their daughter Jane Singh, who obtained her doctorate at UC Berkeley and lectures in ethnic studies there, has done significant work in researching and documenting the history of South Asian immigrants in North America.

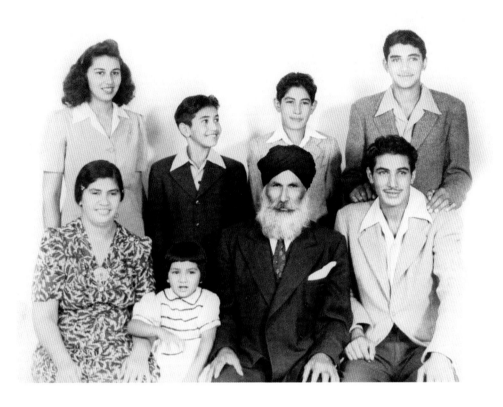

Nand Kaur and Puna Singh with their family, circa 1946. *Courtesy of the Puna Singh and Nand Kaur family.*

There were only about five couples farming in California where husband and wife were both from India, and it could be an isolating experience for the women, who had left all familiar family ties behind. They had to form new "families" among the people who were here or remain unhappy. According to her daughter Kartar, Rattan Kaur Dhillon never got over her feeling of being exiled in a strange land. In her essay "A Parrot's Beak," Kartar Dhillon wrote that her father had the company of other men, friends and workers on the job. "My mother had no one, no other Indian women to keep her company, no sisters or relatives to give her a hand."[59]

THE MUSLIM COMMUNITY

Fateh Jang and Bob Mohammed

There were fewer Muslims than Sikhs who came to the United States around the turn of the twentieth century, but those who did thrived in the agricultural areas of Northern and Southern California. Robert "Bob" Mohammed had a wealth of stories about his father, Fateh Jang Mohammed, who came to America at the age of eighteen in 1907. He was from Mundh village, about 150 miles from Lahore. "He left there with a couple of buddies, and how they got to China I don't know, but before they came here they stopped in Shanghai. They were there for a while," he said. "What happened in those days, the steamship line needed a crew on the ship, and they told whoever was interested where their ship was going and that's where their employment would end." His father and his friends worked their way across the ocean to Vancouver, Canada. But they wanted to come to the United States, so they crossed the border and got jobs in Aberdeen, Washington, with the Bay City Lumber Company.[60]

"The Bay City Lumber Company had housing for people who wanted it, single individuals. I don't know how many in the group, but six or seven of the guys had come from India. And they worked there for Bay City Lumber and lived in the house for several months. And one night they got off shift and went back to the house, and…no house. It had been burned down." Bob Mohammed said they were targets of hostility because the locals thought that migrants took jobs away from them. "This was a way of telling them to go back home. They couldn't speak English, they had no friends, the only friend they had was the British Raj, so they went to the British Raj and told them what happened and there was nothing they could do about it."

The house burning was not an isolated incident: 1907 was the year of the so-called Bellingham Riots, when a group of several hundred white men attacked East Indian workers, throwing them out of their lodgings, stealing their belongings and throwing the men in jail. It galvanized the organized anti-Asian groups in the Pacific Northwest, and there were subsequent incidents in Canada; Aberdeen and Everett, Washington; and farther south, in Oregon and California.

Fateh Jang and some friends left for California. "Dad worked on the railroad for a while," Bob said, before he started farming rice in Arboga, near Olivehurst. "He planted rice there, forty acres of rice in 1914. He kept growing rice and then went into the fruit business," leasing land in someone else's name because of the Alien Land

The Northern California Muslim Association, circa 1920. *Courtesy of the Karen Leonard Collection, Green Library, Stanford University.*

Law. "Most of the Singhs went into the fruit business," Bob said, while "most of the Muslims—there weren't too many of them—went into the rice business."

Fateh Jang married Mary, a German national and a Catholic. They settled into farming and had two children, Lillian and Bob. Bob recalls a happy childhood but remembers how the laws disadvantaged those of East Indian descent. "They had no rights. They had to prove to the community who they were, what they were. And the few that were here, my dad was one of them, I don't want to brag about him but he established himself very well in the community." People had trouble pronouncing his name, Bob said, so a banker at what was then the Bank of Italy told him, "'You know, I cannot pronounce your name. Is it alright if I call you Joe?' So everybody called him Joe. Fateh Joe Mohammed.

"He grew rice and then the Depression came, and he went broke," after which, Bob said, the family had to work for other farmers for a few years. "The Depression, it was hard living, but it was good for kids growing up. It showed you what a dollar was worth. A dollar was a fortune," Bob said, recalling he and his father both worked for the Wilburs. They would also follow the harvest. "We all went to a place up north near Red Bluff called Vina," Bob said. "Somehow my Dad knew one of the foremen of a four-hundred-acre nectarine ranch, the biggest nectarine ranch in the world in those days. And my dad knew one of the field foremen, so we got a job. It was a tent city. Everybody lived in a tent. They hired a lot of people. And you all cooked your own food. My sister got a job in a packing shed. And Dad and I and Mom, we picked nectarines. There was a women's crew. My Mom worked in the women's crew. There was a white man crew and there was a Hindu crew. My Dad and I worked in the Hindu crew. And everybody there in tent city got along real well; everybody was in the same predicament, wondering when things would get better. We lived there about two months in the nectarine season. My Mom and Dad and I worked for fifteen cents an hour, ten hours a day, a dollar and a half a day. My sister was in the big money business, she got twenty-five cents an hour. She worked eight hours."

Bob said his mother showed other ladies in the camp how to harden the dirt floor of the tent by sprinkling water. Then Fateh Jang got a job close to home, west of Yuba City. "There was plenty of work. I worked for people, picked peaches in the summertime," Bob said.

After the Depression, things looked up and Fateh Jang went back to rice planting, in Maxwell. "In 1935, he bought the home where I live now and he started farming rice on his own," Bob said. "Dad had about 1,400 acres one year. He was known as the rice king at one time," Bob said. Bob Mohammed served in the U.S. Army Air Corps and was in Cairo, Egypt, for a while, where he surprised the locals. Their response when they heard his name was, "'How is it that you have the name Mohammed, and you [are] in the military?' It was inconceivable to them." After World War II, Bob returned to help his father and then enrolled at the University of Pennsylvania's new South Asia area studies program. But he missed California, so he transferred to UC Berkeley. He returned to farming when his father became ill.

OPPOSITE, TOP: A grain harvester pulled by a twenty-mule team in Sutter County, 1902. *Courtesy of Sutter County Library.*

OPPOSITE, BOTTOM: Funeral of Marian Singh, Yuba City. Bob Mohammed is the boy at left, in checked shirt. *Courtesy of the Karen Leonard Collection, Green Library, Stanford University.*

Fateh Jang Mohammed and his family participated in the social life of the immigrant community. "They were a wonderful group of people. They all adjusted very well. There was a group near Willows, Kalu Khan and Johnny—they called him Johnny Mohammed. They were big rice growers, and they were well liked there. They even built their own rice dryers," Bob said. Most of the Muslims were rice growers. To relax they would go to one of the parks—Marysville, Gridley, Colusa. "In the summertime in the afternoon, not much to do, they'd go to the park and sit down and cool off. No air conditioning in those days. And somebody would be able to read a paper, and they'd get the paper and read the paper to everybody and then they would discuss independence, independence from Britain. That was the big thing. They loved politics." Or to socialize, they would "go visit somebody, smoke the hookah. My Dad smoked the hookah all the time." Bob changed the water in his father's pipe and tended the coals in the chillum, the bowl where tobacco was put. There was great hospitality when visitors arrived: "Someone came, someone killed a chicken." His mother learned to cook curry. "She could make good paranthas [a typical South Asian flatbread]," he said.

Bob Mohammed's father took him to hear a "firebrand" Indian political speaker in San Francisco once. When Jawaharlal Nehru's sister, Vijaya Laxmi Pundit, came to America in 1947, Fateh Mohammed was invited to a banquet held in her honor. Although South Asian politics "was the topic of the day," Bob said, "It's unbelievable how they adored, how much respect they had for the United States."

Important Muslim customs were observed in the Yuba City community. Few of the farmers had telephones then, so "whenever one of the old timers died," Bob said, "some guy would go round in a car and tell all the fellows that *janaaza* (funeral prayer service) was on such and such a day. There was no mosque in those days so they would rent a building in Sacramento to hold the prayers and things." Bob recalls going with his father to the Sikh temple in Stockton one time, for a funeral. Mary Mohammed was a devout Catholic, but being a Muslim was part of the Mohammed family life. He recalls conversations about Islam with his father and a learned friend. "For food, there was no pork in the house, but every Friday we ate fish," Bob said.

Bob and his sister attended the local schools. The family moved to Maxwell, and Bob graduated from Maxwell High School. "I had no trouble whatsoever. Oh, kids, teenagers would call me 'You Hindu,' and such. At first it hurt, but after while it was, 'So what?'" He said, "That's one thing about my sister and I, we enjoyed the best of both worlds….We were what we called a 'half and half.' We had a club. We would have a picnic or get-together." His parents became naturalized citizens, his mother first, and his father after the law permitted South Asians to become citizens. His family never went to India, although his father would talk about going back. He had been

betrothed to a woman there before he came to America, but life took a different turn once he settled in America. "Dad died [in] 1953. He was about seventy I think; they didn't keep records," Bob said.

Bob Mohammed attended the University of Pennsylvania before serving in the U.S. Army Air Corps during World War II. He was at UC Berkeley when his father died. He gave up his studies to look after the family farm. He continued to farm the rest of his life. He met his wife, Lillian, on a trip to Mexico, and they married in 1962, living happily in Yuba City. Robert Mohammed died in 2016, aged ninety-eight. Lillian died at the age of ninety in 2019.

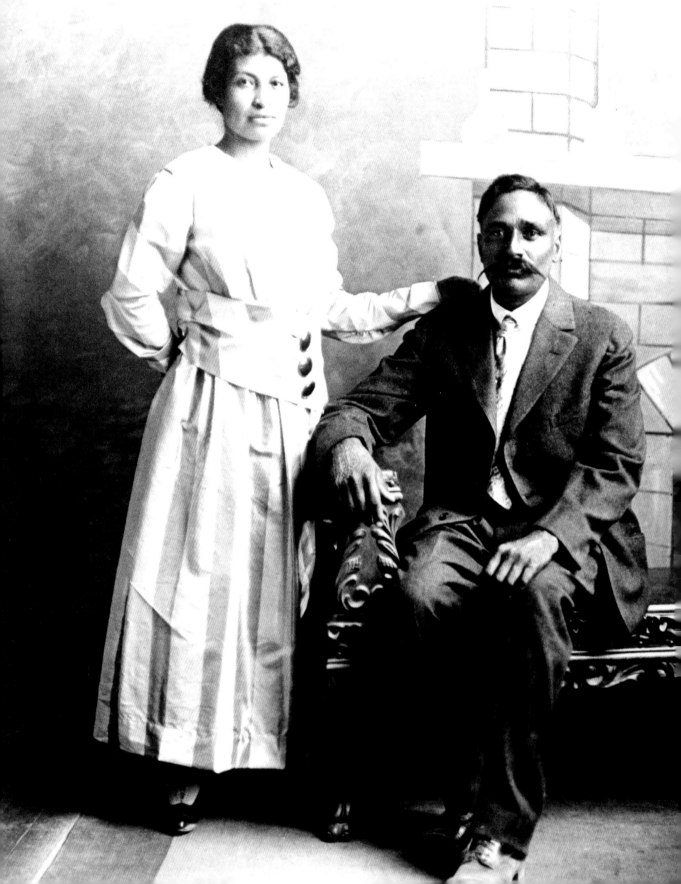

MARRIAGES BETWEEN CULTURES

GANGA SINGH BHATTI

Ten years before Ganga Singh Bhatti died at the age of 101, he spoke with T.S. Sibia about his experiences in America in the 1920s. Bhatti left his village, Verra, near Garhshankar, in the Punjab on January 31, 1924. He embarked from Calcutta, India, and traveled via Japan to Mexico, where he arrived in April 1924. Two months later, he was in Stockton, California, having entered the country from Mexicali. Eventually, he settled in Rio Vista, where he worked for the California Packing Corporation for about five years, farming asparagus with a crew of Punjabis, Mexicans and Filipinos. Some of the workers at the packing company, including the supervisor, were from his village in the Punjab. They used horses for most of the work. It was not until 1931 that a tractor was purchased.

"We had no problem getting jobs," Bhatti told Sibia.[61] "Americans used to give us jobs first, before they gave them to anybody else because we didn't need any supervision. We were always on time, especially at harvesting time. We were always picked first. They

OPPOSITE: Valentina Alvarez and Rullia Singh, wedding photo, 1917. They were one of many "Mexican Hindu" couples. *Courtesy of the Karen Leonard Collection, Green Library, Stanford University.*

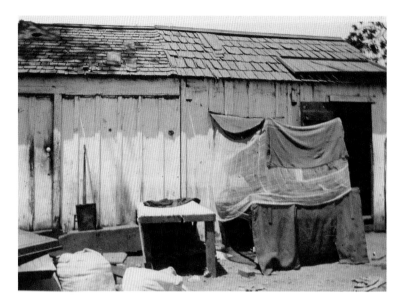

LEFT: A shack that housed South Asian migrant laborers, circa 1910. *Courtesy of UC Berkeley, Bancroft Library.*

BELOW: Irrigation in Tehama, 1938. *Courtesy of UC Davis Library Special Collections.*

said, 'here is a Hindu, give him a job.'" Bhatti moved to Yuba City in 1931, but problems with his immigration status prompted a move to Colorado. He lived there for fourteen years, working for the Pueblo Steel Company. He married Josephine Lucero in 1941 and brought her back to Yuba City, where he bought land.

"Finally I settled down in Live Oak in 1954. I knew a lot of people there at that time. Their names were Chanchal Singh Rai, Lal Singh Rai, Arjun Singh Mahilpuri, Hazara Singh Bedi, Dalip Singh Fulah, Karam Singh Fulah. When I moved back… life was a little easier when you knew somebody from back home," he said. At harvest, hundreds of Punjabis would come to work, he said. "The main thing was most of the Americans—farmers—they always looked to us for irrigation.…They knew that nobody could do a better job in irrigation than these Indians. That was great. A big help to us, that they knew we were hard workers also made us happy, that they think highly of us."

Bhatti described how Tuly Singh Johl irrigated the peach orchards by building levees and irrigating in the evening to protect the trees from frost, the way farmers do in the Punjab. "Irrigation was one of the reasons many American farmers liked us.…I think we are the ones who taught these American farmers here, in 1924, 1926, maybe, that if you water your land it will not freeze, it will not destroy the crop. This is the biggest thing we have taught them," Bhatti said. "In 1931 and 1932, after Hoover Dam, irrigation was going on and some of the Americans said to these big farmers 'Why are you hiring Hindus for your irrigation, why don't you hire us?' They said, 'no problem, but remember one thing, I pay these Hindus once a month,' and they said 'No, no we cannot work for you, we need every week salary,' so they never came to work." Bhatti worked for Richard Wilber in Yuba City and Farmer Griffin in Mendota, living in camps. He said there were a few tough years when several Punjabis worked for Griffin for free, until he got on his feet. Griffin eventually paid the money back to the men.

Bhatti said life for Asian farmers was very hard. If you wanted to buy land, there was a restriction on owning land. He recalled the regular trips to the Stockton gurdwara, gatherings of families and the two Indian stores where people would meet and socialize.

"PUNJABI MEXICAN AMERICANS"

Ganga Singh Bhatti married Josephine Lucero, whose father was a Spaniard who settled in Colorado and her mother a Native American. She grew up on an eighty-acre farm where her family raised livestock and a few crops. She was educated. She was an

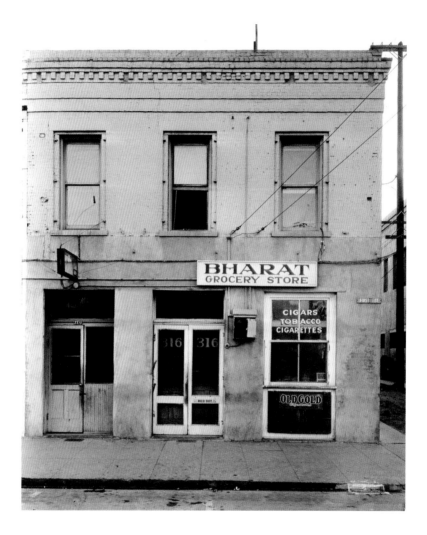

"Bharat" is a name for India. The grocery store in Marysville, California, was a place for immigrant Indians to meet. *Courtesy of UC Davis Library Special Collections.*

experienced horsewoman, and Ganga Singh liked to tell a story about first seeing her on horseback. Josephine said her family was as conservative as any South Asian family. She related how she and Ganga Singh met and married: "It was a beautiful day, the day I met him. My father was as strict as the Indian people. No dating, no talking, no nothing. Ganga came to my house with one of my cousins and we met. Then he

wrote me a couple of letters. Then he came and asked for my hand, and my Dad said it was up to me. So we fell in love with each other and got married. But there was no dating."[62] She objected to the assumption that the early Punjabi marriages with non-Asian women were only for reasons of money, property or immigration. "It was not for money, it was for love. We fell in love and we got married. It wasn't for papers, either, because he had already his papers," she said.

Ganga Singh and Josephine came to California a year after they were married. By then they had Maryann, their first child. Josephine said it was a struggle. "There were no houses to lease, so if the farmer gave us—let's say for these modern children, a shack—we'd live in it. We'd get up early in the morning before daylight, and pick peaches, prunes, whatever, to make money. And went home in the evening and washed clothes by hand, no automatic washer, everything by hand. We kept our little shack clean and the next day we'd go work again. We lived close to an Indian camp; they called it a Hindu camp." A cook at the camp brought lunch to the field workers: "He would put a roti in newspaper and he'd put the food inside of that roti, and we'd eat the roti."

JOSEPHINE'S VIEW

The family worked side by side. Josephine said, "We never had a babysitter, we didn't have no preschools, we didn't have nothing. We carried our children with us. The little one, we put him in a peach box, the ones that were walking, they walked around. But we worked hard all day long." By contrast, she said, the new generation "have it made now. We didn't have it."

As the children grew, Josephine took care of the children and farm when Ganga Singh worked outside: "He was a farmer, a field worker, a laborer, he had to make a living; we had children. And I would irrigate the farm in the daytime, because he couldn't take care of the farm so I took care of it." Ganga Singh sent money to India. "I was never against it," Josephine said. He had told her about his country. She wanted to go to India but never did. Ganga Singh went in later years for a three-month visit. Josephine stayed home and took care of the farm.

"There was no choices for [immigrants], because they were not educated there were no jobs other than the field for them. They worked hard. But I'll tell you one thing, whoever they worked for…if the farmer was not watching, the men were working. They did not sit down like nowadays, as soon as the farmer leaves, they sit down to rest. In those days there was no rest. They worked. They always worked." Later

generations, she said, "came to a brand-new house, thousands of acres, a brand new car. These men didn't come that way."

Ganga Singh Bhatti and Josephine had seven children, four girls and three boys. Their daughter Maryann said her father, a self-taught man, was a wonderful father. "He had the most tranquility about him," she said. He was involved in community concerns. He made sure his children were well educated. Maryann said, "Education, no one can take it away from you. My brothers and I bought a farm. We farm but can work in the world."

Culturally, Mexicans and Punjabis were not a bad match, all things considered. Their religions may have been different, but their values were similar. Christians, Sikhs and Muslims all believe in one God, they believe in treating others with respect. Helping people when possible is part of serving God. Punjabi men were known for taking good care of their families, making sure their wives and children were well dressed and housed. The children were given the best possible educations. Even their eating habits were not dissimilar: dal (lentils) and roti (flatbread) are not all that different from beans and tortillas. Both cultures share a love of chilies.

The sticking point was often the South Asian attitude toward women. As Karen Leonard chronicled in her study of California's Punjabi Americans, many of these marriages prospered just as Ganga Singh's and Josephine's did. Others did not. Leonard's study revealed that it was not always an easy adjustment. There were sad stories, too. Sometimes American or Mexican women, used to independence, objected to the way conservative Punjabi men treated them, expecting them to stay at home and look after friends and business partners from India who came to stay. There were divorces. But many worked out a satisfactory balance.

THE RAI FAMILY

The Rai name, like Johl, is well known in the Yuba-Sutter area. Lal Singh Rai and Chanchal Singh Rai were cousins who came from the Punjab in 1926. They were born in Boparai village, between Ludhiana and Jullunder. Their journey was a long one. They went to Fiji and worked there before heading to Panama, Belize and finally to Mexico.

"There were sixteen of them," Mary Rai, Lal Singh Rai's widow, said. They worked for passage along the way. When they had enough saved, they traveled as far as the money would take them.[63] Their son David Rai said that when his father and his companions got to Sonora, Mexico, they worked as farm hands. As soon as the critical

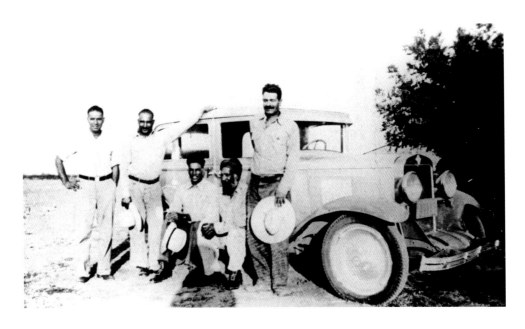

Pioneers in Sutter County, *left to right*: Kartar S. Bahawal, Lal S. Rai, K. Rehana, Gurgachan S. Purewal, Chanchal S. Rai. *Courtesy of PAHS.*

seasonal work was finished, police came for them at night in trucks. They were jailed and sent back to Belize.

"The Mexicans knew they were there but waited until they finished the work before rounding them up." Lal Singh contracted malaria but was able to recover in jail. "He said it was the best thing that ever happened to him, to get thrown in a Mexican jail," Mary and Lal Singh Rai's daughter Leela Rai said. "He had food and he said there was a beautiful little courtyard. They could walk all around. They had freedom to move."

David Rai said his father and traveling companions paid the same guide to bring them back to Sonora. It required ingenuity just to survive the trip to America: "When they were coming from Mexico they walked. And they walked at night so they wouldn't be seen. At one point they were walking through the desert, they had no water, and they came across an abandoned car. They drained the radiator to drink the water," David recounted. Lal Singh's parents were in Vancouver. So during his trek through Mexico, Lal Singh telegraphed his father for money. With the extra money, he rode the train to Mexicali, while the others kept on walking. After meeting up again in

Mexicali, the traveling companions found an American who agreed to take them across the border.

David Rai said Lal Singh and Chanchal Rai promised the driver $250. "They came all the way in the trunk. And they didn't have the $250 they promised the guy." They were depending on a man to meet them at their destination with the money. "He wasn't there when they got there. So they gave the driver food and drink." Lal Singh told David they kept him drunk until the next morning when the person arrived with the money and the cousins could pay the man who brought them across the border.

Lal Singh Rai did not settle in the United States immediately. He went to Canada because his father was there, Mary Rai said. "He went to see about the labor market. But it was so cold. He had to work in the lumber mills, and he didn't like it." She said, "He came back here. He liked it better in California. He started out working for others, but soon he and Chanchal Singh got their own work crews together. They saw this was the best way to get ahead."

While Lal Singh Rai was establishing his business in California, his future wife, Mary Singh Gill, was in Phoenix, Arizona, where she grew up. She was the daughter of Bishen Singh Gill, who arrived in California from India in 1909, and Ernestina Zuniga Gill. He worked on the railroad before going into farming.

Mary Rai told the story: "My father farmed in the Imperial Valley. Then he went to Arizona." She said her mother's cousins had married Punjabi men. "My grandfather was from Spain, and my grandmother was from Mexico, but when he married my grandmother, he didn't want to stay in Mexico." He moved to Arizona. "So he pushed my dad to marry my mother."

Bishen Singh and Ernestina had five children. Mary Rai said her father decided to shift his farming to the Imperial Valley during World War II, when there was a water crisis in Arizona. The land was put in the names of her aunt Betty and her mother, who were American citizens, Leela said. Mary graduated high school in Phoenix before moving to the Imperial Valley to help her father farm vegetables. "We worked in the fields, as my Dad used to say, so we would keep out of trouble. I was the one who kept the books." Her father paid her fifty cents for bookkeeping. "That was a lot because I'd get a hamburger for a nickel. A movie was fifteen cents, pair of shoes for two dollars," she said. They had to buy their own books and supplies for high school in Arizona, "So we all would work ourselves in the fields so we could make money." She did everything around the farm. "I was the housekeeper. I was the secretary." When her father went to Yuba City to collect a debt, Mary accompanied him. That is where she met Lal Singh Rai. "He was sixteen or seventeen years older than I, but he was the nicest thing that happened to me."

LEFT: Wedding photo of Bishen Singh and Ernestina Gill, 1924. *Courtesy of David Rai.*

BELOW: Bishen Singh and Ernestina Gill family portrait, 1932. *Courtesy of David Rai.*

Mary and Lal Singh Rai in 1950. *Courtesy of David Rai.*

Mary's family was friendly with the Poonians, another Punjabi pioneer family. Janey Singh Poonian was her good friend. David Rai said, "Janey Singh's father introduced deep tillage in Arizona." Diwan Singh bought a lot of land during World War II, "a lot of desert land. He introduced irrigation methods and is in history books in Arizona."

David told a story about Diwan Singh, who was the first farmer to buy a Caterpillar tractor in his county. "He was using the tractor one day," David said, "and he got it

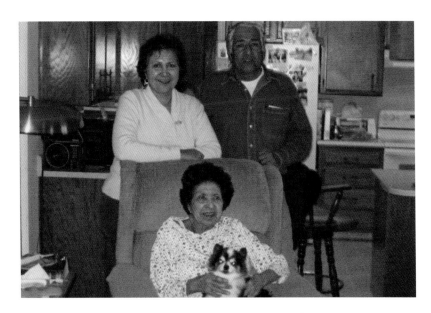

TOP: Mary, David and Leela Rai. *Courtesy of David Rai.*

BOTTOM: Public service was important to Leela Rai. *Courtesy of the Rai family.*

stuck. He went to the county and asked if they would pull his tractor out. And they told him, yes, for so much. And he thought what they wanted was so outrageous, he bought another caterpillar tractor and pulled the stuck one out."

David and Leela grew up speaking English, Spanish and Punjabi. They went to the Stockton gurdwara with their father and the Catholic church with their mother. David, who calls himself an American Punjabi Hispanic, worked beside his father on the farm, and he continued the farming business after his father's death, growing rice and plums, among other things. "My heart's in farming," David said. David is now semi-retired.

Leela recalled the social and cultural activities around the Stockton gurdwara—an annual Indian movie night and celebrations for Indian Independence and Republic Days. When the Yuba City gurdwara was built on Tierra Buena Road, her uncle Chanchal gave the land. He wanted an American-style gurdwara where people didn't have to cover their heads. "He figured we are in America now and when in Rome, do as the Romans. It started out that way, but it didn't stay that way," she said. Factionalism arose among those who wanted it the new way and those who wanted the traditional way. The traditionalists won out in the end.

Leela followed a different path from David. She went into real estate and was involved in the Yuba City business scene. She was president of the Yuba City Chamber of Commerce in her early forties, the first woman of Punjabi-Hispanic ethnicity. She was on the board of trustees for Yuba College. Like her mother, Mary, Leela was involved in many community activities. She later took over managing the commercial side of their properties and business, while David continued to farm. Leela Rai passed away in 2015 after battling cancer. Mary Rai died in 2013.

RALIE AND STELLA SINGH GILL

Ralie Singh is Mary Rai's youngest brother. His wife, Stella, is the daughter of pioneer Harnam Singh, who arrived in Seattle on the SS *Minnesota* in 1911. Her father also married a Mexican woman, Cruz Perez. "Our fathers were among the first," Ralie Singh said. "They worked hard. Most of them in them days they worked for the railroad. That's how they got to know each other."[64]

Both Ralie and Stella recall hard labor and good times. Ralie Singh helped his father farm, first in Arizona and later the Imperial Valley, when his family moved there. Ralie eventually moved north to Yuba City to do his own farming. In Arizona, he recalls, there were only a few Punjabi farmers, the most memorable being Diwan Singh, who

turned arid wasteland into a productive farm. "I was a little kid, and he was going to go to Casagrande. And all of them said about Diwan, 'he's crazy, he's loco in the head,' because Casagrande is desert. But Diwan went up there and he developed a lot of property there. He became one of the wealthiest cotton growers in the state of Arizona," Ralie said.

Diwan married a Mexican lady, Cruz Moreno. Their son Johnny expanded Diwan's farming operations to Mexico and Florida. His daughter Janey became

ABOVE: Bishen Singh with his son Ralie Singh in Live Oak. *Courtesy of Ralie and Stella Singh.*

LEFT: Harnam Singh and Cruz Perez, parents of Stella Singh. *Courtesy of Ralie and Stella Singh.*

Wedding photo of Stella and Ralie Singh. *Courtesy of Ralie and Stella Singh.*

wealthy. Casagrande eventually became prime commercial and residential real estate. Diwan Singh took Casagrande as a surname, following the Punjabi tradition of clans being identified by the place name of their birth village. This is memorialized on a plaque at the El Centro gurdwara in the Imperial Valley, where Diwan Singh also farmed.

Stella warmly recalled how people came from all over the state to the Stockton gurdwara. She said it was a social thing for the Mexican wives and a religious event for the Punjabis. "It was always a fun time, for us. Happy memories." She added, "I think another reason for the Mexican ladies marrying east Indians is they were available. That was years ago and there was prejudice involved, let's face it. They were working the fields, they had a need for a husband and the men had a need for a wife." And they had similar tastes in food, she said. When they were growing up, the families represented East Indian heritage at festivals, Stella recalls. "I feel that the women the men chose to marry did help, did do as much as possible to mix socially and culturally." She said, "We were just all like family. We were more like family than I see them today because there weren't that many of us. Hundreds back then compared to thousands we see today."

With their fathers hard at work all day on their farms, there was little chance for them to teach their children Punjabi, so the kids learned Spanish and English "with a few words of Punjabi," Ralie Singh recalled. The Punjabis learned English and Spanish and talked to each other in Punjabi. He also recalled prejudice: "hijo de Hindu," or son of a Hindu, was a common insult, he said. Mexicans were often prejudiced against South Asians, and "East Indians looked down at the Mexicans," he said. "The new young generation came and looked down on me because they thought I was Mexican."

THE UNFORGETTABLE CHANCHAL SINGH RAI

Chanchal Singh Rai, Lal Singh's cousin and business partner, remains legendary among the Punjabi pioneers for his business sense, his kindness, his flair and his philanthropy. Amarjit Rai, his grandson, who came to America in 1979 and was close to his grandfather until Chanchal died in 1993, recalled, "My grandfather, he helped a lot of other people in the community, and he always told us always do a good job, don't cheat anybody, and if you can, help other people."[65] Amarjit Rai added, "He gave a donation of ten acres to Sikh temple, and he gave them more

Chanchal Singh Rai is fondly remembered. *Courtesy of the Rai family.*

than $60,000 in 1978—at that time it was a lot of money, you know." Chanchal donated money to Fremont hospital. He and Lal Singh built a school for their Punjabi hometown, Boparai. People came to him for his business advice. He was an example of the determination of early immigrants, a man who worked hard and didn't look back.

Although he had a wife and children back in India, Chanchal Rai didn't see them for forty years. He finally went back to India on a visit in 1958. His son Sohan Singh, Amarjit's father, came to America in 1957 but didn't stay. He had become a famous wrestler in India and preferred to live there, so he went back. Chanchal's granddaughter-in-law Rani remembers him

fondly. She said when he gave money to help people, he didn't want it to be public knowledge. For that reason, he didn't want a plaque on the gurdwara that he generously funded, she said. "He didn't wear the turban and he wasn't orthodox, but...he was one of those silent angels." Amarjit recalled that he was a smart dresser, and "he liked to live over here like an American." Rani added, "He was very American, Chanchal....He believed in that, to kind of blend into the society...he liked the American way." A cousin brought Chanchal's wife to America in 1989, and she stayed until her death three years later. Chanchal passed away a year and a half after she did. "He would never complain," Rani said, even when he was ill. "He lived a very simple life, my grandfather," Amarjit said.

ISABEL SINGH GARCIA

Isabel Singh Garcia was proud of her heritage as a "Mexican Hindu" and preserved many photos and mementos that chronicle the community in Marysville–Yuba City. "A lot of times we were considered half-breeds because of the two races," but she remembers a happy life in which children were well cared for and loved. "It was just a wonderful, wonderful life, lots of happiness, lots of love for children. A lot of the men who came had no children, so we were their children. When I married, my husband asked me, 'Gee how do you have so many uncles,' and I said, 'Well they all came from the same village and they are our uncles.'"[66] Plucky Isabel met her husband, Alfred, when he was eighteen and she was fourteen. She told him she was sixteen, and he didn't find out the truth until things got serious. She

Wedding photo of Memel and Genobeba Singh. *Courtesy of Isabel Garcia.*

said he'd have to wait until she graduated high school to marry, which he did.

Her father, Memel Singh Saran, was among the early pioneers. He married Genobeba, with whom he had ten children, although only three survived. He made a fortune in rice but went broke when rains destroyed farmers' crops in the early 1920s, only to rebuild his fortune. "They took [business] partners.… Sometimes it would work out, sometimes it didn't," Isabel recalled. Her father eventually stopped the partnerships and bought his own piece of land. "A lot of times the partner expected the other partner's wife to do everything for him, too, cooking and washing and cleaning and I think finally, after a while, my mother got tired of that."

Wedding photo of Alfred and Isabel Singh Garcia, 1953. *Courtesy of Isabel Garcia.*

When Isabel was eleven years old, she had to assume management responsibilities at the family's ten-acre peach orchard when a stroke paralyzed her father from the waist down.

"The lower part of Marysville was the gathering place for the East Indians, and they would go down there and sit in chairs on the sidewalk. They'd take their kids down there and of course, we had lots of fun. We'd roller skate on the sidewalk, and

there wasn't a Hindu that didn't reach into his pocket and pull out a dollar bill—and in those days that was a lot of money—and hand it to us to go buy ice cream and candy." Four times a year they went to the gurdwara in Stockton, Isabel said, "and every time we went to the temple it was a new suit of clothes for all of us." She said they always wore Western clothes. "It was very important that we were dressed very nice, clothes, shoes and a purse. The women would dress very elegant with everything to match." At these gatherings, the men would talk about politics and Indian independence. "Lots of money was raised in this community, and when India did receive her independence, there was a big, big party in Marysville. There was a big auditorium, a veteran's hall, and people came from all over to celebrate," Isabel said.

Punjabi Mexicans usually married in the Catholic Church, and the children were all baptized Catholics, she said. The Sikh religion was not taught at that time. "The (Mexican) mothers became adapted to the Indian way of life very, very quickly, but they did not give up their religion. They learned to make the curry foods, they learned to make the roti. They kept their husbands very clean, very neat. None of them wore anything but white shirts, and in those days you had to starch them and iron them…. They all dressed nice in their suits and hats."

Religion could present a dilemma when a Sikh died. When Memel Singh died in 1948, Genobeba was confronted with a decision. Isabel said although her father was baptized a Catholic a few weeks before he died, the Church frowned on cremation. But cremation was Sikh custom, and it was expected by his Punjabi friends and relatives. Isabel said her mother consulted the priest, who advised that she go ahead with cremation. "She didn't want to upset my uncles," Isabel said. Memel Singh's ashes were interred at the Marysville cemetery. "The Sikh temple in Stockton bought a piece of property in Marysville so that the Sikhs that had no family or had nowhere after they were cremated, they were placed in a little plot with their names on little bronze plaques," Isabel said. "At that time, the ashes were not allowed to leave the cemetery. Later on they were able to take them home and to India." Genobeba continued to run the farm after Memel Singh's death. Upon Genobeba's death, Isabel petitioned the Stockton gurdwara to allow her to move her father's ashes to be buried beside her mother. "Paritem Poonian was president at that time, and he gave me permission," she said.

Isabel was a community activist. She supported the schools and volunteered for numerous charities and community organizations, including forty-nine years as a 4-H leader. She and Alfred, who predeceased her, ran several businesses together. They had four children, two boys and two girls. Isabel died in 2011, aged seventy-six.

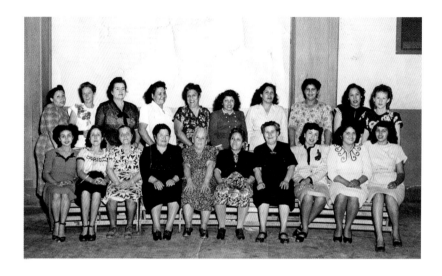

Punjabi Mexican wives at the first Yuba City Indian Republic Day celebration, 1948. Among the women are Mary Rai, Amelia Bidasha, Nand Kaur and Dorothy Sexton Singh, Happy Sahota's wife. *Courtesy of David Rai.*

Alfred and Isabel Singh Garcia with Mary Singh Rai at the 1988 Old-timer's Christmas dance, Yuba City. *Courtesy of Karen Leonard Collection, Green Library, Stanford University.*

Rasul's El Ranchero Restaurant

It was a fixture in Yuba City from 1954 to 1994, one of the few places people could taste Punjabi Mexican food outside of a Punjabi Mexican home. Ghulam Rasul was a farmer, but when he and his wife, Inez Aguirre Rasul, opened El Ranchero restaurant on Garden Highway in Yuba City, they began what became a neighborhood institution.

A Punjabi pioneer farmer from the Jullundar area in today's India, Ghulam Rasul came to California around 1910 with his brother and cousin, according to his granddaughter Tamara Rasul English. They started farming cotton near El Centro in the Imperial Valley. His son Ali Rasul said that when farming was not going well, his father came up to Yuba City to work in the orchards. His father and uncle also had a restaurant in El Centro. Ali was born in Holtville in 1931, but he grew up mostly in El Centro. "We would go back and forth to El Centro," he said.[67]

Rasul's El Ranchero Restaurant in Yuba City was famous for Punjabi Mexican food. *Courtesy of Karen Leonard Collection, Green Library, Stanford University.*

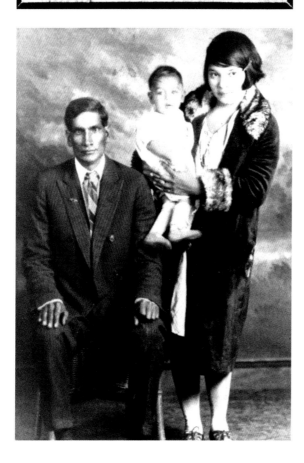

EL RANCHERO
Restaurant
440 Garden Hiway — Yuba City — 742-7076
FEATURING:
MEXICAN & EAST INDIAN FOOD
Open Tuesday — Sunday
5 P.M. to 11 P.M.

Curried Chicken — Curried Lamb — Roti
RASUL'S OWNERS

TOP: An ad for Rasul's El Ranchero, *Appeal-Democrat*, September 12, 1969. *Courtesy of the* Appeal-Democrat.

LEFT: A Punjabi Mexican family: Jon Bux Abdulla; his wife, Juanita Chavez Abdulla; and son Ali, circa 1928, Brawley, California. *Courtesy of Karen Leonard Collection, Green Library, Stanford University.*

OPPOSITE: Lucy Singh and Ali Abdulla wedding photo, 1949. Both Ali, an infant in the 1928 photo with his parents, and Lucy were children of Punjabi Mexican marriages. *Courtesy of Karen Leonard Collection, Green Library, Stanford University.*

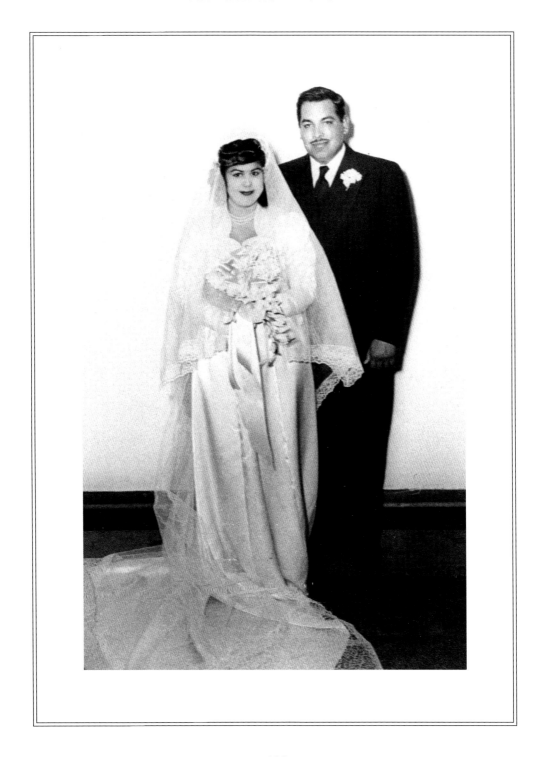

Like other early Asian immigrants, they farmed on leased land, since they were not allowed to buy land—not until children, who were American by birth, came, and land could be bought in their names.

Eventually, Ghulam Rasul's family settled in Yuba City and opened the El Ranchero restaurant. At first it was a gathering place for friends in the Punjabi Mexican community. They served up chicken and lamb curries and "roti quesadillas" alongside standard Mexican fare. Ghulam taught his wife, Inez, who already knew Mexican cooking, how to cook Punjabi style. Because Ghulam Rasul was Muslim, pork was not served. Tamara recalls their delicious chicken chili verde, a recipe made with pork in typical Mexican cuisine. The roti in Rasul's famous quesadillas was a paratha, a substantial flatbread with multiple layers slathered in ghee.

The food was so good, people brought pots to take their favorite dishes home with them, Ali said. Bob Mohammed was one of those. He would bring his pot and order a stack of rotis to take home to freeze.

After Ghulam Rasul died in 1967, Ali, one of the Rasuls' thirteen children, took over the business. The family all worked in the restaurant. Tamara, who waited tables there, said the clientele was like family; everyone knew everyone's name. People came to chat with Ali as well as eat. "They would come into the kitchen to watch me make rotis," Ali said, adding, "If there were kids, I'd put an apron on them and let them wash dishes." He closed the restaurant when he retired in 1994. Ali passed away in December 2021, at the age of ninety.

Ali Rasul said the community was close-knit and religion was not a big issue. Christians married Muslims and Sikhs, and there was not dissension about it. After immigration from India and Pakistan became easier, marriages between Punjabi men and Mexican women became far fewer, as men could marry in India and bring back their brides. Society became more compartmentalized along ethnic and religious lines compared to the easygoing early years. The sizable California subculture that developed from Punjabi Mexican American marriages began to wane. The closing of Rasul's El Ranchero, in a way, marked the end of an era.

The first wave of old-timers who had the determination to stay in America despite official rebuffs, discriminatory laws and homegrown bigotry are gone, but their legacy remains in their children, grandchildren and great-grandchildren. It also remains in the hard-won acreage they bought and farmed, much of which is still in the hands of their families. The next wave of immigrants came legally and planted South Asian culture more firmly in American soil.

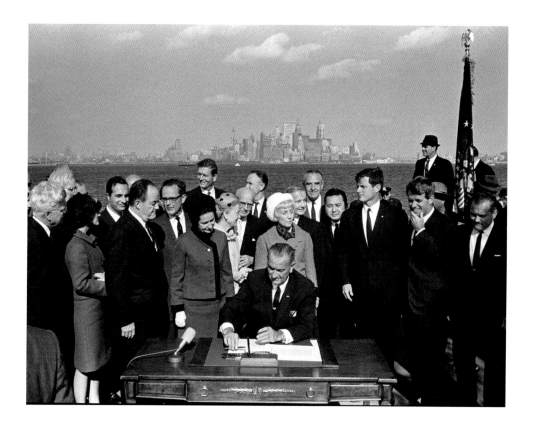

President Lyndon B. Johnson signs the Hart-Celler Act into law on Liberty Island, New York City, 1965. Witnesses include Senators Robert F. Kennedy, Ted Kennedy and Everett M. Dirksen. *Courtesy of LBJ Library.*

LAWS CHANGE, FAMILIES REUNITE

The Chinese Exclusion Act was repealed in 1943, and in 1946, the Luce-Celler Act lifted immigration restrictions on Asians from India and the Philippines. But the quota system based on national origins, set up in a 1924 law, remained. About 70 percent of immigration slots went to Northern European countries. The patently nativist law severely limited immigration from Eastern and Southern Europe, Asia and Africa. When President Lyndon B. Johnson signed the Immigration and Naturalization Act, also called the Hart-Celler Act, in 1965, he said, "It corrects a cruel and enduring wrong in the conduct of the American nation." It abolished the quota system.

WIVES AND FAMILIES ALLOWED

The gateway opened for South Asians. Since it was no longer necessary for Punjabis to marry non-Indians, traditional practices that faded when the men were isolated far from the Punjab rebounded in America. Newly arrived Punjabi wives made sure of that. The latter part of the twentieth century brought doctors, scientists, academics and other South Asian professionals to America. Often, they came as students, took postgraduate degrees and chose to remain in America. Many set up successful businesses and raised American families. Their children participated in

both worlds: they possessed a rich South Asian cultural heritage with the advantage of being Americans.

On a warm May evening in 2006, a gathering took place at the house of Davinder Deol in Yuba City. Davinder is part of the generation who came from India after the U.S. immigration law changed to allow families to reunite in America.

At the center of the group of women having tea and talking about their lives were several elderly ladies. The women, Harbhajan Kaur Purewal, Swaran Kaur Johl, Gurmit Kaur Takhar and Diljinder Panu, all came to America from India as young brides in the 1950s and 1960s. For the younger generation, they are links to the "old days." They were significant arrivals in the midcentury second wave of South Asian immigrants: They were the wives, who would nurture family values and tradition.

Thanks to the Luce-Celler Act, Asian immigrants could now become U.S. citizens, come and go freely and bring wives and other kin left behind. Marriages were arranged with brides and grooms in South Asia again. A quota of one hundred immigrants per year was set for India and Pakistan. It wasn't much, but it ensured a trickle of immigrants, year after year. Those already here could legally sponsor family members or friends. This continued the early established pattern of chain migration. Years of isolation from family were finally over.

MAKING A NEW HOME IN CALIFORNIA

Harbajan Kaur Purewal's husband arrived in 1951, but his grandfather came in 1906. She heard of the many hardships he endured from her husband's uncle, who lived in her house when she first came to America. "He would tell stories that when they saw the immigration people coming. They would literally duck down into the river so they wouldn't be visible," she said. "Illegal" immigrants could be deported, even if they had been in America for several years. By the time she arrived, pioneer Punjabis had farms in and around Yuba City. A small South Asian community was there to greet the young wives.

The elderly women assembled at the Deol home agreed that despite the difficulty of leaving their homes in familiar India, they had good lives in America. Unlike Nand Kaur, who felt isolated, these women had a community with whom they could interact. They would help it grow.

The vague information about America that the women gleaned by word of mouth before coming to the new land did little to prepare them for the reality. They recounted

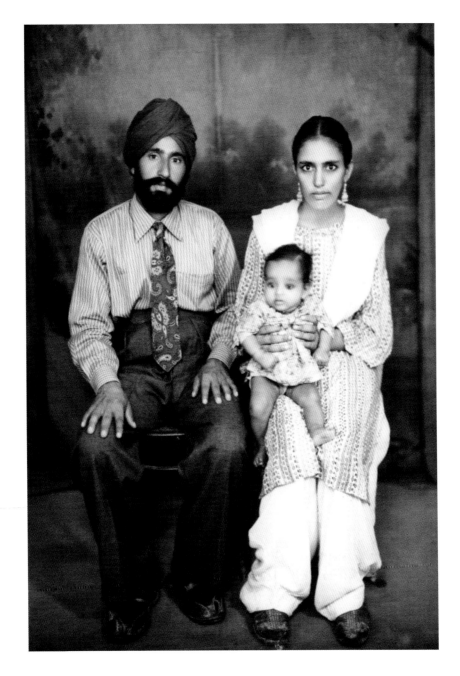

Karnail Singh Takhar, wife Gurmit Kaur and daughter Davinder, 1950. *Courtesy of the Takhar family.*

their confusion after leaving their villages in India, alone or with a child or two, to board a flight into the unknown.

Davinder Deol, then Takhar, was five years old when she accompanied her mother, Gurmit, from India to join her father, Karnail Singh Takhar, in Yuba City. She was only four months old when her father left for America. Gurmit said that en route they spent the night in a Tokyo hotel room, where she worried that they would miss the plane. Despite assurances that they would be called in time, Gurmit was afraid to leave the room. But they landed safely in San Francisco, met by Karnail Singh.

Harbhajan Purewal[68] said that after she arrived, she lived in Yuba City, while her husband worked in Lodi. "I would travel with him for harvesting to Lodi, but other than that I lived here. I took care of kids and house."

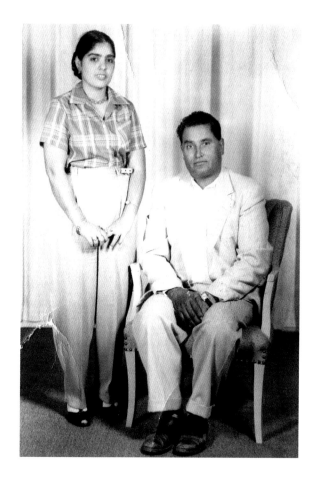

Harbhajan Kaur and Bakhtawar Singh Purewal. *Courtesy of the Purewal family.*

Later, her mother, father and six brothers and sisters joined her in America. "It was pretty hard when my brothers came and we all lived in the same house. It was difficult to keep house, my husband being the breadwinner." She said with so many people and two families living together, she had to keep her thoughts to herself. "Now I say whatever I want," she added. The Purewals, like other ethnic South Asians, brought the traditional "joint family" to America, where several generations live in the same house. Mrs. Purewal lives with her sons, daughters-in-law, daughter and grandchildren in a spacious ranch house on the land generations worked so hard to farm.

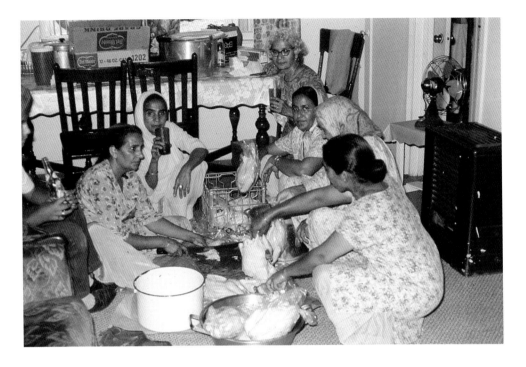

Cooking together was a pastime for Yuba City Punjabi American women. *Courtesy of PAHS.*

The women enjoyed each other's company as they bore and raised children and helped their husbands, they said. Some days, Gurmeet Takhar said, "The men would drop the wives off at one house on their way to work. We would talk and share stories while preparing a meal for that evening together. When the men would finish work that day, they would come to pick us up and we would all have dinner together. It was an enjoyable way to pass the time." Diljinder Panu added the South Asians here warmly welcomed the newcomers. "We became like all family, you know? At that time we didn't have much of our own family. Everybody was like an extended family." She added, "There was a lot of love between all the families." The other women in the group agreed. "We had good parties, great times," Harbhajan Purewal said.

All their lives they had worn the modest salwar-kameez, a long blouse worn over loose-fitting pants accented by a long scarf draped across the shoulders, at times used to cover the head. Some wore elegant, draped sarees. Now they had to adapt to wearing dresses and pants. The women said they would have a couple of outfits ready for female newcomers, advising them not to wear traditional Punjabi clothes into town.

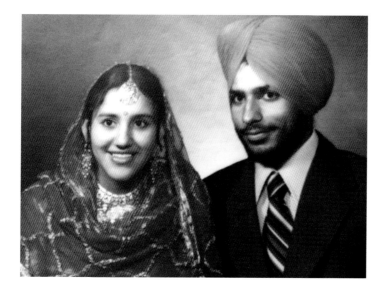

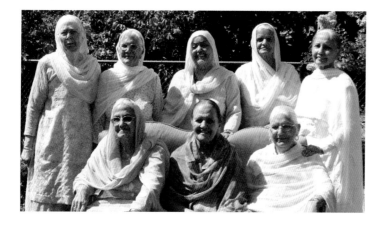

TOP: Davinder and Hitpal Deol were married in India, 1974. *Courtesy of Davinder Deol.*

BOTTOM: Pioneering ladies of the 1960s (*left to right, seated*): Harbhajan K. Takher, Gurmit K. Takhar and Rajinder K. Takhar; (*standing*) Pritam K. Purewal, Bakhsish K. Mann, Harbhajan K. Purewal, Swaran K. Purewal and Harbans K. Panu. *Courtesy of Davinder Deol.*

OPPOSITE: Harbhajan K. and Bakhtawar S. Purewal in later years. *Courtesy of the Purewal family.*

Davinder translated a burst of discussion among the elder women: "Initially they never went out in Indian clothes, they always wore a dress or pants as they had been instructed. They'd walk long distances to go to each other's homes because they didn't drive, and the men were at work all day. They spent the days visiting, have tea together and walk back home in the evening." On holidays like Diwali, the winter festival of light, the women got together and made the special holiday sweets together.

There was no gurdwara in Yuba City those days, and for religious observations such as funerals they all went to the Stockton Sikh Temple. There were few weddings in the

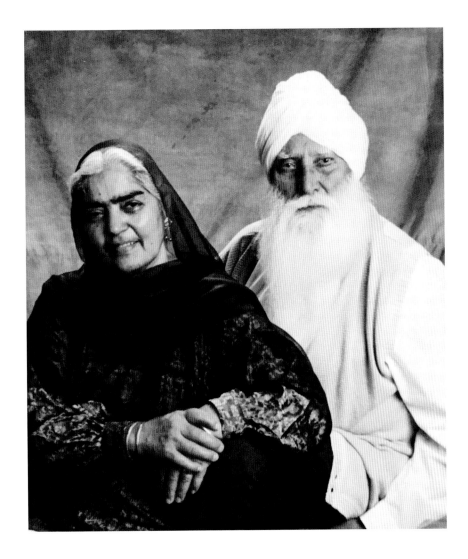

community, as most of the new immigrants were young and so were their children. The weddings that took place those days were simple ceremonies. "The couple sat in front of the Guru Granth Sahib on chairs and the *granthi* (priest) read the *lavan* (marriage prayers) and that was it," Davinder Deol said. In Sikh tradition, during the recitation to music of each part of the marriage hymn, the bride and groom linked together by a *pula* (sash) walk around the Guru Granth Sahib. "I was married in 1974 (in India) and I had never seen the traditional lavan until my own wedding. There were no wedding receptions. You would have the wedding ceremony, the *langar*

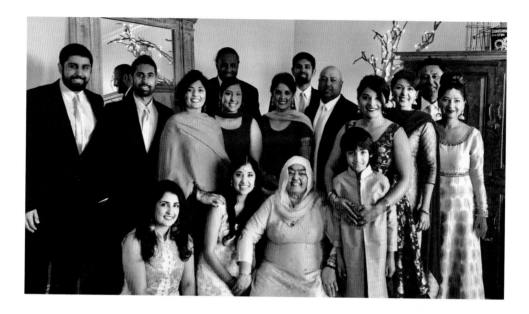

A gathering of the Purewal family, with Harbhajan Purewal seated, center. *Courtesy of the Purewal family.*

(community meal) and then go home. In the evening the immediate family would have a celebration and a big dinner at home," Davinder said.

Weddings aside, informality was the norm in the gurdwara. There was little to no observance of traditional protocol in the gurdwara then. "Everyone sat without covering their heads in the gurdwara which is unheard of these days. It's not that they didn't show respect, it just wasn't deemed as important….What was important was that you practiced your faith in your daily actions and the way you lived your lives."

The women began to discuss how times have changed, Davinder translating: "Things are very complicated now. Things were simpler then. Everyone would make major decisions together just like one big family, but now nobody wants to listen, they all do their own things. The kids won't listen to you. That part has changed. There was a lot more love between everyone who was here together. Now, not so much." They described a small town where everyone got along, everyone knew each other.

Most of the women became American citizens in the 1960s. Davinder added, "Some of the women had absolutely no formal education. Thinking back, I find their determination and drive amazing." Despite being unable to speak English at first, the women passed oral and written exams on American government to become

naturalized American citizens. "They did this so they could sponsor their families from India. Being one of the oldest female children, many of these women counted on me to tutor and help them with the process," Davinder said.

Harbhajan Purewal recalled sitting under a tree and crying from homesickness for India and the family she left behind. But she had little desire to return there now. "We don't feel like going because there is no one left there. The country [India] isn't bad, but the people who were part of our lives are no longer there. They are all either here now or have passed on. Our families are here." It took courage to migrate to unknown Yuba City. There they raised their children to participate in both cultural worlds: American and Punjabi.

DAVINDER AND HITPAL DEOL

Davinder Deol, née Takhar, recalled how hard her father worked to save up to buy their first home and then land. She also remembers a strict upbringing. "We never went anywhere without our parents," who wanted to preserve tradition in their family. "Although my dad's insistence on speaking only Punjabi in the home really bothered me as a child, I truly understand his intentions as an adult." She may not have appreciated it as a child, but as a result, Davinder Deol is fluent in Punjabi.

Like her own parents, she passed on traditions and culture to her own children, who also speak Punjabi. She strives to maintain the traditions of her native land in the community, as well. She served on the organizing committee of the Guru Ram Das Khalsa Preschool at the Tierra Buena Sikh Temple, which taught the Punjabi language and Sikh religion to young children, one of the first such schools in the United States.

Davinder's father, Karnail Singh, took the entire family to India in November 1974 to arrange Davinder's marriage to Hitpal Singh Deol, who was born and raised in India. Hitpal worked on farms and for the Pirelli Cable Company after his arrival in the United States. His hard work allowed him to achieve his dream of owning his own business. Besides farming walnuts and pistachios, he owns four successful Subway sandwich shops in the area. He frequently mentors new and aspiring business owners in the community. He has served as regional chairman of the Subway Franchise Advertising Fund and and the North American Association of Subway® Franchisees.

Both Hitpal and Davinder are active members of the Punjabi American Heritage Society. With a passion to preserve the history and tell the stories of early immigrants from India to the United States, they were key members of the committee that planned

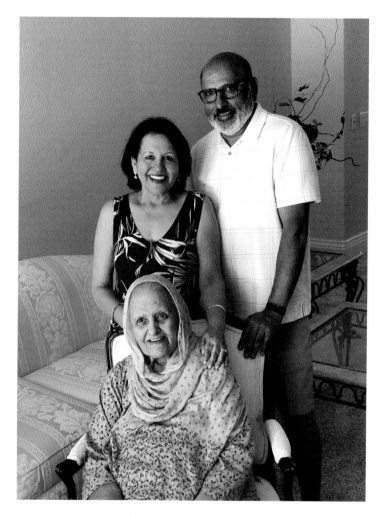

Davinder and Hitpal Deol with Gurmit K. Takhar, seated. *Courtesy of Davinder Deol.*

the permanent exhibit on South Asian immigrants at the Sutter County Museum in Yuba City.

Davinder Deol, who earned her bachelor's degree from California State University (CSU), Chico, and master's degree in educational administration from CSU Sacramento, spent her entire professional career in education. She was an elementary school administrator until her retirement in 2018. Since then, Davinder has taken a

more active role as a member of Punjabi American Heritage Society's Sikh Community Center, where she hosts a class titled *Sada Virsa Sade Geet* (Our Heritage, Our Songs). There ladies come together to learn, discuss and sing ancient Punjabi folk songs. She also organizes retreats for women that focus on a variety of contemporary issues.

SARB AND PRABJHOT JOHL

Sarbjit "Sarb" Johl was thirteen years old when he accompanied his mother and sisters to the United States from India. Sarb's father, Gurbax Singh Johl, arrived in 1963. Once established, Gurbax sent for the family. Sarb's elder brother came first, in 1965. The others joined them the following year.

Sarb explained that his family relocated to India in 1947 during the partition of India and Pakistan. They migrated from Jindayala village, near Lahore in Pakistan's Punjab, to India's Punjab, near Jalandhar, before Sarb was born. In Jalandhar, Gurbax saw an announcement that refugees from Pakistan would be given preference in the United States immigration quota. He applied, but it was more than ten years before he was selected to receive a U.S. visa. Then he had to find a sponsor and meet other immigration requirements,[69] all of which took several more years.

Like other Punjabi immigrants, Gurbax worked on farms until he could start his own farming operation. As a farmer in India, he was used to working for himself. "Here," Sarb said, "the tables completely turned. Now he was starting from scratch by working in the fields for someone else." Gurbax irrigated and pruned orchards. He earned enough money to buy a small piece of land with a house on it. Sarb hardly spoke any English when he and the rest of the family joined his father in America. "I could read and write, but speaking was a little difficult," he said.

School in Yuba City was so different from the village. At Yuba City High School, besides studies, Sarb and his sister had to put up with discrimination as they adjusted to a new culture and country. "Nobody wanted to talk to us," Sarb said. "It wasn't easy." Gradually, the Johl children found their niche, making friends with other Punjabi students trying to fit in. After school there were farm chores.

The farm was a family business. Sarb's parents supervised workers in the field. The kids helped, too, from driving the tractor to loading it up. "We did all the day-to-day farming ourselves and hired people when we needed help at harvest." If Sarb wanted a car, he worked on weekends to earn money for it. "That's how we got to where we are. Everybody pitching in." He added, "Keeps you out of trouble."

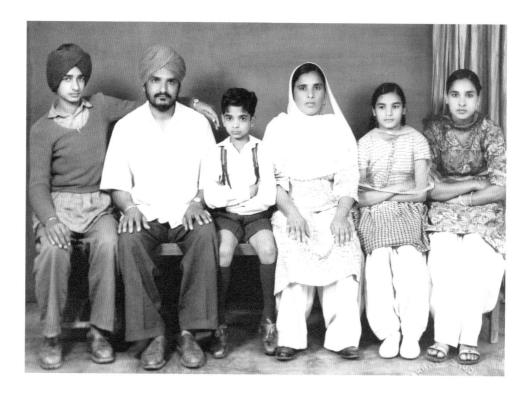

ABOVE: Sarbjit Singh "Sarb" Johl sits between his parents, Gurbax Singh and Jaswant Kaur Johl, in India, before the family emigrated. *Courtesy of Sarbjit S. Johl.*

OPPOSITE: Wedding portrait of Sarbjit Singh and Prabhjot Kaur Johl, 1976. *Courtesy of Sarbjit S. Johl.*

Bob Singh, a Yuba College teacher for twenty-six years who came to America in 1954, knew them well. He remembered the Punjabi kids as a good group who wanted to get things done.[70] They raised money to give to the Red Cross for Bangladesh after the war and a terrible cyclone there in 1971. They organized car washes and held benefit screenings of Indian films.

The Punjabi boys started the first soccer team at Yuba City High School, mostly Punjabis and a few Anglo kids interested in trying a new sport. "We started the International Students Association, and sophomore year we started our Indian Students Club," Sarb said. He described an ambitious event, the "Big Feast," that they organized to introduce non-Indians to Indian culture.

Sarb Johl attended the school of engineering at Cal Poly in San Luis Obispo. There, he said, maturity transformed relationships: some of the Anglo kids who

184

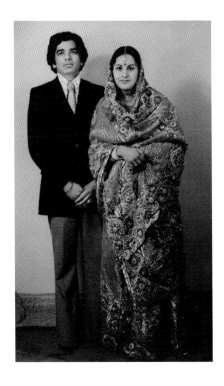

gave him grief in high school became his good friends. After college, Sarb returned to the Yuba-Sutter community to farm and start a family.

In addition to the farming business, he formed an agricultural cooperative, the Sacramento Grower's Cooperative, which was later bought out by Tri-Valley Growers. Sarb was also the first Punjabi to be accepted into the California Agricultural Leadership program. This program trains young farmers to be future leaders, taking people from different backgrounds and abilities from all over the state. This is what makes the program so valuable, he said. "Everybody's perspectives are so different."

Over the years, Sarb Johl has diversified his business to include not only orchards of walnuts, peaches and plums but also a cold storage and irrigation company and a walnut processing and marketing business. Bob Singh says of Sarb, "That's an example of our people's entrepreneurial spirit. He and his brother are among the biggest farmers here."

Sarb has been supported in his many accomplishments by his wife, Prabhjot, who came to the United States after marrying Sarb in 1976. Her grandfather, who was a high school principal in the Punjab, valued education and made certain the girls in the family were as well educated as the boys. He inspired his three daughters and granddaughters to become teachers. "He used to say teaching is a noble profession," Prabhjot said.[71] She was working on her master's degree in India when she married, but she postponed her studies to care for her young children. Eventually, she earned a bachelor's degree and teaching credential at CSU Chico. She taught elementary school in Yuba City for more than three decades. She volunteers to teach Punjabi language and culture at a Sunday school. For Prabhjot, teaching is a passion. "It's a labor of love," she said.

Prabhjot has been involved in outreach to women who are victims of domestic violence. She also helps new immigrants adjust. The Yuba-Sutter National Sikh Women's group, of which she was a member, formed a support group for women in difficult circumstances. "We are a liaison between them and other resources in the community."

O P P O S I T E : Sarb Johl in his peach orchard. *Courtesy of Sarbjit S. Johl.*

A B O V E : Kiran Black, like her father, is a leader in California agriculture. © *Dean Tokuno.*

Speaking of strong women, Prabhjot and Sarb have three daughters, one of whom, Kiran Black, made her career in agriculture. She worked for the California Farm Bureau in political advocacy before returning to the family business. She is senior marketing and grower relations manager at the Sacramento Valley Walnut Growers, the Johls' walnut processing facility that distributes products to more than twenty-five counties.

As an advocate for agriculture in California, her concerns have been to ensure that farmers and ranchers have a voice in public policy at state and federal levels.[72] "California, especially, is growing so rapidly that growth is now being seen in our Central Valley which has been predominantly agricultural. We want to make sure agricultural communities in our valley don't become like Los Angeles or Silicon Valley," noting that in the mid-twentieth century, Los Angeles was the no. 1 agricultural producing county in the country. Santa Clara County was also important. "Those

The Sarb Johl family (*left to right*), Kiran Black, Sarb, Prabhjot, Sureena and Anu, at the 2021 Sacramento Valley Walnut Growers Holiday Party. *Courtesy of Sarbjit S. Johl.*

farmlands are paved over, and industries are keeping those communities vibrant, but we want to make sure we don't lose all of agriculture in California. Once that land is paved over, there is no rewinding the clock, it's gone."

Kiran Black's participation in the two-year California Agricultural Leadership Fellowship enriched her knowledge about diverse agricultural interests in the state and internationally. Although several ethnically South Asian men have been fellows since her father, she was the first Punjabi American woman in the program.

Black feels her participation in two cultures has broadened her outlook. "In this country, who or what you become is up to you and what you're willing to put into it, how hard you're willing to work," she said.

Community service is second nature to her and her sisters. She credits her parents' example as inspiration.

Sarb continues to farm and remains active in the community. In 2016, he was named Agriculturalist of the Year by the California State Fair. He has served on California Cling Peach Board, Northern California Growers Association and Butte-Yuba-Sutter Water Quality Coalition. His youngest daughter, Sureena, also joined the family farming operation. Active in the Punjabi American Heritage Society, Sarb was on the committee that organized the exhibit on Punjabi Americans at the Sutter County Museum.

HARBHAJAN SINGH JOHL AND KULWANT SINGH JOHL

Kulwant Singh Johl, although not directly related to Sarb Johl, hails from the same village in the Punjab. Like Sarb, he is a hardworking farmer. Kulwant's peach, plum and almond orchards are a few miles from Sarb Johl's orchards and packinghouse on Highway 20 north of Marysville. Although Kulwant himself is a more recent arrival—he came to America in 1970—his grandfather was Nand Singh Johl, who arrived in 1906.

Harbhajan S. Johl was a popular radio personality among Central Valley Punjabi Americans. *Courtesy of the H.S. Johl family.*

As recounted earlier, Nand Singh Johl worked for other farmers until he acquired enough land to start his own farm. His son, Kulwant's uncle Harbhajan Singh Johl, arrived in Yuba City in 1955 at the age of nineteen to help his father farm. It was the first time Nand Singh had seen his son since he left India. Nand Singh died a year later without visiting India again as he wanted to do.

"I came here as a student first," Harbhajan said.[73] He attended junior college in Marysville followed by Chico State University, where he majored in agriculture and crop production. But his father's passing a year after his arrival left him with new

responsibilities. "He had a small ranch, which I took care of at the same time as I went to school. I started farming full time after my college," he said. Harbhajan leased more land.

CALIFORNIA'S FIRST PUNJABI AMERICAN RADIO HOST

Farming was not enough for Harbhajan, however. In 1968, he and his friend Nirmal Shergill started a weekly Punjabi-language radio program to serve the local Punjabi-speaking community. The program aired news, music and community announcements for thirty-four years, the first of its kind in California. It was so popular that people would drive from the Bay Area to the nearest reception point and sit in parking lots to listen on their car radios.

Harbhajan contributed to the community in other ways. He raised funds to build the Tierra Buena gurdwara, of which he was one of the twenty-six founders. He also sponsored relatives and helped them when they arrived.

He farmed full-time until 1973, when he took a job as a pest control advisor for Pure-Gro Chemicals, selling fertilizers and pesticides. He worked there nearly twenty years, until it closed. Then he took a similar job at John Taylor Fertilizer Company.

"When I came, we didn't have very many East Indians in this area, compared to now. I would say at that time, probably about one thousand," Harbhajan Singh said. "Most of the people who were here didn't have much education.…They were all mostly farmers or farm workers.…Their holdings were small, ten acres, twenty acres. They worked hard. Very earnest people." Like others, he noted the good reputation the South Asians had.

He recalled the big farmers' labor camps that housed 100 or 150 workers. "They lived there and worked there; they would have a common kitchen. They'd pay so much a month for that. I don't see that anymore." Now most Punjabi American farmers have big farms, at least one hundred to more than one thousand acres, Harbhajan said.

He may have arrived with no money, but Harbhajan Singh Johl did well. His secret to success: "When I started work in farming I saved, like any other person. If I made $10 a day, I tried to save $5 at least. And that's how you do it.…And a day would come when I would buy some more land and start farming it. Eventually, slow and steady, you have something," he said with a chuckle.

Work on his farm was shared by the family. His wife and children were working hands, getting up in the middle of the night to machine harvest the fruit. "I think we

Kulwant Johl grows peaches, prunes and almonds near Marysville. *Courtesy of California Farm Bureau.*

are where we are because of the hard work. Children were not spoiled. They were not roaming around at night," he said.

Harbhajan retired from John Taylor in 2001 but continued to farm 125 acres of peaches, plums and walnuts. His two sons and two daughters are well educated and married, but one son and grandson still helped on the farm. He said he was grateful for the opportunity for honest work and education the United States had given to him, something he did not have in India. He didn't even mind paying high income tax, feeling that when the country had given him so much, he wanted to give back. Although he returned to India in 1965 to get married, he did not stay long. He was happy in America. "I became a citizen in 1970. The way of life for me is now American all the way."

Harbhajan Singh Johl passed away in 2017 at the age of eighty-two. His obituary said he was a good man who "left this world a better place than he found it."

Among the relatives Harbhajan sponsored and helped settle in Yuba City was Kulwant Johl.

FOLLOWING IN HIS FOREBEARS' FOOTSTEPS

When Nand Singh Johl left India, his son, Kulwant Johl's father, was two years old. He grew up, married and had a family without seeing his father again. Kulwant was six when news of his grandfather's death reached Jindayala village. When it was Nand Singh Johl's grandson's turn to come to America in October 1970, Kulwant Johl was nearly twenty years old. "You are really kind of nervous when you come, but my parents gave me assurance that 'you are going to live with your uncle, he will take care of you,'" Kulwant recalled.[74] "It's not like when my grandfather came. I sometimes wonder how he survived here. I don't think he even knew where he was going. You know, he was not educated. Nobody was there to receive him or support him."

Kulwant's wife, Jaspal, accompanied him from India. His uncle Harbhajan sent him to college, first Yuba College, then to Chico State, where Kulwant majored

The Kulwant Singh Johl family. *Courtesy of Kulwant S. Johl.*

in agriculture. "After that he got me a job. This was his desk," Kulwant said in his office at John Taylor Fertilizer Company, where he is a consultant. In the tradition of Punjabi farmers in California, he has a day job and looks after his peach orchards in the mornings, evenings and weekends. His brothers eventually joined him in America, and together they farm nearly one thousand acres, each farming his own land, helping each other out when necessary. Unlike his grandfather, Kulwant Johl and his family visit India from time to time. He appreciates how different it is for his generation. "Everybody who comes here now has somebody here, relatives or friends, to look after them, so it's not as hard now as it used to be," he said, adding, "and we have temples here."

Kulwant is on the board of the Yuba-Sutter Farm Bureau and was its president from 2006 to 2009. He is also active in the Punjabi American Heritage Society and was on the museum exhibit committee.

NOOR KHAN

Fellow farmer and pioneer descendant Noor Khan dropped by Kulwant's office and joined our conversation about the immigrant experience. "My grandfather, he had a poultry farm in the 1800s in Petaluma. At that time, foreigners could own property. And he went back and married in 1900, and then my dad was born. We didn't have any links with America for about thirty, forty years. Then Dad came here in the early '50s," he said, but his grandfather stayed in

Noor Khan with his brothers. *Courtesy of M.A. Khan family.*

India, where he died around 1947. "Dad got married, and there were three of us boys that were born; Mahmood wasn't born yet when he came to America."

The Khans are Muslims, and the part of India where their family lived became Pakistan. Noor Khan said his father came to America in 1956, returning to Pakistan for his wife and four sons—one of whom was Noor—in 1962. "And we've been here

ever since. Going back and forth," he said. Four more boys were born in America. "My grandfather, he came by boat, he had to work his way, you know on those steam liners. It took him a couple of years to get here," he said. Noor Khan's family is from the area near Peshawar, in Pakistan. "Our ancestors came from Iran, then Afghanistan and then Pakistan. We are Pathans; our native tongue is Pashtun," he said. He went to Pakistan to marry and brought his wife back. Noor Khan and his brothers have farms in the Yuba-Sutter area, where they raise almonds and produce prunes. Noor Khan died in 2021, aged seventy.

Centers of Worship

Most Punjabi Americans in Yuba City are Sikhs or Muslims, but there is a small Pentecostal Christian Punjabi American Church in town. Those growing up with Mexican mothers and Punjabi fathers had two religions observed at home. Punjabi Americans may be Catholics, Jehovah's Witnesses or other religions. Sikhism is a major religion in Yuba City, just as it is in the Punjab. A gurdwara, or Sikh temple, is the center of Sikh religious life. It is a gathering place for the community. That is why founding the Stockton temple in 1912 was a priority.

Members of the Sikh community, even those settled in other states, donated money to build and maintain this temple, and the annual meetings drew people from all over California and beyond. With the small migrant congregation, which in the early days included Muslims and Anglo or Mexican wives, there was a casual approach to observance of gurdwara rules, as members adjusted to different circumstances in another country. Clean-shaven Sikhs who had relinquished their turbans were the norm. Chairs were put in the temple, replacing the custom of sitting on the floor. In the 1940s, some members challenged the way the temple operated and introduced reforms.

The Sikhs in the Imperial Valley founded their own gurdwara in 1948 after purchasing a Japanese Buddhist temple in El Centro. It is still active today. Until Yuba City's temples were built, religious observances often were

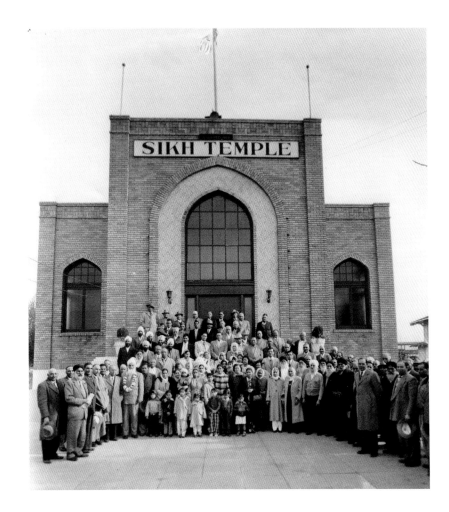

The "new" Stockton Sikh temple, dedicated in 1930, drew congregants from all over California and neighboring states. *Courtesy of PAHS.*

held locally in private homes because Stockton was so far. Any Sikh may read the Guru Granth Sahib for a prayer service. A trained priest is not essential. Some Sikh homes have a prayer room or corner where the Sikh scripture is enshrined and where daily prayers are recited.



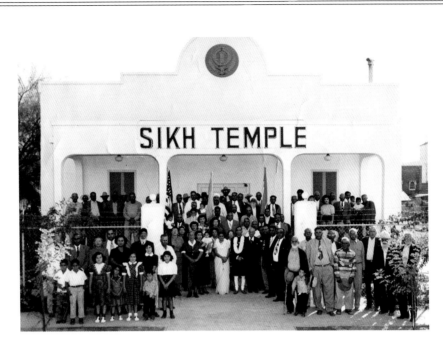

OPPOSITE, TOP: The interior of the Tierra Buena temple during services. © *Dean Tokuno.*

OPPOSITE, BOTTOM: The Sri Guru Nanak Temple, Bogue Road, Yuba City. *Courtesy of PAHS / Jamila Krambo.*

ABOVE: The Islamic Center of Yuba City. *Courtesy of the Islamic Center of Yuba City.*

Road was donated by Bakhtawar and Udham Singh Purewal for the temple. Other community members, including Didar Singh Bains and Dr. Narender Singh Kapany, have donated land and funds over the years. By 1970, the Yuba City gurdwara was built and functioning. At last, major holidays could be celebrated locally in a striking, Indo-Persian–style temple. It was a significant change for the Sikh community. A newsletter informed

Holi celebrations at the Shri Narayana Hindu Temple, Yuba City. *Courtesy of the Appeal-Democrat.*

the community of events. Daily morning and evening prayers were said at the gurdwara, just as at the Golden Temple in Amritsar. A few years later, another gurdwara was built in Yuba City on Bogue Road. Today there are about thirty gurdwaras in California.

Muslims also wanted permanent places of worship. A Muslim Association was started in 1917 to respond to the religious needs of Muslim immigrants, mainly to ensure proper burials. As Bob Mohammed recounted, important religious functions were held in private homes or in rented halls. In 1944, a Mosque Association was formed to raise money to build a mosque. The first mosque in California was completed in 1947, in Sacramento. It became the religious center for Northern California Muslims just as the Stockton gurdwara had been for Sikhs. Bruce La Brack writes: "Not only did the Muslim finally have a place of worship, but his co-religionists were often not only South Asians, but Arabs, African Muslims, and other followers of Islam from around the world. This pan-Islamic perspective tended to draw them together at the

same time it increased the distance between Muslims and both the Sikhs and Hindus."[75] There are well over one hundred mosques in California today. Yuba City now has its own mosque, as do other Central Valley cities with substantial Muslim populations. Sadly, in 1994 the Yuba City mosque burned down in a fire determined to be arson. It has since been rebuilt.

There were few Hindus in the early years despite the widespread use of the word *Hindu* to describe all South Asian immigrants. Actual Hindus began to come in larger numbers after 1946. Eventually, they, too, founded their own temples. The first Hindu temple in Yuba City, the Sri Narayan Temple, was built by a Sikh, Hardial Singh Hunji.

HARDIAL SINGH HUNJI

An example of inclusiveness was set by Hardial Singh Hunji, who was thirty-two when he came to the United States in 1948 from his home in Mugwal village, Hoshiarpur District of the Punjab. His father, Gurdas Singh Hunji, had immigrated in 1910 and managed a farm in Lodi. When Hardial arrived, he was put to work there as a farmhand, where, he said, he worked "sunrise to sunset, seven days a week." He wanted to go back to India, but his friends and coworkers suggested that he earn his fare first, rather than make his father bear the expense. "It has been sixty years, and I still don't have that money," he said.[76] He eventually returned to India three times, first to bring the ashes of his father, then his mother and finally his wife to the land of their birth.

Hunji, a Sikh, was married to a Hindu woman, Kushalia Devi. When he felt financially secure, he brought his wife and daughters to California in 1952. He bought farmland in Yuba City and became a peach and plum grower. With his cousin he also purchased land in Washington where they grew asparagus. By 1956, they were farming 250 acres in all. When his wife arrived, she missed having a Hindu temple to visit. In time, Hunji donated $1.8 million in cash and land on Franklin Boulevard in

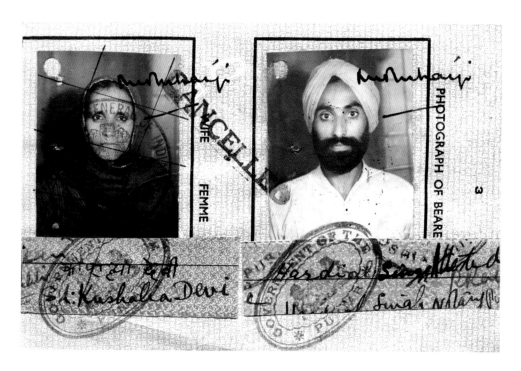

ABOVE: Hardial Singh Hunji and his wife, Kushalia Devi. *Courtesy of PAHS.*

LEFT: Hardial Hunji, the Sikh who built a temple for his Hindu wife. *Courtesy of PAHS.*

Yuba City for the Sri Naryan Hindu temple. He said he did not want to force his wife to change her religion to his. "We should nurture one's religious feelings," he said. His wife was still alive when work began on the temple, and after she died in 1993, Hunji completed it in her memory. It is the first Hindu temple in Yuba City. Hunji was the major contributor.

Not neglecting his own roots, he donated money to the gurdwara in his home village to build a school. He also generously supported the Guru Nanak Singh Temple on Bogue Road. His other charitable causes included those that help homeless individuals and Rideout Foundation. Like other old-timers, he wasn't impressed with the younger generation or the direction society has gone. "Youngsters don't realize what kind of difficulties their forefathers faced to bring the comforts they are enjoying these days," he said. Kushalia Devi went to college and became a real estate broker. Hardial Hunji died in 2017, a month before his 101st birthday.

After 1946, more educated immigrants came from the Punjab than ever before. They often were direct beneficiaries of a pioneer relative's remittances. It became easier for the younger generation to get a high school education in India, so more arrivals had at least a basic education. Some had college degrees. Many who had college degrees came for higher education and stayed to set up successful careers in America.

HARI SINGH EVEREST

Hari Singh Everest was the first South Asian teacher hired by the Yuba-Sutter school system. He had several skills when he arrived in the United States at the age of thirty-nine. Born in Lalpur in the Punjab that is now in Pakistan, he was educated at Punjab University in Lahore and worked at a publishing house there for four years. He also wrote for an education journal. It was when he chose the name Everest: "I picked out the unconquered mountain of Everest as my pen name," he said in an interview at his home across from the Sikh temple on Tierra Bucna Road, where he lived with his wife and son's family.[77] He was a civil servant for the government of India under British rule, where he was employed at Indian independence. He saw the sufferings of partition firsthand. "After independence I felt Sikhs would not be in the same position as under the British," he said. When his name came up on the American visa quota list, he decided to take the chance. "I left my wife and children—my son was less than one year old—and I came alone to find out whether I can make it or not," he said.

OPPOSITE, TOP: Hari Singh Everest with children. *Courtesy of the Everest family.*

OPPOSITE, BOTTOM: Hari Singh early in his teaching career with school principal Hartman, 1960. *Courtesy of the Everest family.*

ABOVE: Hari Singh Everest with his wife, Amar Kaur. *Courtesy of the Everest family.*

He came to America on the *Queen Mary* in 1955. A few days after disembarking in New York, he boarded a Greyhound bus bound for Stockton. "All I knew is that there was a Sikh temple in Stockton. There was no other Sikh temple in the United States," he said. Everest had been accepted to several American universities, including Stanford, his university of choice. But he didn't have the $6,000–$7,000 annual tuition, so, like immigrants before him, he went to work in the fields. It gave him a special perspective on America. "I had the experience in this life how the illegal Punjabis were treated. I stayed within the labor camp of Mendota, saw what they were eating, what their life was, how they were scared of immigration [authorities], and they just didn't have any spokesperson." He said, "I started farm work, 85 cents an hour...It took me more than a year to have funds I needed, and in April 1956 I joined Stanford." He was the only turbaned Sikh on campus.

Everest became a citizen in 1960 and, on the recommendation of a friend, obtained teaching credentials. He got his Yuba City teaching job in 1961. At his job interview, when asked whether he would wear his turban while teaching, he said, "You made me a citizen like that, you gave me a teaching credential like that, what is wrong if I go to the classroom like that?" He was hired, the first Sikh schoolteacher in California. Everest said he encountered some discrimination because of his appearance, but it was nothing

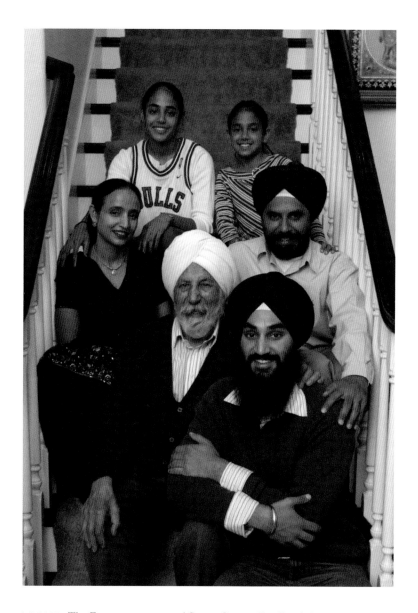

ABOVE: The Everests were named Sutter County Family of the Year in 2005. Hari Singh (*center*) is flanked by his son Paramjit, daughter-in-law Surinder and grandchildren Amarpreet, Harkiren and Harpreet. *Courtesy of the* Appeal-Democrat.

OPPOSITE: Dr. Paramjit Singh Everest is a dentist who grew up in Yuba City. © *Dean Tokuno.*

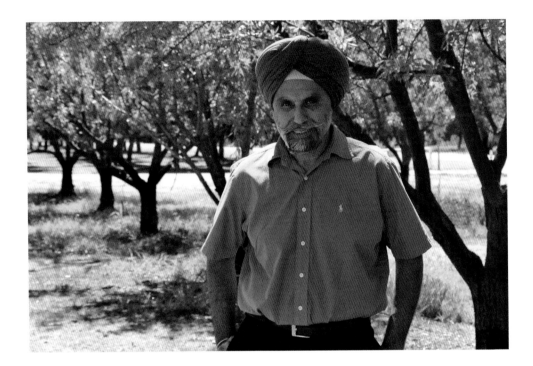

compared to what some other immigrants had to endure. "And I marvel at their tenacity, marvel at their sturdiness," Everest said of the field hands who dreamed of being farmers, whom he knew from his time as an agricultural laborer. "Unless you are in their shoes you can't really understand how these people were living, dying, what their dreams were about."

With a secure teaching job, he sent for his wife, Amar Kaur, in 1965. He spent forty years as a teacher, always engaged in the community. He was on the advisory council for Yuba College. Into his nineties, he still wrote and worked in the library, participating regularly in Sikh temple activities.

His children have grown up to follow in his footsteps. Son Paramjit, a dentist, is active in the community coaching basketball and gives free dental care to those in need at the gurdwara clinic. He is a founding member of the Punjabi American Heritage Society and active officer. Paramjit credits his upbringing and his parents for inspiring him. Their community service was recognized when they were named Sutter County Family of the Year in 2005. Family patriarch Hari Singh Everest died in 2011.

BOB AND VEENA SINGH

Baldev "Bob" Singh, an educator who enjoyed politics, came from India in 1954 to study at Yuba College. He went on to the University of Oregon in Eugene, earning a master's degree in international relations. "My English was good because I had left the village a few years earlier and I didn't have much of an accent. Lucky for me, my instructors sort of adopted me, invited me to their homes, and to talk to service clubs, so I didn't have much trouble," he said about adjusting to American life.[78]

He returned to India for a year to teach and marry his wife, Veena, but North America called. He returned to Canada but soon found himself in Oregon again to complete his studies, where Veena joined him. After getting his teaching credential, he was back in California teaching high school in Modesto and part time at Modesto Union College. After nine years in Modesto, he decided to relocate to Yuba City. "Luckily Yuba College gave me the job right away, so I taught at Yuba College from 1972 to 1998," he said. Even after retiring at sixty-two, he continued to teach a few classes. He was on the Yuba College foundation board of directors.

Always politically active, Bob Singh's enthusiasm for politics led him to become a delegate to the 1972 Democratic convention, one of the first Indians to be chosen. His community service includes being vice president of the Democratic National Committee, stints on the Yuba-Sutter County Fair Board and the Sutter County housing authority, where he was commissioner for eighteen years and chairman four times. He was a founding member of the Board of Directors of the Sri Guru Nanak Sikh Temple in Yuba City.

Perhaps Singh's greatest contribution has been his involvement with his students: teaching, mentoring and helping them enter productive adult lives. His wife, Veena, also a teacher, made her own contributions in this regard.

Bob Singh had many memories of Yuba City Punjabis: "Chanchal Rai gave money for the Bogue Road temple…very generous," he said. Times have changed, he said, from when there were few South Asians in politics. On the 2006 election of Tej Mann and Kash Gill to the Yuba City Council, Bob Singh said, "It speaks very well for the mainstream Anglo community, that it's changing, becoming more tolerant, more open, because the

OPPOSITE, TOP: Bob and Veena Singh, London, 1980. *Courtesy of UC Davis Library Special Collections.*

OPPOSITE, BOTTOM: Bob Singh, an educator keen on politics, with the Dalai Lama. *Courtesy of PAHS.*

two of them could not have been elected without the help and the votes of enough white people." He added, "Our community is transforming itself now," a welcome transition from earlier days. "The ones who came before us were the victims of a lot of prejudice… Their wages were low, they weren't educated, their hands were tied behind their backs," he said. Bob Singh passed away in March 2022 after a lifetime of public service.

TEJINDER "TED" SIBIA, A LIBRARIAN PASSIONATE ABOUT PUNJABI AMERICAN HISTORY

Tejinder "Ted" Sibia compiled an invaluable online archive of the Punjabi American immigrant community during his years as librarian at the University of California, Davis. Born near Ludhiana in India, he came to United States in 1960

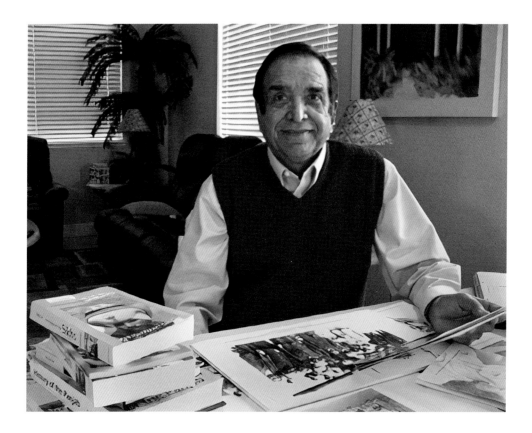

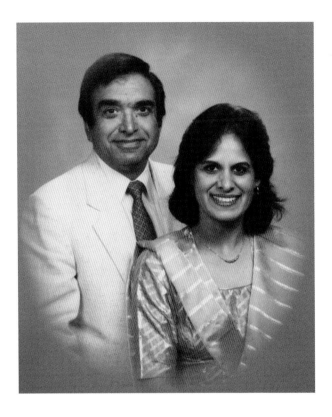

to earn his master's degree in horticulture at Kansas State University. He later obtained a master's in library science from Emporia State University. Sibia began his library administration career in Kansas but took a position at the University of California, Davis, in 1978, where he headed the Biological and Agricultural Sciences department at the Shields Library.

Sibia and his wife, Manjeet, involved in the Sacramento gurdwara, started a Sunday school cultural program there in the 1980s. Sibia pursued his interest in educating people about Sikh culture and Sikh history in America by bringing it online in the 1990s. The Sikh Pioneers website he created was a rich source of historical photos and information about the community

OPPOSITE: Ted Sibia initiated the Punjabi Pioneers digital archive while he was UC Davis librarian. *Courtesy of UC Davis Library Special Collections.*

ABOVE: Ted and Manjeet Sibia. *Courtesy of PAHS.*

in North America. After his retirement from UC Davis until his death in 2008, Sibia devoted much of his time to collecting archival material. He encouraged and touched thousands of students. He was a key organizer of the Sutter County Museum exhibit on South Asian immigrants. Sadly, he passed away before he could see the fruit of his efforts.

GURMEET AND JAGTAR SIDHU

Jagtar Singh Sidhu was born in Lalpur, now in Pakistan, to a prosperous landowning family. He was seventeen during the 1947 partition of Pakistan and India, when, like many Sikh and Hindu Punjabis, he migrated to India. After studying chemistry at Aligarh University, he went to England as a student in 1953. He majored in food technology and processing at Imperial College, London. He owned a cannery in London, but he only attained his dream of owning a farm later, in the United States.

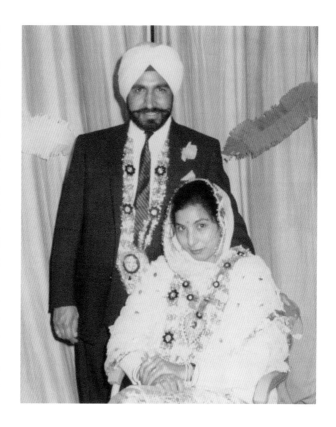

Gurmeet took a bachelor of arts degree in history and political science and a master of arts degree in sociology from Punjab University in Chandigarh, India, before moving to London, where she received a teaching certificate and taught elementary school for five years. She met Jagtar over tea at a friend's house in London. "It was a 100 percent arranged marriage," she said.

After a friend in Oakland sent him an article about Yuba City, Jagtar visited. He made a life-changing decision. He and Gurmeet moved to Yuba City in 1968. He became a peach farmer. Jagtar applied his business expertise and knowledge of food and food processing to production at his 150-acre farm.

Once in Yuba City, Gurmeet received a master of arts degree in education at California State University, Sacramento. For thirty years, from 1975 to 2005, when she retired, Gurmeet worked in migrant education covering an area from Chico to

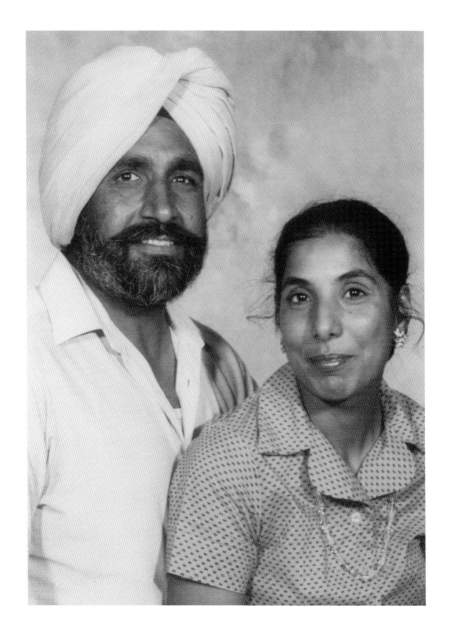

OPPOSITE: Gurmeet and Jagtar Sidhu after their London wedding. *Courtesy of Gurmeet Sidhu.*

ABOVE: Gurmeet and Jagtar Sidhu, settled in Yuba City. *Courtesy of Gurmeet Sidhu.*

Santa Rosa. She held several positions as teacher, specialist and principal during those years, encouraging many migrant children and their families to pursue education. She developed English Language Learner strategies, programs about South Asian and other cultures and worked in early child development, among other things.

Jagtar devoted himself to farming and community service, contributing to the Tierra Buena gurdwara, particularly for educational programs. So did Gurmeet. As members of the Punjabi American Heritage Society, they helped organize the exhibit on Punjabi Americans at the Sutter County Museum, Gurmeet serving on the museum committee.

Jagtar Singh and Gurmeet Sidhu had three children, a daughter who is assistant director of the undergraduate budget office at UC Berkeley, and two sons, who became software engineers. Jagtar passed away in 2007.

Men may have been at the forefront of immigration, but the women, once here, made significant contributions, particularly as educators. The daughters of Kartar Dhillon, Ayesha and Dildar, became distinguished academics. Davinder Deol is a prominent educator in the community. Prabjhot Johl continued to shape young minds in elementary school until her retirement. Veena Singh, Bob Singh's wife, also had a successful career in education, as did Gurmeet Sidhu. Punjabi language is offered in several Yuba-Sutter area schools as part of the regular curriculum thanks to Punjabi American women who introduced the language and volunteered their time to teach it.

CHAPTER 11

SETTLED AND PROSPEROUS: ACHIEVING THE DREAM

A turban-wearing Sikh on a bicycle is not an uncommon sight in Yuba City. *Courtesy of PAHS / Laura Schwoebel.*

The worst days were behind them: South Asian immigrants legally belonged; they owned property and were able to become U.S. citizens. Their American roots were no longer tentative; they were strong. Comfortable houses replaced the shacks of labor camps.

Punjabis led the way as pioneers. Today immigrants come from all over South Asia. New immigration regulations favored skilled individuals and family members, so the constellation of the South Asian immigrant community changed. Hard agricultural labor was no longer the chief road to success.

Joining the flow of professionals, academics and others were tech entrepreneurs. In the 1990s, information technology specialists from India filled the offices of California's Silicon Valley and the Microsoft hub in Redmond, Washington. South Asian entrepreneurs helped build Silicon Valley and fund its growth.

California still has the largest concentration of South Asians in the United States. Yuba City remains the Punjabi American heartland. It's often called *Chhota Punjab*, or "Little Punjab" for that reason. You can walk down a Yuba City street or stop for gas and hear Punjabi and Hindi music playing. In Target and Walmart—built on land purchased from Didar Singh Bains—women, young and old, wander the aisles quite comfortably in Punjabi dress. Indian grocery stores and restaurants are easy to find. After 1965, the number of South Asian immigrants to the United States rose dramatically and continues to rise. Studies show that they are not only the largest group of immigrants to the United States but also well educated and economically secure.

MILITANCY IN THE PUNJAB SPURS IMMIGRATION

Besides the opportunities America offered, political concerns caused many Sikhs to emigrate in the 1980s. What began as a peaceful movement that called for greater autonomy in the Punjab attracted extremist members who sought, sometimes violently, a separate Sikh state, Khalistan. Separatist leaders occupied the Golden Temple complex in Amritsar for weeks in 1984 before they were removed in a military action called Operation Blue Star.

After the Indian army breached the sanctity of the Golden Temple, Sikhs who already felt slighted by the Indian government felt betrayed. Rather than contain the militancy in the Punjab, Operation Blue Star exacerbated it, increasing tensions between the Sikh community and the government. Not only were militants and

civilians in the Golden Temple killed, but also the sacred shrine was severely damaged when the army shelled the temple complex. Other Sikh temples around the country were besieged. To Sikhs in India and around the world, it was an attack on their religion by the government of India.[79]

According to Human Rights Watch, more than six thousand Sikhs were detained, often ruthlessly. There were extrajudicial killings. Militant Sikhs pledged revenge. Five months after the attack on the Golden Temple, Prime Minister Indira Gandhi, who ordered Operation Blue Star, was assassinated by her Sikh bodyguards on October 31, 1984. In the four days following her assassination, thousands of Sikhs were killed in rioting throughout northern India. The worst of the killing took place in and around the capital New Delhi, which has a large Sikh population. Sikh shops were looted and burned; men were dragged out of their homes and cars by murderous gangs, beaten with iron rods and set on fire; thugs boarded trains to murder Sikh passengers. Much of the violence was allowed, condoned and in some cases orchestrated by politicians from PM Gandhi's Congress Party. Government figures state that about three thousand Sikhs were killed in Delhi alone. Other estimates are higher. Journalist Kushwant Singh said five thousand died.[80] This, on top of the violation of the Golden Temple, set even moderate Sikhs against the government. Historically Sikhs have been patriotic citizens, as civilians and members of the military. They were in the forefront of India's independence struggle.

Militancy now exploded across the Punjab. Bombs were planted in Delhi cinema halls. Sikh militants targeted politicians for assassination. Innocent civilians became frequent victims of militants or reprisals by government forces. Gunmen attacked buses and trains in the Punjab. This continued through the 1980s.

It was difficult for people to live normal lives. Whole families left or sent their children abroad for safety. Many Sikhs came to America

DR. JASBIR KANG BELIEVES IN UNITY ACROSS CULTURES

Dr. Jasbir Singh Kang's decision to come to America was prompted by human rights abuses in India. Recalling the 1984 targeted killings of Sikhs in New Delhi, he said, "I never expected those things can happen in a democratic country." He obtained a medical degree from the prestigious Government Medical College in Patiala before he came to America in 1986. After a demanding residency in internal medicine at Chicago's Cook County Hospital, he moved to Yuba City in 1991. "A

large concentration of the Punjabi community was an attraction," he said, "It was not the only reason I came here, but it was one of the major reasons."[81] These were "people with similar values." The area also reminded him of the Punjab.

After interacting with his patients in Yuba City, he saw was a lot of ignorance about Sikhs. "I knew Sikhs were here for a hundred years, but still people knew very little about Sikhs. Sikhs were not well understood."

Despite business and occasional social interactions, the average American knew little if anything about Sikh culture and values, "which I think are very much American values," Kang said. "I will not say I was discriminated against. I was met with a lot of 'stranger' anxiety from people. They don't know, and I don't blame them," said Kang, who, according to Sikh custom, wears a turban and beard.

TOP: Jasbir S. Kang, MD, co-founded the Punjabi American Heritage Society. *Courtesy of Jasbir S. Kang.*

LEFT: The Kang family in India. *Courtesy of Jasbir S. Kang.*

OPPOSITE: The Punjabi American Heritage Society group photo. *Courtesy of PAHS.*

He saw a need for an organization that would help explain Sikhs and promote more interaction and cross-cultural understanding. There had been South Asian associations formed in the past, but those were different times, when the Punjabi American community was much smaller. Now it was large. Multigenerational families live together; marriages are made in South Asia; and Hindu, Muslim and Sikh places of worship are common. South Asian culture and tradition are alive in America but not fully shared.

It was time for new areas of social integration to be explored. "It helps if communities can see us as one of them, not see us as outsiders. I want them to see us as Americans."

THE PUNJABI HERITAGE SOCIETY

Some of Kang's friends supported the idea. In 1993, the group organized an event at Yuba City High School, inviting all the teachers for a "teacher appreciation." They hosted a dinner party with entertainment by Punjabi performers and a slide show. It was a success, and many of the guests said they learned things about Punjabis

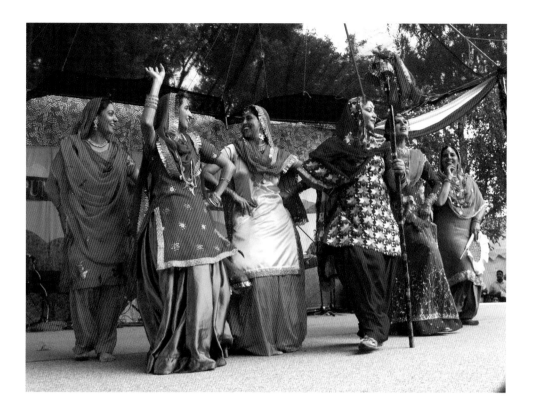

ABOVE: Costumed dancers perform traditional Punjabi dances at the annual Punjabi American Festival. *Courtesy of Jasbir S. Kang.*

OPPOSITE, TOP: A professional Punjabi folk dancer at the festival. *Courtesy of PAHS.*

OPPOSITE, BOTTOM: Ladies dressed for the festival carry brass pots, often used in India. *Courtesy of PAHS.*

they didn't know before. It was the beginning of the Punjabi American Festival—and the Punjabi American Heritage Society. The group decided to organize a bigger event, where everyone could experience Punjabi culture and "where our own children can understand their roots," Kang said. He said they wanted to include everyone, regardless of ethnicity or religion.

"We already had a Sikh Parade, which is a great event, but sometimes people tend to treat religious events like they are just for Sikhs." The parade is an annual event, every November, that honors the Sikh holy scripture, the Guru Granth Sahib. "Everybody's welcome. Sikhs believe in universal equality and inclusiveness," Kang said. But it was

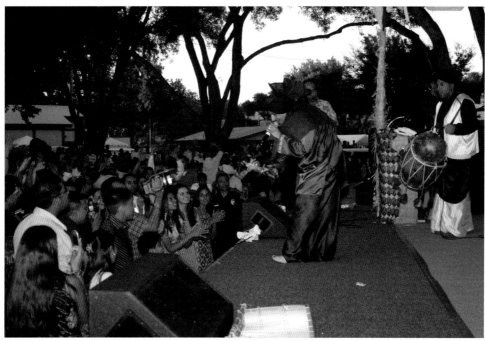

OPPOSITE, TOP: Trinkets stall at the festival bazaar offering Indian hand drums, elephants and brass lamps. *Courtesy of PAHS.*

OPPOSITE, BOTTOM: Singer Jazzy B performs for the festival crowd. *Courtesy of PAHS.*

ABOVE: Children wait to perform at the festival. *Courtesy of PAHS.*

still perceived as a Sikh event in the general community. They wanted the festival to be a mainstream event. "We wanted to say to everybody, come on in!"

The festival, now an annual event, has grown. When it is held at the Yuba-Sutter Fairgrounds on Memorial Day weekend, thousands attend to watch local children, adults and professional dancers and singers perform. Typical Punjabi dishes such as kababs, chole bhature and biryani are on the menu. Stalls resembling those in a North Indian bazaar are stocked with trinkets, Punjabi-style clothing, jewelry and handicrafts.

Kang embodies the dynamic and enterprising spirit of Punjabis with his thriving medical practice on Plumas Road. A born organizer, he was instrumental in forming

Jasjit Singh Kang receives the Spirit of Freedom award for public service. With him is his mother, Charan Kaur Kang. *Courtesy of Jasbir S. Kang.*

the medical group that developed the complex on Plumas Boulevard. "There are twenty plus physicians in this community," he said of the Sikh doctors. "In Yuba City there is no specialty where there is not a Punjabi American physician." In 2009, he became chief of medical staff of two hospitals in the Yuba-Sutter area and received the "Physician of the Year" award. He says Punjabis are doing well in all kinds of businesses, large and small, from gas stations to hotels and construction. "We have bankers, we have realtors," he said. "You name it."

He and his brother Jasjit, environmental health director for San Joaquin Valley, started a public service program on a local television station in Punjabi called *Aapna Punjab* (Your Punjab). American and South Asian notables were interviewed. Guests might be politicians, intellectuals or celebrities. Health and other public concerns were highlighted. After the terrorist attacks of September 11, 2001, such public outreach was critical, as Sikhs became the targets of hate crimes. "It became very

important that our people should spread more information about who we are and how we are different," show host and producer Jasjit Kang told the *Appeal-Democrat* at the time.

FIGHTING STEREOTYPES AND MISUNDERSTANDING

Dr. Kang takes pride in his work on promoting mutual understanding. When it became known that Arabs linked to Osama bin Laden were responsible for the September 11 attacks, backlash fell on Sikhs and Muslims. The turbans and beards worn by observant Sikhs made them stand out as targets. That's what happened to Balbir Singh Sodhi, the first American Sikh to be murdered because of "mistaken identity," as Sikhs call it. The man who shot Sodhi also shot at a Lebanese American and the home of an Afghan family. The harassment of Sikhs persists.

Dr. Jasbir Kang (*center*) receives the KVIE local hero award from then KVIE president David Hosley (*left*). Also pictured is Kevin Smith Fagan (*right*). *Courtesy of Jasbir S. Kang.*

Who Was Balbir Singh Sodhi?

Balbir Singh Sodhi had friends among Punjabi American Californians. His death on September 15, 2001, days after the September 11 attacks, pushed some American Sikhs into activism.

A gas station owner in Mesa, Arizona, Sodhi was working with a landscaper on his property when a man drove by in a pickup truck and shot him dead. Why? Because he wore a turban reminiscent of Osama bin Laden. The killer wanted revenge for the September 11 attacks.

After Sodhi came to America, he drove a taxi until he saved enough to buy the gas station where he died.

He was a generous man. Upset by the September 11 attacks, the morning he died, Balbir Sodhi donated money to help its victims. In a *Story Corps* broadcast first aired on National Public Radio in 2018, his brothers Rana and Harjit Sodhi remembered him. Harjit said that when they opened the gas station, "I saw he gave the free candies to children, free drinks. And some people, they not have [*sic*] enough money, he said, 'Pay me tomorrow.'"

Rana said that after bin Laden's photo was widely published, "People yell to us using F-word and asking to 'Go back to your country.'" Friends and neighbors warned them to "be very careful" and asked if they could remove their turbans for safety, "But I say, 'This is part of my religion, I can't take off my turban.'"

Balbir's murder devastated the family. Even so, Rana said he talked to the man who killed his brother in 2016. "He say that if he die and go to the God, only thing he want to do is see my brother and say sorry to him. You know, Balbir's death teach us love and peace. And I decided this is my mission of my life."

Dr. Kang with wife Sukhjit and kids on Alaska vacation. *Courtesy of Jasbir S. Kang.*

Kang and some of his colleagues worked overtime in the months following September 11, giving talks, writing articles and doing whatever they could to explain to people that Sikhs are not terrorists but responsible Americans. "Obviously as an American I was very hurt about what had happened to our country. And then I was doubly hurt that we were blamed." Rather than being angry, Kang felt it was his duty to help other Americans understand. He worked closely with the Sikh gurdwara to organize open houses, educational and media events to better inform non-Sikhs in the area. He collaborated on a documentary film, *Mistaken Identity*, about Sikhs in America after September 11. For his work, Dr. Kang was named one of five Asian Pacific American Local Heroes in 2006, an annual award given by the Sacramento public television station KVIE for outstanding public service.

Kang has served on the board of the Great Valley Foundation, was a founding member of Way Way Off Broadway and coordinated work on the *Becoming American* exhibit at the Sutter County Museum, installed in 2012. He worked with Nicole Ragnarath to build the Punjabi American digital archive at UC Davis and assisted in her effort to introduce a Punjabi language course at the university. Dr. Kang's wife, Sukhjit, and his three children likewise are active in Yuba City community functions.

A board member of Adventist Health-Rideout Foundation and medical director at Yuba-Sutter Medical Group, Dr. Kang belongs to a huge network of South Asian American doctors, dentists and health workers, men and women who are increasingly important to the American healthcare system.

Explaining Sikh Identity

The Washington, D.C.–based Sikh Legal Defense and Education Fund (SALDEF) was founded to protect Sikh civil rights. The organization monitors the media for misinformation about Sikhs, provides legal aid and educates non-Sikhs about Sikh customs. SALDEF offers training to federal, state and local agencies, particularly law enforcement. Co-founder and chairman Manjit Singh consults with the U.S. Department of Justice to improve sensitivity of agents to Sikh religious practices and guard against civil rights violations.

Sadly, in the years since Sodhi's murder, hate crimes against Sikhs have continued. These include harassment, beatings and murder. A horrific hate crime was perpetrated on worshippers at a Sikh temple in Oak Creek, Wisconsin, in August 2012. A gunman killed six people and wounded four others before shooting himself. The killer was a known white supremacist with links to neo-Nazis.

The Oak Creek Sikhs reacted with forgiveness that moved the town's police chief, John Edwards, to commend the "compassion, concern, support" that he saw from the community. "What I didn't see was hate," he said. "I want you all to understand how unique that is."

The Sikh Coalition has reported thousands of incidents of attacks on Sikhs since 2001. Sikh children are bullied at school, and Sikhs are routinely singled out by airport security. In 2018, the well-liked mayor of Turlock, California, Surjit Malhi, was attacked by assailants who viciously beat him with sticks, telling him to "go back to your country" and spray-painting a white supremacist symbol on his truck. Attacks, especially on elderly Sikh men, have increased in recent years.

The National Sikh Campaign found that 60 percent of Americans know little to nothing about Sikh Americans. They don't know that the Sikh religion is one of peace and that hard work and community service are core Sikh values.

PUNJABI AMERICANS IN POLITICS

For some Punjabi Sikh Americans, community service means holding public office. Kash Gill and Tej Singh Maan were the first Punjabi American Sikhs to be elected to public office in Yuba City. Both hail from the Punjab originally, immigrating as children with their parents. They made news in 2006 when they were elected to the Yuba City Council.

Kashmir "Kash" Gill, the First American Sikh Mayor

Kash Gill was only three years old when his family arrived in Yuba City in 1967, sponsored by his uncle Didar Bains. They came from Hoshiarpur District in India's Punjab.

Kash Gill is a banker, farmer and the first Punjabi American mayor of Yuba City. *Courtesy of Kash Gill.*

He grew up working in his family's peach and plum orchards and attending local schools. These included Yuba Community College and California State University, Chico, where he studied agriculture business. He rounded that out by graduating from the California Agricultural Leadership Program and the Graduate School of Banking in Boulder, Colorado. He has pursued dual careers as a farmer and a banker ever since. He is currently senior vice president for Banner Bank, where he oversees agricultural lending.

"The nice thing about it is that I know firsthand what commodity prices are doing. I know if farmers are affected by weather. So I understand their pain when they are going through tough times because I am also a farmer," he said.[82]

ABOVE: Neena Gill celebrates her Athena Award, received in recognition of her community service. *Courtesy of Kash Gill.*

OPPOSITE: The Gill family. *Courtesy of Kash Gill.*

His political career began early, when, at age thirty-one, he was elected president of the Yuba City Chamber of Commerce—not only the youngest in that chamber's history but also the first Sikh. He served in the Rotary Club and on the hospital foundation. He decided to run for public office because he wanted Indian Americans to be better represented in local politics.

He narrowly lost his first bid for public office in 2004, but he won the second time he ran. When he ran for re-election, he got the second-highest number of votes, which put him in line for Yuba City mayor after serving as vice-mayor for a year. He was sworn in as mayor in 2009, the first Sikh mayor in the United States. He served a second term from 2013 to 2014, devoting time to upgrading the levees protecting the flood-prone town.

"It was a great honor to represent our Sikh community," he said, "but also nice to get things accomplished."

Gill's wife, Neena, was a valued educator before her untimely death in 2020. She and Kash married in 1987. She spent three decades as an academic counselor and professor at Yuba College in Marysville, mentoring young women, minority students and those from disadvantaged backgrounds. She called it her "dream job," according to her son Rajan. Her remarkable dedication and success resulted in Yuba College creating an award in her honor, the Neena Gill Spirit Award, to single out those teachers who show similar care for students.

In 2018, Gill was the recipient of the Athena Award, given by the Yuba-Sutter Chamber of Commerce in recognition of community service and advocacy for women. Battling metastatic breast cancer herself, in 2013 she helped raise $75,000 for an advanced 3D mammography machine for the local hospital.

She received two posthumous awards, one from Yuba College graduating students given to a faculty member who significantly helped them academically. The second honor was bestowed by Congressman John Garamendi, who included her in the 2020 Women of the Year awards. His statement appears in the Congressional Record. It reads, in part, "Neena Gill will be remembered as a tireless community leader whose constant smile and ceaseless gratitude brought joy to all around her."[83]

Tej Maan, Years of Public Service

Tej Maan arrived from a village in India's Punjab, speaking no English, in 1975. He was thirteen years old. Like other Punjabi immigrants, he picked peaches while he learned English at Yuba City High School. He went on to attend the University of California, Davis.

Maan spent his career working for the local government. He retired in 2017 after thirty-one years as director of Yuba County Environmental Health. "I've worked with many different organizations in the community, and this was just kind of the next step,"[84] he said of running for city council. His motivation was to represent the Indian American community. "As individuals we are very successful, whether we're doctors, bankers, farmers, we are all successful. We contribute to the community. But collectively we did not have a voice within the community," he said. Maan was pleased with the vote that elected him, which showed support across ethnic lines. He served two terms on the city council and has held other offices, including president of the Yuba-Sutter Fair Board and chairman of the American Red Cross Board. He is a longtime member of the Punjabi American Heritage Society and a co-founder of the Punjabi-Khalsa School.

In 2020, Maan jumped into the fray again, running for county supervisor in a race that saw three Punjabi Americans vie for the office—Maan, Karm Bains and Sarb Thiara—the latter two descendants of early immigrants to California. He lost that race but continues to be active in the community. He owns a walnut orchard in Yuba City.

Sarbjit S. Thiara, Businessman, Farmer

Besides vying for political office in his spare time, Sarb Thiara owns and manages six thousand acres of peaches, plums, almonds and walnuts. Harvesting, trucking, dehydrating and hulling operations are part of his farming business.

Like other Punjabi Americans, he began working in other farmers' orchards. He began his own business in 1972. He devotes time to community concerns and has been president of the Tierra Buena Sikh Temple. He is also involved in promoting the traditional Punjabi contact sport kabaddi, and he is owner of the Royal Kings USA kabaddi team.

ABOVE: Tej Maan has spent his adult life as a public servant in government and politics. © *Dean Tokuno.*

LEFT: Sarbjit S. Thiara is active in the community and kabaddi. *Courtesy of the Sarbjit S. Thiara family.*

Preet Didbal, Courage and Commitment

Preet Didbal, a Yuba City native, is full of positive energy—energy that landed her in public office. After years of working for the State of California, she first served on the Sutter County Planning Commission, then on the Yuba City Council. That led to her becoming the first Sikh woman mayor in the country in 2017.

Didbal's parents, Gamdoor Singh and Gurbaksh Kaur Didbal, came to the United States from India in 1968. With little education and no English, they headed to Yuba City, where they could find work as farm laborers. Being Punjabis, they knew farming well. Her father approached Punjabi American farmers to find work, among them Didar Bains. He helped the Didbals then, and he remains a family friend.

Gamdoor Singh's strong work ethic caught the attention of farmer Allen Eager in Live Oak. Eager hired him as a foreman for his properties. According to Preet, her father did not buy land to farm because he had four daughters. In traditional South Asian culture, boys carry on the family name and girls leave the family to marry. Nevertheless, she recalls a loving, nurturing family life growing up with her three sisters in the house her father bought.

Preet was the first in her family to attend college. But a sexual assault when she was nineteen years old turned her life upside down and delayed her education. "I was shunned out of Yuba City," she said. "I left Yuba City for many years." She sought help and eventually got her life back on track. "I went back to Yuba City to face it head on." She finished her education, earning a master's degree in public administration and health services and a bachelor of science degree in physical education and physical therapy. She married and had a daughter. She divorced her husband when her daughter was four years old and continued life as a single mother. She first spoke publicly about the rape at a forum on bullying a few years ago to encourage other women to open up about similar experiences and start "healing the body and healing the mind."

Didbal founded Redefine and Empower, an organization focused on giving young women confidence to become leaders. She coaches young women in life skills that restore self-esteem and enable them to achieve cherished goals.

"My passion is to empower women," she said, "because my entire life, because of culture, I was told 'no,' not because there was a lack of ability or a lack of work ethic, it was because I was a girl."

After her work for the state, she served for ten years as planning commissioner for the Sutter County Board of Supervisors and later for Yuba City. Entering politics was

Preet Didbal holds the 2020 Distinguished Service Award from the Sacramento State Alumni Association. Her motto: "Redefine and empower." *Courtesy of Sacramento State / Andrea Price.*

her next step. She ran for board of supervisors and lost, but she persisted. She ran for city council, was elected in 2014 and became Yuba City mayor in 2017

She still works for the state in process planning, teaches at California State University, Sacramento, gives workshops and is a running coach.

Karm Bains, Great-Grandson of Pioneers

Karm Bains descends from Punjabi old-timers on both sides. The Bains family has farmed the land in Yuba City since the early twentieth century, as has his mother Santi's family, the Poonians. Through his father Didar Bains's astute investments, Karm and his siblings, brother Ajit and sister Diljit, were born into a successful agricultural and development business. Karm joined his father's business after college.

"I'm raising the fifth generation in the same district. Our kids joke about it at the dinner table… ninety-six years here and not being able to move more than two miles," Karm said.

Karm looked for ways to contribute to the community besides through his work. He served on civic

ABOVE: Karm Bains is a fourth-generation Punjabi American, farmer and politician. *Courtesy of Karm Bains.*

OPPOSITE, TOP: Karm Bains with his wife, Harpreet; daughters Meaghan, Jaya and Devika; and son, Barron. *Courtesy of Karm Bains.*

OPPOSITE, BOTTOM: Karm (*standing*) with his father, Didar Singh Bains. *Courtesy of Karm Bains.*

boards and donated money to worthy causes. He decided to run for public office, and in 2020, he was elected supervisor for Sutter County. Two other Punjabi American contenders were among his three opponents.

He ran for office partly because he was raised to give back, and he wants to help his community grow in a positive way. "I want to be a unifier. I want to bring people together," he said. He aims to boost the local economy by making Yuba City more welcoming to businesses, among other things.

His political career began when he was appointed to the Sutter County Board of Education. When his term ran out, he ran unopposed for a second term. His bid for county supervisor was his first contested election and a real eye-opener. As a turban- and beard-wearing Sikh, he encountered bigotry along with the significant support that won him the seat. He was advised that he'd do better not stumping door-to-door himself. He did so anyway. "I got shooed off property," he said, and this fourth-generation American Yuba City farmer and businessman was told to "go back to your country."

Bains did not always wear a turban. He began to do so after the September 11 attacks. Bains is proud of his Sikh faith, which observes three golden rules set down by Guru Nanak: to remember God always; to be honest and hardworking; and to be generous, giving back through charity or however one can.

His father, Didar, taught him, "Be thankful that God gave you opportunity to serve." Karm Bains continues to farm and help run the family business.

"I'm working to bring everybody together," he said. "When people come together great things can happen. They influence each other in a positive way."[85]

BUSINESS, INNOVATION AND ENTREPRENEURSHIP

It's no secret that South Asian Americans dominate in Internet technology and play important roles in science and medicine. They are also legendary entrepreneurs. Their contributions are invaluable.

Dr. Narinder Singh Kapany: "The Man Who Bent Light"

One Punjabi American, Dr. Narinder Singh Kapany, helped pave the information highway with his research and inventions in fiber optics and laser technology. So important is his work, he is called the father of fiber optics. He also seamlessly bridged science and business.

Born in the Punjab, he grew up in Dehradun, in Uttar Pradesh. He went to Agra University and studied at London's Imperial College of Science and Technology, earning a doctorate in fiber optics. It was there in 1953, working with British physicist Harold Hopkins, that he successfully transmitted high-quality images through fiber

ABOVE, LEFT: Portrait of Dr. Narinder Singh Kapany. *Courtesy of the Kapany Collection.*

ABOVE, RIGHT: Dr. Kapany with a prototype of a laparoscope, a fiberoptic tool now used routinely in surgery. *Courtesy of the Kapany Collection.*

bundles. He coined the term *fiber optics* in a 1960 *Scientific American* article. "When light is directed into one end of a glass fiber," Dr. Kapany wrote, "It will emerge at the other end. Bundles of such fibers can be used to conduct images." Fiber optic broadband is the standard for today's fastest Internet service.

Kapany moved to the United States with his wife, Satinder Kaur, where he taught at Rochester University and later at the Illinois Institute of Technology. But he gravitated to California to develop his fiber optics business, Optics Technology Inc. The initial public offering was in 1967. In 1973, Kapany founded Kaptron Inc., which he later sold. He was among seven "unsung heroes" in *Fortune* magazine's 1999 "Businessmen of the Century" issue.

On the ground floor of what would become Silicon Valley, Kapany succeeded many times over as an entrepreneur and innovative scientist. He estimated that he held

"140 or 150" patents for laser and biomedical technologies, information transfer, solar power and pollution monitoring. During the energy crisis in the 1970s, Kapany shifted focus to renewable energy. "I had half a dozen patents during the Carter days, when Carter started solar energy research." But the crisis eased. Containing greenhouse gas emissions became less of a priority. "We continued to go on and pollute the world," he said.[86]

Parallel with his business interests, Kapany maintained an academic career, teaching at the University of California, Berkeley and Santa Cruz campuses, and at Stanford University. He often lectured on entrepreneurship.

He said he faced no problems starting his own business. He felt America was conducive to success. "The opportunities are here, and they continue to be here," but he added that today there is more competition.

After retirement, Kapany continued to write and lecture. He was a generous philanthropist. He endowed a chair of Sikh studies at the University of California, Santa Barbara. In 1979, he co-founded the Center for Innovation and Entrepreneurial Development (CIED) at the University of California, Santa Cruz, where he later endowed a chair in opto-electronics. Kapany directed the center for seven years.[87]

Kapany started the Sikh Foundation in 1967 to inform Sikhs and non-Sikhs about Sikhism. Giving back was natural to him. "I think it's very important," he said. "Once you have met your basic requirements, taking care of yourself, your family, you must help your community," he said. "You can't take it with you." Investing in others, "That's definitely part of the Sikh culture."

He raised the profile of Sikh art and produced high-quality books about Sikhism. His dream was to create a place for talented students from all backgrounds to learn entrepreneurship in ways that serve the world's needs.

Dr. Kapany and his wife, Satinder, who predeceased him, lived in the San Francisco Bay area and owned a walnut orchard in Yuba City. His daughter Kiran is a lawyer and filmmaker, and his son Rajinder is a business executive. Dr. Kapany died in December 2020.

Gurdev Singh Khush, a Leader in Agronomy, Genetics and Plant Breeding

Born in the Punjab, Gurdev Singh Khush graduated from Punjab Agricultural University and took his doctorate at UC Davis in 1960. His special area is breeding and improving rice. After seven years doing research at UC Davis, he joined the International Rice

Research Institute (IRRI). He stayed for thirty-five years, from 1967 to 2002. Hundreds of breeding lines of rice were developed under his direction. He returned to UC Davis as an adjunct professor in 2002. He has been a consultant to rice improvement programs of several Asian countries.

Khush is considered a father of the Green Revolution, which introduced high-yield rice varieties that helped lift poorer countries out of poverty; his work has been recognized by many awards. These include the World Food Prize, shared with his mentor Henry Beachell in 1996, and the Wolf Prize. He received the highest honor that university bestows, the UC Davis Award, in 2018. Japan, Thailand, China and the Philippines have honored him, as has his native India, which awarded him the prestigious Padma Shri in 2000.

He has also worked to improve educational opportunity in developing countries.

A young Dr. Gurdev Khush doing research in a rice field. *Courtesy of UC Davis Library Special Collections.*

SILICON VALLEY ANGELS

Silicon Valley is full of South Asian information technology trailblazers who head companies or are venture capitalist "angels" who built information technology by funding startup projects.

Vinod Khosla, On the Ground Floor

Among the best known and most successful of these is Vinod Khosla, an Internet technologist and venture capitalist who is deeply committed philosophically and financially to development of renewable energy sources with minimal environmental impact, including biofuels and solar energy. He also is engaged on water and construction issues. A realist, he has said that business will not sacrifice growth for the environment, so he sinks money into development of competitive green energy technologies to replace fossil fuels. "When it comes to technology, the best way to change the world is not by revolution but by evolutionary steps. Change must follow from step to step, from innovation to innovation, as technology matures, each step justifying its economic viability and attracting investment," he wrote.[88] Khosla co-founded Sun Microsystems along with Scott McNealy, Andy Bechtolsheim and Bill

Vinod Khosla, a noted venture capitalist and Silicon Valley visionary. *Courtesy of Khosla Ventures.*

Joy. Khosla was one of the founders of the Silicon Valley–based networking and mentoring group The Indus Entrepreneurs (TiE). A billionaire, Khosla was listed among the four hundred richest people in the United States by *Forbes* in 2020.

Indian American Sabeer Bhatia co-created Hotmail, the first free web-based email service, with Jack Smith in 1996. Bhatia is of Punjabi heritage. Ajay Bhatt is credited with inventing the USB (universal serial bus), among other technologies. Engineer and venture capitalist Vinod Dham was a key developer of Intel's Pentium microprocessor chip. Microsystems' Ruchi Sanghvi was the first female computer engineer hired by Facebook. She went on to co-found her own company, Cove, which was later acquired by Dropbox, where she continued as an executive.

The list of tech business leaders of South Asian heritage is long. Satya Nadella succeeded Steve Ballmer as CEO of Microsoft when Ballmer stepped down in 2014, and Sundar Pichai became CEO of Alphabet, Google's parent company, in 2019. There are many others.

Entrepreneur Sonny Caberwal Seeks Unity in Diversity

The Punjabi American entrepreneurial spirit is exemplified by Sonny Caberwal. A marketing whiz and serial entrepreneur, Sonny has launched five successful startups and counting, but his passion is social upliftment and equal opportunity. Now settled near San Francisco, he grew up in North Carolina, son of Punjabi Sikh immigrants. His interest in exploring common ground between people of diverse backgrounds began as an undergrad at Duke University, before studying law at Georgetown University.

When Sikhs became targets of hate crimes after the September 11 attacks, Caberwal's desire to find unity in diversity was galvanized. He became the first turban-wearing fashion model for a major fashion house when he modeled for the Kenneth Cole "We All Walk in Different Shoes" twenty-fifth anniversary ad campaign. The campaign reflected the values that permeate many of his projects: diversity and connecting with people. He founded Tavalon Tea in New York with John Paul Lee in 2005, selling high-end teas online and in the Tavalon Tea Bar in Union Square.

In 2009, Caberwal moved to India for a few years, where he started an ecommerce company. In 2013, he developed Bond, a digital letter-writing company, which was acquired by Newell Brands in 2016.

Caberwal's latest startups focus on social diversity, particularly in education. "We're working on a project to help multicultural kids learn where they come from," Caberwal said. In a diverse society, he believes, "our common ground is American history." If

Sonny Caberwal, a serial entrepreneur. *Courtesy of Sonny Caberwal.*

children learn about their own cultural history, then they can share their history with their schoolmates "and show them that everyone is different, not just that you are the different kid."[89]

AGRIBUSINESS

The history of South Asians in California revolves around agriculture and has from the beginning. But newer arrivals have succeeded in agribusiness, too.

Harbhajan Singh Samra, Who Made His Own Story

Farming is in Punjabi blood, and new arrivals still gravitate to it. An example is Harbhajan Singh Samra, who emigrated during the Punjab militancy. His success is built on the work ethic that has long characterized South Asian immigrants. Samra came to California in 1985 with degrees in agriculture and economics. Friends told him about opportunities in America. "I listened to their stories, and I thought, let me make my own story," he said.[90]

Within ten years, he established a successful business selling Asian-style produce to Indian restaurants and grocery stores when tinda (a round summer squash), karela (bitter gourd), methi (fenugreek) and other staples of South Asian cooking were hard to find. He worked as a security guard at first; then he began buying produce at the downtown Los Angeles produce market to sell out of a pickup truck. There were ups and downs, but by 1994 he had his own well-placed stall in the Los Angeles Ninth Street wholesale produce market. He later moved to the Seventh Street market, and in 2006 Samra Produce & Farms Inc. moved to the new Los Angeles Wholesale Produce Market on Olympic Boulevard. Samra believes in hard work. "My worship is my work," he said.

Once he built his wholesale business, he saw the best way to expand was to grow his own produce. He bought land and planted okra, but the land was unsuitable. The crop failed, and debts forced him to sell it. But in a few years, with the help of friends, he was back on his feet. He bought land near Indio and at last had a good okra harvest. Things took off, and he became so successful that people began calling him "okra king."

"You have to find your own niche. Once you create that, you have confidence," he said. "If you are determined, you can do anything in the world. But in some places in the world it is rough, and in others it is smooth. In America you can do things smoothly." He likes the fairness and the ease of getting things done. "Nothing can beat the system in America," he said, adding, "America is the best country in the world. Anybody who works hard can become a millionaire faster than anywhere else. But you have to work for it."

He commutes between the Los Angeles market, his three-hundred-acre farm in the Coachella Valley and his home in Anaheim Hills, which is midway between the two. Of his past losses, he said, "Everybody makes mistakes. If you learn from your mistakes, it becomes an asset. If you don't learn from them it becomes a loss." He places value on integrity. "Don't think you are cheating and nobody's watching you. God is always watching you….If you are working hard and nobody is watching you, God is watching you and he will reward you one day. It has come to me."

Harbhajan Singh Samra turned his business selling Indian vegetables into an agricultural success story. *Courtesy of Samra Produce.*

Hardworking newcomers and descendants of pioneer South Asian immigrants to California who stuck with agriculture have reaped many benefits. They achieved a significant share in California's agribusiness throughout the state. In the Yuba-Sutter area they are well known as farmers who hold their own in a complex and often challenging business. Charanjit Singh Batth made a name and a fortune growing grapes and producing raisins in the Fresno area. His company began in 1969.

The Vintner

Agriculture became a second career for Avatar Singh Sandhu, who came as a student to the United States in 1962. He got his structural engineering degree at Berkeley and went on to become an engineering executive with Bechtel and Stone Webster. He retired to focus on vineyards he planted on his land in Sonoma County, where his house at Mushal Vineyards in the Dry Creek Valley overlooks the adjacent Gallo Sonoma vineyards.

After vigorously promoting California wine in India, he won important clients there, such as New Delhi's elegant Imperial Hotel, which sells his chardonnay and cabernet sauvignon wines under its own house label. His wines, which were served in the White House, won gold medals. He succumbed to COVID-19 in 2021, age eighty-three.

California grapes. *Jeremy Iwanga / Unsplash.*

PROUD SERVICE IN THE U.S. MILITARY

Inspired to enroll in West Point after visiting Pearl Harbor, Anmol Narang became the first observant female Sikh to graduate West Point in 2020. She follows a tradition of Punjabi Americans not only in the military but also in education.

Although Bhagat Singh Thind wore beard and turban as a World War I soldier, until recently, observant Sikhs were obliged to remove their turbans and cut their hair and beards to serve in the U.S. military, with a few exceptions. After several religious freedom court cases, in 2017 the restrictions were rescinded. Sikhs were allowed to wear turbans and beards, and Muslim women could wear hijab. Second Lieutenant Kanwar Singh was the first Sikh to graduate Officers Candidate School after this decision. Commissioned in the Massachusetts National Guard, he was awarded several medals, including the Army Commendation Medal for his service. As a signals officer, he specializes in computer technology. He built a mobile app to help soldiers organize inventory and communicate.

South Asian women have distinguished themselves as astronauts. Punjabi American Kalpana Chawla, the first Indian American NASA astronaut, was a flight engineer and mission specialist. Born in Karnal, India, she immigrated to the United States to continue her education, obtaining a doctorate in aerospace engineering. She became an American citizen and began working for NASA in the 1980s. Tragically, she died with the crew of the Space Shuttle *Columbia*, which disintegrated on re-entry in 2003. She was honored with the Congressional Space Medal of Honor and NASA Space Flight and Distinguished Service medals.

ABOVE: Second Lieutenant Anmol Narang, graduating West Point cadet, 2020. *Lauren Karbler.*

OPPOSITE, TOP: Second Lieutenant Kanwar Singh receiving Army Commendation Medal. *Creative Commons.*

OPPOSITE, BOTTOM: Astronaut Suni Williams has distinguished herself as an astronaut in the military and pursues a commercial spaceflight career. *NASA.*

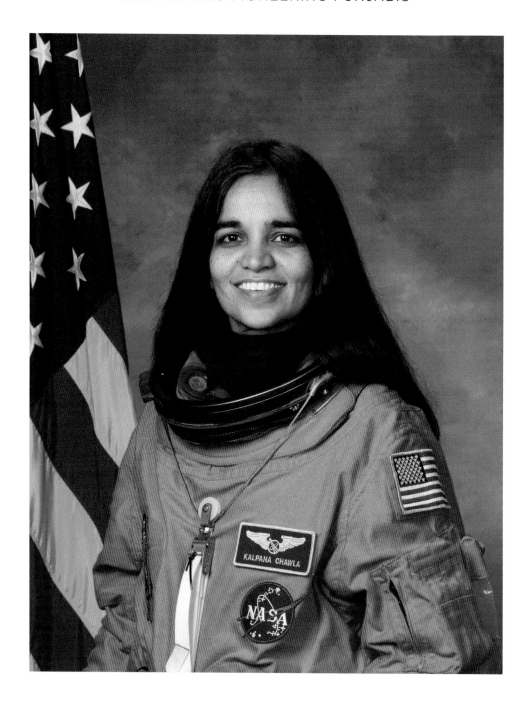

OPPOSITE: Astronaut Kalpana Chawla, a naturalized American citizen born in the Punjab, died serving the country when the *Columbia* space shuttle disintegrated. *NASA.*

ABOVE: Astronaut Raja Chari is slated to explore the lunar south pole. *NASA.*

Sunita "Suni" Williams, who retired as a captain, U.S. Navy, is a veteran of two missions to the International Space Station, with a total of 322 days in space. While in space, she completed the Boston Marathon on a treadmill. She made a total of seven space walks. She was appointed by NASA to the first Commercial Crew Program and currently works with Boeing and SpaceX. Her honors include Navy commendation and achievement medals, the NASA Space Flight Medal and India's Padma Bhushan. She continues to pursue a career in space as a commercial crew member, working with Boeing and SpaceX.

Astronaut Raja Chari joined NASA in 2017 after a distinguished Air Force career. A former test pilot and commander of SpaceX Crew 3, in 2020 he was tapped by NASA for the Artemis team to explore the lunar south pole.

SOUTH ASIA STUDIES AND INNOVATORS IN EDUCATION

Emigrants from India early in the last century were not all farmers. South Asian scholars gravitated to the University of California, Berkeley, or nearby Stanford. Sanskrit entered the Berkeley curricula in 1897, and the first Sanskrit professorship was established in 1906.

Since those early days when few U.S. universities had South Asia studies programs, robust undergraduate and graduate programs now thrive across the United States. At least twenty major universities, including Harvard, offer comprehensive programs. Many other, smaller schools also offer South Asian language and culture courses.

Today, Hindi, Urdu, Bangla, Tamil and Punjabi languages are but a few that are taught. While Berkeley has offered Punjabi since the early nineties, in 2021 the University of California, Davis, launched its program. Middle East and South Asia studies professor Dr. Nicole Ranganath and members of the Punjabi Heritage

Punjabi American Heritage Society signs Punjabi language initiative agreement with UC Davis. Dr. Gurdev Khush is seated, far left, next to Tej Maan. Standing are Nicole Ranganath and members of the PAHS museum committee. *Courtesy of PAHS.*

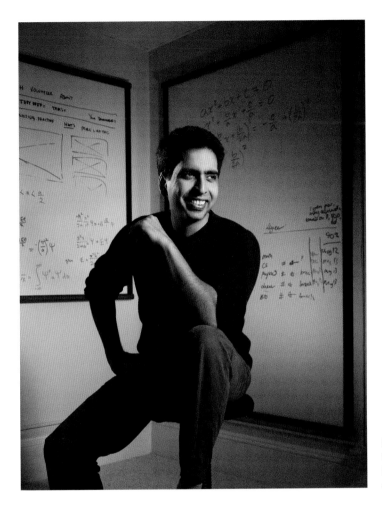

Sal Khan, whose online tutorials for family led to founding the Khan Academy. © *Gary Laufman.*

Society worked to achieve this. UC Davis, noted for its agricultural and environmental programs, is in the heart of the Sacramento Valley, where many Punjabi Americans live. Ranganath took over the project begun by the late Ted Sibia and now curates the online Pioneering Punjabis Digital Archive hosted by the university.

The Sikh Foundation established the first North American chair in Sikh studies at UC Santa Barbara in 1998. Since then, the foundation funded chairs in Sikh and Punjabi studies at UC Riverside, UC Santa Cruz and California State University, East Bay.

Online study opportunities were revolutionized by Sal Khan, the son of Bengali immigrants, when he started tutoring his cousin in mathematics on the Internet.

Today the free Khan Academy employs more than 150 people and offers courses in math, science, reading, arts, humanities and other subjects to students in preschool through secondary school.

As Khan wrote in his book *The One World Schoolhouse: Education Reimagined*, "The world needs all the trained minds and bright futures it can get, and it needs them everywhere." While his roots are not in the Punjab, he is among the many South Asian Americans who are making people's lives better through their innovation. Khan lives in Mountain View, California.

Simran Jeet Singh is a writer, educator and activist for social justice. His interest is in "disrupting bias, building empathy, seeking wisdom." In 2021, he was appointed executive director of the Religion & Society Program at the Aspen Institute. He is chaplain at New York University and Columbia University and works with the Sikh Coalition and several interfaith committees.

SPIRITUALITY IS A WAY OF LIFE

California has always been a magnet for spiritual teachers from all over the world. South Asian teachers made an indelible mark quite early. Hindu teacher Swami Vivekenanda (1853–1902) first visited America in 1883 to attend the first World Parliament of Religions held in Chicago. Others followed, notably Paramahansa Yogananda (1895–1952) and Jiddu Krishnamurthi (1895–1986), both of whom established centers in California. As noted earlier, Bhagat Singh Thind spent his life as a spiritual teacher after he won his battle to become an American citizen.

The late Yogi Bhajan linked spirituality with entrepreneurship. He began his international organization 3HO in California. 3HO stands for Healthy-Happy-Holy Organization. Yogi Bhajan was born Harbhajan Singh Puri near Lahore, in what is now Pakistan, in 1929. He mastered kundalini yoga in his teens. After studying economics at Punjab University, he became a civil servant, teaching yoga on the side. When he came to California in 1968, it was at the perfect moment, when sixties-era hippies sought a path of spiritual awakening. He began to instruct non-Sikhs in the Sikh faith but incorporated kundalini yoga as a central part of his teaching.

Students followed a disciplined path of yoga, meditation and service that combined Sikh values and practices with yogic traditions. They adopted a distinctive style of dress: white Punjabi-style clothing and turbans for men and women. They took Khalsa

LEFT: Yogi Bhajan, 1985. *Courtesy of Kundalini Research Institute / Soorya Kaur Khalsa.*

BELOW: Yogi Bhajan with students in Santa Barbara, California, 1969. *Courtesy of Kundalini Research Institute.*

Golden Temple Conscious Cookery Restaurant, Los Angeles, 1974. *Courtesy of Kundalini Research Institute.*

as a surname. According to the 3HO website, members now number in the hundreds of thousands.

Besides his role as a spiritual guide, Yogi Bhajan was a successful entrepreneur. Opening the Golden Temple Restaurant in Los Angeles in 1969 was his first business venture. Marketing Yogi Tea, the restaurant's signature beverage, and other Golden Temple products, followed.

While the herbal tea business grew, Yogi Bhajan launched other successful enterprises, Akal Security and a computer software company among them. He wrote business management guides and more than thirty philosophy and yoga books. An effective drug and alcohol de-addiction program that he started relies on yoga and meditation. The Kundalini Research Institute carries on his teachings.

Siri Pritam Kaur Khalsa: The Healing Arts

Two of Yogi Bhajan's American disciples, Siri Pritam Kaur Khalsa and her late husband, chiropractor Pritam Singh Khalsa, made Yuba City their home in 1985. They set up a chiropractic clinic that emphasized natural methods of healing. Pritam Singh, the former Pat Pyeatt, grew up in Oklahoma. Siri Pritam Kaur, the former Gisela Gehret, was raised in a small Bavarian town in West Germany. When she was twenty-one, she had a chance to come to the United States, where she found a job in San Francisco. She was drawn to the burgeoning movement of spiritual seekers of which San Francisco was an epicenter.

In 1973, she began studying Kundalini Yoga at Yogi Bhajan's ashram in San Rafael. She lived in an old Victorian house with about thirty other young people dedicated to yoga and meditation. It was there she met and married her husband.

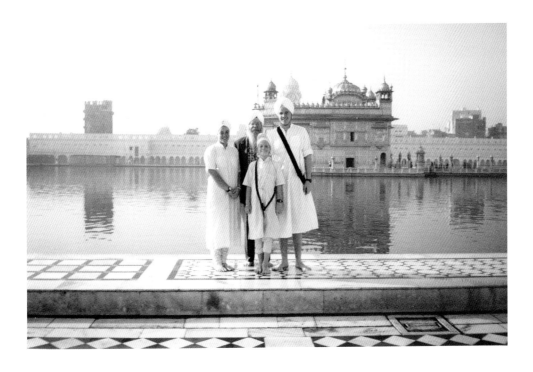

Pritam Singh Khalsa with his children Siri Vias Singh, Guru Kirin Kaur and Har Simran Singh at Golden Temple, Amritsar, India, 1992. *Courtesy of Siri Pritam Khalsa.*

Siri Pritam Khalsa. *Courtesy of Siri Pritam Khalsa.*

Both were inspired by the teachings of Yogi Bhajan. They moved to Yuba City after Dr. Pritam Singh Khalsa—a former civil engineer—graduated from chiropractic school. He focused on noninvasive treatments. "He had a natural, intuitive gift for healing," his widow said. They became recognizable in the community not only by their conspicuous white Punjabi dress but also their engaging approach. They joined the chamber of commerce and other local organizations. They raised their two sons and daughter in Yuba City. Dr. Khalsa passed away in 2002. Their youngest son followed in his father's footsteps, becoming a chiropractor. Siri Pritam continues to work in healthcare and teaches yoga and meditation at her own clinic, Sierra Injury & Sports Rehab Inc. She is a former president of the Punjabi American Heritage Society, of which she and her husband were founding members.

UNITED IN FOOD

Most towns with a South Asian population also have Indian restaurants, ranging from high end to affordable. A variety of regional cuisines are available, sometimes in the same restaurant. In India, roadside restaurants where a traveler can stop for tea and a meal are called *dhabas*. Punjabi Americans have brought that to the United States in a big way with their successful truck stop restaurants that dot the interstate highways from coast to coast.

And the clientele isn't limited to the many Punjabi American truck drivers who transport goods around the country. As a 2019 *CBS Sunday Morning* segment showed,

Punjabi Dhaba in Dixon is one of a string of popular truck stops serving Punjabi-style food. *Courtesy of PAHS.*

the popularity of Punjabi food at the Akal Travel Center on the I-80 in Laramie, Wyoming, is universal. "It's bringing the world here, rather than keeping our world small," the local deputy sheriff Bill Yates, a regular, told CBS.

California has a Punjabi dhaba in Dixon, one in Bakersfield and another in the Mojave Desert off I-40, just a few miles from the old Route 66. A string of such Punjabi American truck stops serves truckers and travelers across Nevada, Arizona, New Mexico, Texas, Oklahoma, Utah and Indiana.

A Trucking Legend

Sonny Samara started small but now hauls for big corporations. *Courtesy of Sonny Samara / New Legend Inc.*

Sonny Samara started driving trucks in 1996 when he was twenty-two. He purchased a truck and began his own trucking business at the age of twenty-five, hauling for a few companies across the United States. He incorporated Legend Transportation in 2008. Legend contracted with other owner-operators at first but then began purchasing a fleet of tractor-trailers.

Today the company partners with Fortune 500 companies such as Walmart, Target, Macy's, Home Depot, Coca-Cola and many others. Legend Transportation now has one thousand tractors, four thousand trailers and more than one hundred employees.

ENTERTAINMENT, THE ARTS AND ACTIVISM

Today, talented people with South Asian roots are now actors and filmmakers in the United States, but it took many decades for them to become accepted there. Sabu (1924–1963), who gained fame as the "elephant boy," was the lone South Asian actor in a studio system that shied away from casting minorities in films. White actors, complexions darkened with makeup, usually played African Americans, American Indians, East and South Asians. In recent decades, young actors and filmmakers have broken through the old barriers, often through independent ventures.

Family History Inspires Thought-Provoking Films

Kartar Kaur Dhillon's granddaughter Erika Surat Andersen is among this talented generation of filmmakers. Andersen was close to her Punjabi pioneer grandmother Kartar, whose story is told in chapter 4.

With a degree in computer science from UC Berkeley and a master of fine arts' degree in cinema and television production from the University of Southern California, Erika began her career as a writer, producer and director. She distinguished herself with her award-winning short film *Turbans* (1999), based on the experiences of her grandmother's family when they lived in Astoria, Oregon.

Erika was inspired to make the film after reading Kartar's diaries that recounted the life and times of Bakhshish Singh Dhillon and his family in Astoria, Oregon. She was struck by the tale of her two great-uncles who were bullied by local boys because they looked different. The film depicts the personal anguish of their parents at the decision to cut the boys' hair and remove their turbans, contradicting Sikh religious tradition in the interest of their sons' welfare. Erika wrote that the hair cutting "was a watershed moment for a Sikh family since hair is considered sacred, and for me it was a visual and moving symbol of the great sacrifices that immigrant families make in order to survive in America." She spent about five years researching, writing the script and fundraising. Kartar Dhillon assisted with historical and cultural details during filming. "For my family the issue of whether to cut one's hair happened in 1916. What I realized as I began sharing the script and later when I screened the film, was that for first- and second-generation Sikh-Americans these questions and dilemmas are very much alive, and not historical."

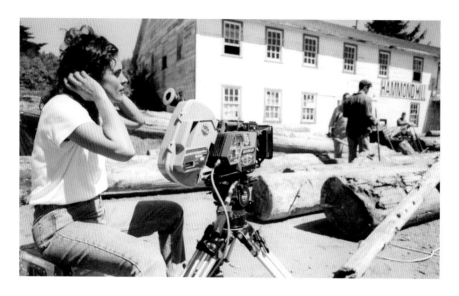

TOP: Director Erika Surat Andersen behind the camera during *Turbans* filming. *Courtesy of Erika Surat Andersen.*

BOTTOM: Erika and her grandmother Kartar Dhillon trimming a dupatta on the *Turbans* set. *Courtesy of Erika Surat Andersen.*

Post–September 11, *Turbans* is now used in diversity education, to acquaint adults and young people with Sikh culture.

Because of her mixed ethnic identity, half South Asian and half Danish, Erika looked for people like that in films. She didn't find them. So in her work she strives to depict people who are not often represented. Her documentary *None of the Above: People of Multiracial Heritage* focuses on identity issues for people with multi-ethnic/multi-racial backgrounds. She is currently working on women's stories. "Female stories are drastically under-represented. With the #MeToo movement, we are beginning to see a shift in better representations of women—usually made by women themselves—but we still have a long way to go."

Valarie Kaur, Activist Filmmaker, Granddaughter of a Pioneer

In her book *See No Stranger: A Memoir and Manifesto of Revolutionary Love*, Valarie Kaur writes, "My family had lived in the United States for a century, but Sikh Americans still had no place in the nation's racial imagination, which meant that I was illegible, unable to be read except by negation."[91] She set out to change this.

Kaur grew up on the farm in Clovis that was started by her Punjabi pioneer grandfather Kehar Singh, who came to California in 1913. She left the farm to earn a bachelor's degree in religious studies and international relations at Stanford, a master's in theological studies from Harvard Divinity School and a law degree from Yale.

LEFT: Valarie Kaur, founder of the Revolutionary Love Project. *Courtesy of Valarie Kaur / Amber Castro.*

The murder of family friend Balbir Sodhi after September 11, 2001, motivated Kaur to become a documentary filmmaker. Her award-winning film *Divided We Fall: Americans in the Aftermath* documents hate crimes against Sikh and Muslim Americans. She continues to make films about social justice and Internet neutrality, often with her husband, Sharat Raju.

Kaur is a noted speaker at interfaith and other venues. Her moving speech on Watch Night, New Year's Eve, 2016, about social justice went viral. She described her grandfather's detention at Angel Island and urged people to strive for social justice through "revolutionary love." She founded and directs the Revolutionary Love Project to "generate thought leadership on how the love ethic can challenge systems of injustice."

Kavi Raz and the Wandering Players

Kavi Raz was no newcomer to films when he played the father in Erika Andersen's film *Turbans*. A Punjabi who migrated to America in the mid-1970s, he was the first South Asian to be cast as a regular in a television series, the popular 1980s drama *St. Elsewhere*. Raz is among a very few South Asians who found work in Hollywood in those years, but his success didn't come easily.

Before he could pursue his acting dream, he, like so many before him, labored on farms. He and his brother tended the Yuba City orchards of his sister's father-in-law Hazara Singh. "The first three years after coming here to Yuba City was in that work. That's the initiation. It's the last thing you'll ever forget," he said.[92] In 1977, he moved to Los Angeles to join the Actors Studio West founded by the legendary Lee Strasberg. It was modeled on Strasberg's Actors Studio in New York, which taught method acting techniques that influenced actors such as Marlon Brando, Marilyn Monroe, Jack Nicholson, Al Pacino, Sidney Portier and Robert De Niro. Raz studied under Strasberg, who died in 1982, and with other instructors, among them Hedy Sontag, Susan Baston and Walter Lott. It was Sontag who encouraged Raz to read the works of his countryman Rabindranath Tagore.

"There was one play that I like by Tagore called *Sacrifice*. And she said why don't you produce it? Just do it. So that's how I started getting some actors together," Raz said about the formation of the Wandering Players. It was the first South Asia–focused repertory company in America. "I couldn't find Indian actors, so I used mostly non-Indian actors. We used to rehearse in my apartment. I went out grabbing actors off the street, literally, to come to be in my play." They had no theater but performed

Punjabi American actor Kavi Raz. *Courtesy of K.R. Films Hollywood.*

wherever they could find a venue. "People would offer places to perform in," he said, recalling an open-air theater behind a junkyard. "It was run by a guy who had a junkyard, but he had a passion for theater."

"We were performing a night here and a night there, and we didn't have a name for our theater company, so I thought, well, what about Wandering Players, because we didn't really have a home." Raz said the company ultimately decided not to have a theater on principle. Raz ran the company into the 1980s. His stage work made his name among a group of influential critics who watched for talent, and the exposure led to his landing small parts on television. Since then, he has appeared in several hundred films and television shows, including *M*A*S*H* and *Star Trek: The Next Generation*.

"Hollywood's a tough place," he said. "It was very frustrating in the beginning even trying to get auditions. Hollywood just wasn't used to seeing any Indian actors." Italian or Spanish actors would be cast in roles for South Asian characters, he said, recalling one audition for a role as a Pakistani doctor in a film. He lost out to a non–South Asian actor. "He'd done a lot more roles than I had; I was new to town." Although the director considered Raz, "I think what it really came down to was they didn't have enough confidence in me as an Indian actor, that I could actually carry it as one of the main characters." It was a perception that producers had, partly from

their limited exposure to Bollywood films, "where, you know, acting was never really the strongest part in the film."

Kavi Raz started his own production company, K.R. Films, in 1978, and ten years later he built K.R. Studios on three acres of land in the San Fernando Valley. "I wanted to be like a true artist, I wanted to work where I lived, or live where I worked, so I could work whenever." Although other production companies occasionally use it, he uses it mostly for his own films. Raz debuted as a filmmaker with his 2006 film *The Gold Bracelet*, which he wrote, produced and starred in. The award-winning film, based on actual events, is about a Sikh family in post–September 11 America.

Raz was moved to do the film by the attacks on Sikhs after September 11. His own father was verbally abused. "He was called a camel rider, rag head, escaped a physical attack by a group of young men and his fence was painted with slogans of a derogatory nature," Raz said.

Raz's 2019 film *Sarabha: Cry for Freedom* was inspired by his longtime interest in the Ghadar movement. It intrigued him since he worked in Hazara Singh's Yuba City orchards. "Imagine us, we'd be on our ladders working on the trees, pruning, or thinning or picking peaches, and [Hazara Singh] was walking in the groves," Raz recalled. "He would tell us these fascinating stories about the Ghadar movement, people he had actually lived among and seen." Raz said, "It was really fascinating that this kind of thing happened on California soil."

The brothers moved to Oakland, where Raz met a man named Kesar Singh, who was the last surviving secretary of the Ghadar movement. Raz said there was "a huge press sitting in his basement, and all these newspapers and photographs" that dated to the heyday of the Ghadar movement. "I would pore over them." Raz said that was why, when the role in *Turbans* came up, "I jumped at it."

Raz writes, directs and stars in his films. His films have won more than twenty-six international awards. Most of his films are inspired by true cross-cultural stories. He has appeared in more than 250 films, TV shows and plays, working with well-known actors from Hollywood to Bollywood.

Raz has seen big changes in the entertainment industry during his time in Hollywood. There are more opportunities for ethnic actors, especially in television. "Almost every major series has an Indian character on it. Or South Asian actors are playing characters even if they're not Indian." Feature films offer less opportunity, but he feels that soon will change. "It's much more fascinating to see different colors in a film and different cultures in the film than to keep seeing white faces all the time."

Success takes unflagging perseverance, he said: "Whatever you do, you've got to have the passion for it. You've got to have the commitment."

TOP, LEFT: Kavi Raz as Arjun Singh in *The Gold Bracelet*. *Courtesy of K.R. Films Hollywood.*

BOTTOM, LEFT, : Poster for the Kavi Raz film *Sarabha*. *Courtesy of K.R. Films Hollywood.*

RIGHT: Kavi Raz as the father in *Turbans*, a character inspired by Erika Surat Andersen's grandfather. *Courtesy of Erika Surat Andersen.*

Accomplished directors such as Mira Nair, Deepa Mehta, Shekhar Kapur and Gurinder Chadha are at home in Hollywood. Two of Kapur's films, *Elizabeth* (1998) and *Elizabeth: The Golden Age* (2007), were nominated for Academy Awards in several categories.

Indian American writers have made indelible marks: authors Bharati Mukherjee, Jhumpa Lahiri, Akhil Sharma and Siddhartha Mukherjee, to name a few. South Asian American journalists are household names: Amna Nawaz, Fareed Zakaria, Sreenath Sreenivasan, Vinita Nair, Hari Sreenivasan and Lakshmi Singh, among many others.

MUSIC AND DANCE: BHANGRA, BELLY DANCE AND MORE

The music of South Asia has attracted audiences in the United States for decades. Ravi Shankar introduced the sitar and Indian classical music to American audiences. Tabla maestro Zakir Hussein settled in California, collaborating with other musicians in fusion bands, while continuing to perform classical music. A genre gaining attention in recent years is *bhangra*, the folk music of the Punjab. It is a staple at celebrations of all kinds, where participants dance to its lively tunes.

Bhangra music is played on traditional string and percussion instruments.[93] Nowadays modern, Western instruments may be included. Young people of all backgrounds form college bhangra groups. Cornell Bhangra, a group from Cornell University, reached the finals in the 2014 *America's Got Talent* TV show competition.

Neena and Veena Bidasha, aka Bellytwins

Neena and Veena Bidasha are entrepreneurs who created "Bellytwins," the professional name of these dance fitness doyennes. They are the twin daughters of a Northern California Punjabi American farmer, Richard Singh Bidasha, whose father, Chetin Singh Bidasha, immigrated to California in the 1920s.

Chetin Singh was born near Jalander in the Punjab. He was orphaned when he was about ten years old. After his father died, his mother committed sati, throwing herself on her husband's funeral pyre. This ancient, now outlawed, Hindu practice is not observed by Sikhs. According to Veena, that led the family to speculate that she may have been Hindu. Looked after by relatives for a time, Chetin set out for Vancouver,

Bellytwins Neena and Veena Bidasha. *Courtesy of Bellytwins International.*

Canada, as an uncle had done in the late nineteenth century. A teenager with a fifth-grade education and little money, Chetin Singh boarded a ship bound for France. He stayed for two years, taking any job that came his way. He cut his hair, learned French and, when he saved enough money, continued to North America. He landed in Mexico and made the harrowing trip to the United States, passing through Texas and Arizona before arriving in California's Imperial Valley, where he worked on farms. Around 1927, he relocated to Walnut Grove, south of Sacramento. He leased land and began his own farm. Concha Huerta was a Mexican American, born in California, who worked for Chetin Singh as a farm laborer. By 1929, she had become his wife.

The Depression caused Chetin Singh's farm business to fail, so the family moved to the Imperial Valley to find work. Chetin Singh again leased land, putting the lease in Concha's name. By then they had a son, Rudy, born in 1931. Another son, Richard—Veena and Neena's father—was born in 1933. Work was scarce in the Depression, so Chetin Singh became a migrant laborer. He returned to Northern California and in 1941 bought his own land, a vineyard in Selma, near Fresno, putting it in the names of his two American sons. Then he sold it and moved to Sutter County, where he worked for peach and rice farmers, learning about those crops.

At the same time, Chetin Singh was on the Stockton Gurdwara Committee, which, in those years, was building the new gurdwara. In 1944, he bought peach and plum orchards, and later an almond orchard, on Lincoln Road in Yuba City. He owned about five hundred acres. He helped his sons Rudy and Richard buy fruit and almond ranches on George Washington Boulevard, where the twins grew up.

Chetin Singh's third son, Freddie, wasn't interested in farming. Instead, he was drawn to music. At the age of fourteen he played a tap-dancing Scarecrow in a Sacramento production of *The Wizard of Oz*. He became a musician, forming a band,

Freddie Singh Breaks into Country Western Music

By MICHEL W. POTTS
Special to India-West

MARYSVILLE, Calif. — Freddie Singh Bidasha has already made a name for himself in Northern California as the "Turban Cowboy," and once the record companies hear his demo tape, he is certain he has every chance of breaking into the charts as the first Indian country/western singer.

"Country/western is bigger than it's ever been and the response I'm getting is always good, no matter what I play," Bidasha told India-West.

While playing local gigs over the years, "I began toying with the concept of the 'Turban Cowboy,' and when I did it a couple of times, it really went over," Bidasha said.

He gets laughs from the audience when he does part of the act in an exaggerated Indian accent, but he is also well received when they hear his real voice and realize how good he is, whether performing a recent country/western hit or his own original songs.

"If you can tickle their funny bone and give them good music, too, then that just adds to the act," he maintained.

Bidasha's entire life has been a series of firsts, beginning at the

Freddie Singh Bidasha

age of 14 when he was the first Indian to perform in an Equity theatre as the tap dancing Scarecrow in a production of "The Wizard of Oz" at the Music Circus in Sacramento.

Then, in the late 1950s, while in high school, he was the first Indian rock 'n roll performer, having formed his own band, "Freddie and the Statics," reaping notoriety in local "Battle of the Bands" contests.

In one "Battle of the Bands," Bidasha and his group of young

musicians took first place over Jan and Dean long before they became internationally known, and as the band's reputation grew, they were tapped to appear as the opening act whenever such headliners as the Beach Boys, Sly and the Family Stone, or the Righteous Brothers came to town.

"What made my band so special was the fact we were the only rhythm and blues band around," Bidasha explained. "Our lead singer was black and back then interracial bands weren't happening."

Although he grew up the third youngest of four brothers in the Yuba Valley area, where the family farmed 90 acres of almonds, peaches and prunes, his parents were not steeped in Sikh traditions.

His mother loved the flamboyant pianist Liberace and encouraged Bidasha at an early age to learn the piano, but she and her husband weren't exactly thrilled when their young son veered instead toward rock 'n roll.

"They hated the noise and all the wrong notes, of course," Bidasha recalled. "My older brothers didn't like it very much because they were working on the farm and here I was playing rock

[Cont. on next page]

OPPOSITE, TOP: Wedding portrait of Chetin Singh and Concha Huerta. *Courtesy of the Bidasha family.*

OPPOSITE, BOTTOM: Freddie Singh Bidasha took to music early; here he is tap dancing. *Courtesy of the Bidasha family.*

LEFT: An article about Freddie Singh, the rock-and-roll star also known as "Turban Cowboy." *Courtesy of the Bidasha family.*

Freddie and the Statics. They competed in local Battle of the Bands contests and, in one of them, took first place over '60s singers Jan and Dean. Freddie was probably the first Indian American rock musician.

As his band's reputation grew, they were invited to open for groups like the Beach Boys, Sly and the Family Stone and the Righteous Brothers. He told *India-West* in a decades-old interview that his band was the only rhythm and blues band in the Yuba-Marysville area. "Our lead singer was black, and back then interracial bands weren't happening." In 1964, Freddie moved to Los Angeles and formed a successful band called the Vandelles, playing regularly at the Whiskey A-Go-Go and P.J.'s. The band played on opening night of Gazzarri's, a famous Sunset Strip hangout in the late '60s. His music career was interrupted by military service during the Vietnam War, but when he was discharged he went back to music. Even being robbed and shot after a gig didn't stop him. After a long recovery, he resumed playing. Freddie also played country western music. He called himself the "Turban Cowboy."

With forbears who were not afraid of taking risks, creating and marketing a new kind of fitness regime was second nature to Neena and Veena Bidasha. They grew up dancing Bollywood and bhangra, and later became avid students of Middle

271

Eastern dance. They started teaching belly dance and Bollywood workout classes in Los Angeles.

"Our belly dance was really about staying fit. Bollywood, Indian dance, was our passion, but belly dance was what the world wanted," Veena said. After seeing a poor-quality belly dance video in Egypt, they thought they could produce a better exercise video. That began their dance fitness videos. At first, they mixed belly dance moves with traditional exercises. Always focused on health, they wanted it to be good exercise. "Any mom can do this," Veena said. They designed their own costumes, using the rich textiles and trims sold in Indian shops. Their simple formula was soon copied by others churning out videos.

But their first love, Bollywood, beckoned. "Bollywood, what's that?" was the response they would get in the '80s and '90s when they tried to interest distribution companies in Indian dance videos. Neena and Veena formed the first professional Bollywood "filmi" dance company in North America in 1997, although they had a small company in the '80s. They continued to teach Bollywood fitness in a studio. A distributor picked up and released their first series of fitness videos, *Belly Dance: Fitness for Beginners*. Later, following the success of their belly dance workouts, they added workouts featuring bhangra and Bollywood music. The twins wrote a book, *Way of the Belly*. Since then, the Bellytwins International Entertainment Company provides talent for themed events—boasting celebrity clients—while continuing online fitness classes to promote health and weight loss live via Zoom and on demand.

Kirtan, Traditional Religious Music

Sikh religious music also has a following. The *kirtan*—"to narrate or tell" in Sanskrit—is part of Hinduism and Sikhism. The Sikh kirtan, usually heard in the gurdwara, sets the words of Sikh scripture or stories to the music of traditional instruments.

Snatam Kaur, whose parents embraced Sikhism, learned kirtan as a child growing up in California. She made singing Sikh sacred chants her life's work. She has a large international following. One of her many albums was nominated for a Grammy Award in 2019, and the singer performed at the awards ceremony. Another album she made with Peter Kater, *Heart of the Universe*, won the 2018 New Age Grammy. Her music blends classical Indian elements with Western folk and contemporary genres.

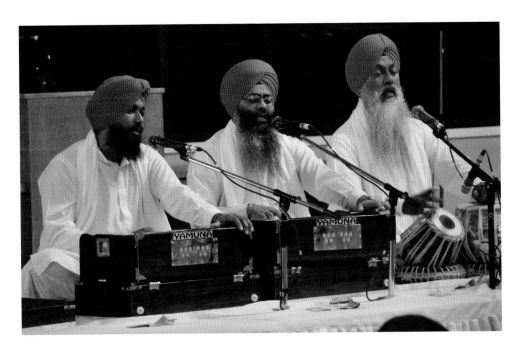

ABOVE: Kirtan—hymns—are sung during services at the Tierra Buena gurdwara. © *Dean Tokuno*.

LEFT: Sikh singer Snatam Kaur. *J Singh / KaurArt.com / Wikimedia Commons.*

273

SOUTH ASIAN AMERICANS, AT THE TOP OF THEIR GAME

Punjabi pioneers started it more than a century ago. Immigrants from all over the Indian subcontinent now spice up American society and culture. They are leaders.

Kamala Devi Harris made history when she was sworn in as the forty-ninth vice president of the United States in 2021. Not only is she the first woman to be elected to that office, but she is the first Asian American and African American vice president. Her mother, a research biologist, was from South India, and her economist father from Jamaica.

Harris, a lawyer, rose through the ranks. She served as San Francisco district attorney and was elected attorney general of California, then U.S. senator, before being asked by Joe Biden to be his vice president.

South Asian Americans are a growing political force. Bobby Jindal and Nikki Haley, both with Punjabi roots, were governors of Louisiana and South Carolina, respectively. Congresswoman Pramila Jayapal of Washington is an outspoken representative of that state. Representatives Ami Bera and Ro Khanna serve California constituents. Raja Krishnamoorthi was elected from Illinois. The four are known as "The Samosa Caucus."

In other states, South Asians have had great success running for office. Some continue to face racist slurs, but that hasn't stopped them from running—and winning—elections in state legislatures. They are mayors and serve in other public offices across the country.

Economist Daleep Singh, who is deputy national security advisor for international economics and deputy director of the National Economic Council for the Biden administration, is great-grandnephew of the first Asian elected to the U.S. Congress, Dalip Singh Saund.

Hospitals rely on South Asian American doctors, nurses and executives who care for the health of the nation. South Asian American scientists continue to expand

OPPOSITE, TOP LEFT: Vice President of the United States Kamala Harris. *Courtesy of the White House.*

OPPOSITE, TOP RIGHT: Deputy National Security Advisor Daleep Singh. *Courtesy of the White House.*

OPPOSITE, BOTTOM: Dr. Ashish Jha, dean of the Brown University School of Public Health and White House COVID-19 response coordinator under the Biden administration. *From the* Brown Daily Herald / *Victoria Yin.*

The Sikh float in the annual New Year's Day Rose Parade in Pasadena, California. *Courtesy of Jag Reyatt.*

knowledge and technologies through their research. Dean of the Brown University School of Public Health Dr. Ashish Jha became a go-to expert on public health matters during the COVID-19 pandemic and was appointed White House COVID-19 response coordinator in 2022. Neurosurgeon Dr. Sanjay Gupta is also an Emmy Award–winning senior medical correspondent on CNN. Atul Gawande is an influential author, researcher and surgeon. *My Own Country: A Doctor's Story* was Abraham Verghese's moving account of being a young doctor in rural America during the AIDS epidemic. He continues to write, practice medicine and teach at Stanford University School of Medicine.

Lawyers, judges, business owners of all kinds, scientists, artists, writers and scholars with roots in South Asia bring their expertise to communities across the United States.

The handful of hardscrabble farmers and former soldiers from India's Punjab who fearlessly crossed the ocean to the unknown set the ball rolling. Sometimes they were turned away, but they persistently came back to work hard, sleep in fields and build a life. The legacy of these early South Asian immigrants touches not only those who followed in their footsteps over the decades but also all Americans, whose lives and society have been enriched by the multifaceted contributions of South Asian Americans.

NOTES

Chapter 2. Guru Nanak and the Sikh Religion

1. K. Singh and Rai, *Sikhs*.
2. Eraly, *Last Spring*, 257.
3. G. Singh, *History of the Sikh People*, 193–94.
4. Ibid., 258.
5. Ibid., 290.
6. Taylor and Pontsioen, *Sikhs*, 43.
7. Ibid., 286.
8. Ibid., 288–89
9 Ibid., 325.
10. K. Singh, *History of the Sikhs*, 1:126.

Chapter 3. Maharaja Ranjit Singh, Emperor of the Punjab

11. Taylor and Pontsioen, *Sikhs*, 52.
12. These clans, called *misl* in Punjab, were associations that dominated a particular region.
13. K. Singh, *History of the Sikhs*, 1:201.
14. Lafont, "Dr. Josiah Harlan of Philadelphia." The quoted material in this section comes from Lafont's article.
15. Now in the state of Haryana, India.
16. MacIntyre, *Man Who Would Be King*. A fascinating account of Harlan's life and adventures.
17. K. Singh, *History of the Sikhs*, 2:1.

Chapter 4. Heading West: New Opportunities, New Struggles

18. La Brack, *Sikhs of Northern California*, 56–57.
19. Ibid., 68.
20. Takaki, *From a Different Shore*.
21. Kartar Dhillon, interview by Lea Terhune, 2006.
22. Sikh Pioneers http://www.sikhpioneers.org/p5witne.htm.
23. La Brack, *Sikhs of Northern California*.

Chapter 5. Angel Island: South Asian Stories

24. Many records of South Asian immigrants were destroyed when the building in which they were stored burned down.
25. "Memorandum for the acting secretary" of the U.S. Department of Labor Louis F. Post, Doc. No. 53627/39-A—51-58-A from U.S. National Archives File No. 12865/13-4.
26. One reason for fewer actual Hindu early immigrants were religious taboos that existed against overseas travel.
27. The document cites Section 2 of the Immigration Act of February 20, 1907. This act codified some earlier legislation and increased the head tax to four dollars, a large sum for the time (U.S. Citizenship and Immigration Services, Department of Homeland Security).
28. "Californians in Portraiture and Caricature: Henry F. Marshall: Attorney at Law," *San Francisco Call*, February 14, 1916.
29. Ibid.
30. "Becoming American: The Journey of an Early Sikh Pioneer," New Moon Productions, 2008.
31. Details of this and the following Angel Island case histories are taken from records on file at the National Archives and Records Administration, San Bruno, California.
32. "Memorandum for the acting secretary," 17.
33. Quotes taken from a record of "A meeting of a Board of Special Inquiry, Angel Island Station," June 5, 1916, in the matter of Bishen Singh, File No. 15287/14-3.
34. Letter of Joseph P. Fallon to the Commissioner-General of Immigration, Washington, D.C., dated June 28, 1916, U.S. National Archives File No. 15287/14-3.
35. Letter of the Assistant Commissioner of Immigration, U.S. Department of Labor, Bureau of Immigration, Washington, D.C., to Commissioner of Immigration, San Francisco, California, July 17, 1916.

36. Lee and Yung, *Angel Island*, 147.

Chapter 6. Difficult Times, Tenacious Immigrants

37. Ibid., 145–46. Chapter 4 cites more cases of Punjabis and other South Asians who were targets of bigotry at Angel Island.
38. For about $300 a year, a young man could cover his tuition, room and board in Berkeley. If he spent his summers as an agricultural laborer, he could earn as much as $125 a month, according to Sarangadhar Das, who advised prospective students in his article, "Information for Indian Students Intending to Come to the Pacific Coast of the United States," published in the *Modern Review* in Calcutta in 1911. Indian benefactors settled in California helped the students.

Chapter 7. From Field Hands to Landowning Farmers

39. Figures from California State Board of Control, *California, and the Orientals* (Sacramento, 1920), as cited by Leonard, "Pahkar Singh Murders," 85.
40. Leonard, "Pahkar Singh Murders," 75–87.
41. Mann, "Life and Times of Pakher Singh Gill."
42. Leonard, "Pahkar Singh Murders," 84. Leonard writes, "In the Imperial Valley today, Pahkar Singh is still remembered, not as the older, unsuccessful farmer he became after leaving prison, but as the tall, striking Hindu whose actions polarized opinion in the valley in 1925. Some Hindus and their descendants feel Pahkar's actions helped Hindus remain in farming by making Anglos afraid to cheat them; others feel the murders hurt the reputation of the Hindu farmers and damaged their relationships with the Anglos." See chapter 9, "Marriages Between Cultures," 147.
43. Leonard notes in *Making Ethnic Choices* that in some instances, Imperial Valley wives were still allowed to hold land in their names. Many of the early Punjabi immigrants who settled in the Imperial Valley, which was close to the Mexican border, married Mexican women.
44. Norma Saikhon, interview by Lea Terhune, June 2006.

Chapter 8. Punjabi Pioneer Families of Northern California

45. Murarka, "Rattan Singh Sahota."
46. Sutter County Historical Society Newsletter 45, no. 4, October 2003.
47. Dr. Gulzar Johl, interview with Lea Terhune, May 2006.
48. Kartar Singh Johl, interview with Lea Terhune, May 2006.

49. "The East Indians in Sutter County," by Balwant Singh Brar, unpublished article, among accounts collected by T.S. Sibia.
50. The Gadar Hall was relocated at 5 Wood Street in 1975.
51. Dave Teja, interview by Lea Terhune, May 2006.
52. Didar Singh Bains, interview by Lea Terhune, March 2005.
53. Jaswant Singh Bains, interview by Lea Terhune, 2006.
54. Gurdev S. Thiara, interview, February 2006.
55. Obituary, *Appeal-Democrat*, April 2001.
56. H.L Bradshaw, from excerpt of his 1958 report on Sikhs in North America, posted on https://www.sikhnet.com/.
57. Gary Thiara, interview by Lea Terhune, February 2006.
58. "My Early Years in America," *Sikh Sanchar* 1, no. 4 (December 1972), 109–10.
59. K. Dhillon, "Parrot's Beak."
60. Bob Mohammed, interview by Lea Terhune, January 2007.

Chapter 9. Marriages Between Cultures

61. Ganga Singh Bhatti, interview by T.S. Sibia.
62. Ibid.
63. Mary, David and Leela Rai, interview by Lea Terhune, March 2006.
64. Ralie and Stella Singh, interview by Lea Terhune, March 2006.
65. Amarjit Singh and Rani Rai, interview by Lea Terhune, 2006.
66. Isabel Singh Garcia, interview by Lea Terhune, March 2006.
67. Ali Rasul and Tamara English, interview by Lea Terhune, March 2021.

Chapter 10. Laws Change, Families Reunite

68. Harbhajan Purewal, interview by Lea Terhune, January 2007.
69. Sarb and Prabjoht Johl, interviews by Lea Terhune, April 2006 and January 2007.
70. Bob Singh, interview by Lea Terhune, January 2007.
71. P. Johl, interview, October 2007.
72. Kiran Black, interview by Lea Terhune, February 2008.
73. Harbhajan Singh Johl, interview by Lea Terhune, January 2007.
74. Kulwant Singh Johl and Noor Khan, conversation with Lea Terhune, March 2006.
75. La Brack, *Sikhs of Northern California*, 219.
76. Kang and Aulia, "Monument of Interfaith Understanding."
77. Hari Singh Everest, interview by Lea Terhune, January 2006.

78. B. Singh, interview by Lea Terhune, January 2006.

Chapter 11. Settled and Prosperous: Achieving the Dream

79. Chakravorty, Kapur and Singh, *Other One Percent*.
80. K. Singh, *History of the Sikhs*, vol. 2.
81. Jasbir S. Kang, interview by Lea Terhune, 2005, 2021.
82. Kash Gill, interview by Lea Terhune, January 2021.
83. Representative John Garamendi of California, "Honoring the 2020 Women of the Year," *Congressional Record* 166, no. 194 (extensions of remarks, November 16, 2020).
84. Tej Maan, interview by Lea Terhune, December 2006.
85. Karm Bains, interview with Lea Terhune, 2021.
86. Narinder Singh Kapany, interview by Lea Terhune, December 2007.
87. The CIED launched startups by UCSC faculty and alumni. As a result of this success, Kapany testified before the Subcommittee on Science, Research and Technology of the U.S. House of Representatives, Ninety-Seventh Congress.
88. Khosla, "My Big Biofuels Bet."
89. Sonny Caberwal, interview with Lea Terhune, 2021.
90. Harbhajan Singh Samra, interview with Lea Terhune, 2007, 2022.
91 Kaur, *See No Stranger*.
92. Kavi Raz, interview by Lea Terhune, January 2008.
93. Examples are the tumbi and sarangi; a two-headed hand drum, the dholak; or its larger cousin, the dhol, played with sticks.

BIBLIOGRAPHY

Barrier, N. Gerald, and Verne A. Dusenbery. *The Sikh Diaspora: Migration and the Experience Beyond Punjab*. Delhi: Chanakya, 1989.

Bhatti, Ganga Singh. Interview by T.S. Sibia, 1989, unpublished.

Brar, Rupinder S. *The Japji of Guru Nanak: A New Translation with Commentary*. Washington, D.C.: Asian Cultural History Program, Smithsonian Institution, 2019.

Chakravorty, Sanjoy, Devesh Kapur and Nirvikar Singh. *The Other One Percent: Indians in America*. New York: Oxford, 2017.

Dhillon, Kartar. "The Parrot's Beak." In *Making Waves: An Anthology of Writings by and About Asian Women*, 214–223. Boston: Beacon, 1989.

Dhillon, Dr. Mahinder Singh. *A History Book of the Sikhs in Canada and California*. Vancouver: Shromani Akali Dal Association of Canada, 1982.

Eraly, Abraham. *The Last Spring: The Lives and Times of the Great Mughals*. Delhi: Viking, 1997.

Harlan, Josiah, and Frank E. Ross, ed. *Central Asia: Personal Narrative of General Josiah Harlan 1823–1841*. London: Luzac, 1939.

Kang, J.S., and Bhahan Aulia. "Monument of Interfaith Understanding." *Amritsar Times*, September 2007.

Kaur, Valarie. *See No Stranger: A Memoir and Manifesto of Revolutionary Love*. New York: One World/Random House, 2020.

Khosla, Vinod. "My Big Biofuels Bet." *Wired*, October 2006. https://www.wired.com.

La Brack, Bruce. *The Sikhs of Northern California 1904–1975: A Socio-Historic Study*. New York: AMS Press, 1988.

Lafont, Jean-Marie. "Dr. Josiah Harlan of Philadelphia: An American in Punjab and Afghanistan, 1827–1839." *Span Magazine*, July–August 2002. https://issuu.com/spanmagazine.

———. *Maharaja Ranjit Singh: Lord of the Five Rivers*. Delhi: Oxford University Press, 2002.

Lee, Erika, and Judy Yung. *Angel Island: Immigrant Gateway to America*. New York: Oxford University Press, 2010.

Leonard, Karen. "The Pahkar Singh Murders: A Punjabi Response to California's Alien Land Law." *Amerasia* 11 no. 1 (1984): 75–87.

Leonard, Karen Isaksen. *Making Ethnic Choices: California's Punjabi Mexican Americans*. Philadelphia: Temple University Press, 1992.

MacIntyre, Ben. *The Man Who Would Be King: The First American in Afghanistan*. New York: Farrar Straus Giroux, 2004.

McMahon, Suzanne. *Echoes of Freedom: South Asian Pioneers in California, 1899–1965*. Berkeley, CA: Center for South Asia Studies, 2001.

Mann, Nirmal S., MD. "Life and Times of Pakher Singh Gill: A Panjabi Californian in the Early 20th Century." Pacific Coast Khalsa Diwan Society Centennial, https://sikhcentury.wordpress.com.

Murarka, Ramnesh. "Rattan Singh Sahota—Incredible Saga of One Man's Journey to America." *India-West*, May 15, 1981.

Raju, Sharat. "Becoming American: The Journey of an Early Sikh Pioneer." New Moon Productions. Filmed 2008. YouTube, February 26, 2009. https://www.youtube.com.

Saund, D. S. *Congressman from India*. New York: E.P. Dutton, 1960.

Singh, Dr. Gopal. *A History of the Sikh People*. Delhi: Allied, 1988.

Singh, Khushwant. *A History of the Sikhs*. Vol. 1, *1469–1839*. New Delhi: OUP, 1999.

———. *A History of the Sikhs*. Vol. 2, *1839–2004*. New Delhi: OUP, 1999.

Singh, Khushwant, and Ragu Rai. *The Sikhs*. New Delhi: Roli, 2004.

Takaki, Ronald. *From a Different Shore*. New York: Little Brown, 1998.

Taylor, Paul, and Robert Pontsioen. *Sikhs: Legacy of the Punjab*. Washington, D.C.: Asian Cultural History Program, Smithsonian Institution, 2014.

Taylor, Paul Michael, and Sonia Dhami, ed. *Sikh Art from the Kapany Collection*. Palo Alto, CA: Sikh Foundation, 2017.

INTERVIEWS BY AUTHOR

Bains, Didar Singh (2005)
Bains, Jaswant Singh (2006)
Bains, Karm (2021)
Black, Kiran (2008)
Caberwal, Sonny (2021)
Didbal, Preet (2021)
Dhillon, Kartar (2006)
Everest, Hari Singh (2006)
Garcia, Isabel Singh (2006)
Gill, Kash (2020)
Gill, Ralie and Stella Singh (2006)

BIBLIOGRAPHY

Johl, Dr. Gulzar (2007)

Johl, Harbhajan Singh (2007)

Johl, Kartar Singh (2007)

Johl, Kulwant Singh (2006, 2020)

Johl, Sarb and Prabjoht (2006 and 2007, 2021)

Kang, Dr. Jasbir S. (2005, 2021)

Kapany, Dr. Narinder Singh (2007)

Khan, Noor (2006)

La Brack, Bruce (2007)

Leonard, Karen Izaksen (2007)

Maan, Tej (2006)

Mohammed, Bob and Lillian (2007)

Purewal, Harbhajan Kaur (2007, translated by Jinger Purewal)

Rai, David (2021)

Rai, Mary, David and Leela (2006)

Rasul, Ali, and Tamara Rasul English (2020)

Raz, Kavi (2008, 2021)

Saikhon, Norma (2006)

Samra, Harbhajan Singh (2007, 2022)

Sibia. T.S. (2007)

Sidhu, Gurmeet (2020)

Sidhu, Jagtar and Gurmeet (2006)

Singh, Amarjit and Rani Rai (2006)

Singh, Bob (2007)

Singh, Jane (email, 2020)

Surat Andersen, Erika (email, 2019, 2020)

Thiara, Gary (2006)

Thiara, Gurdev S. (2006)

Thind, David (2007, 2020)

ABOUT THE AUTHOR

Courtesy of Lea Terhune.

Lea Terhune is a writer and editor who lived for twenty-two years in New Delhi, India. She worked as a correspondent for broadcast and print media, including CNN International, Radio Deutsche Welle and Voice of America. She edited *SPAN* magazine for the U.S. embassy in New Delhi, India, and later wrote and edited public diplomacy materials for the U.S. Department of State in Washington, D.C. She is the author of *Karmapa: The Politics of Reincarnation* and edited *Relative World, Ultimate Mind* and *Awakening the Sleeping Buddha* by the 12th Tai Situpa.

Visit us at
www.historypress.com